Chinese Furniture

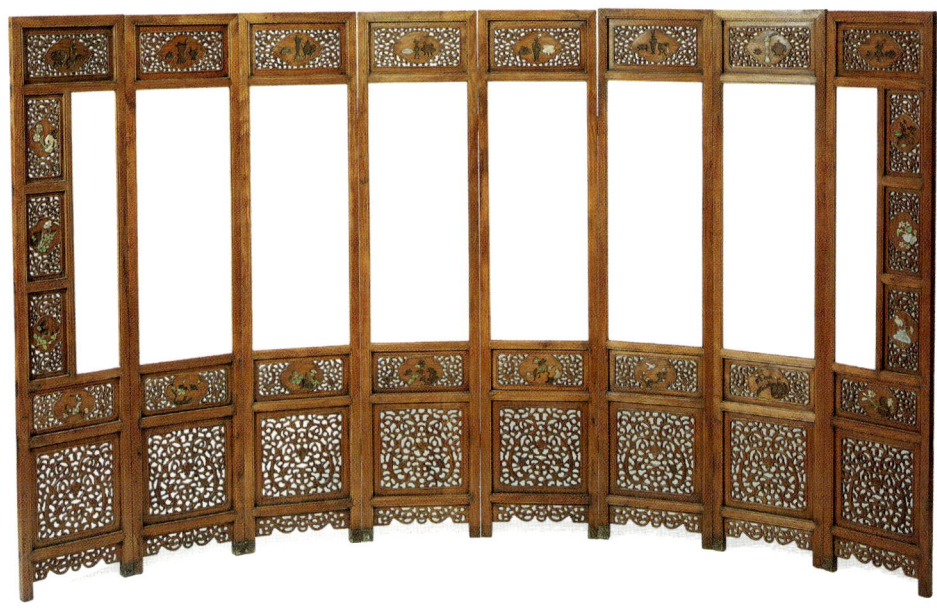

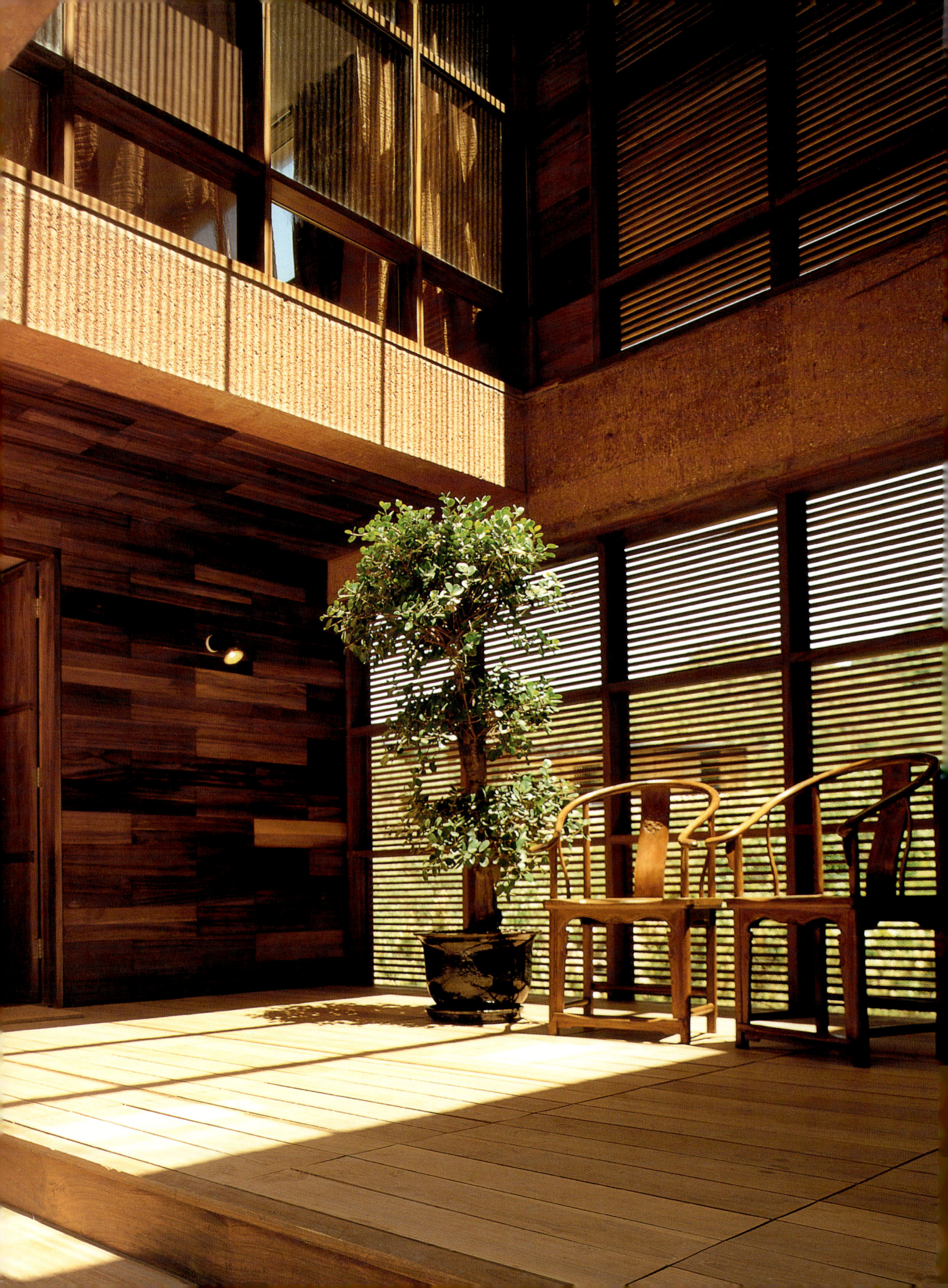

Chinese Furniture
A Guide to Collecting Antiques

Karen Mazurkewich
Location photographs by A. Chester Ong

TUTTLE PUBLISHING
Tokyo • Rutland, Vermont • Singapore

To Martin, Haleh and Yasmeen

First published in 2006 by Tuttle Publishing, an imprint of Periplus Editions (HK) Ltd., with editorial offices at 354 Innovation Drive, North Clarendon, Vermont 15759 and 130 Joo Seng Road #06-01/03, Singapore 368357

Text © 2006 Karen Mazurkewich
Photos © 2006 Andrew Chester Ong and Periplus Editions (Hong Kong) Ltd

All rights reserved. No part of this publication may be reproduced, stored in a retrieval system or transmitted in any form or by any means, electronic, mechanical, photocopying, recording or otherwise without prior permission of the publisher.

Library of Congress Control Number 2004114427
ISBN 13 978 0 8048 3573 2
ISBN 10 0 8048 3573 X

Design: Holger Jacobs and Wiesia Power at Mind Design

Printed in Singapore

Distributors:
North America, Latin America and Europe
Tuttle Publishing, 364 Innovation Drive,
North Clarendon, VT 05759, USA
Tel: (802) 773 8930; Fax: (802) 773 6993
E-mail: info@tuttlepublishing.com
www.tuttlepublishing.com

Japan
Tuttle Publishing, Yaekari Building, 3F,
5-4-12 Osaki, Shinagawa-ku,
Tokyo 141-0032
Tel: (813) 5437 0171; Fax: (813) 5437 0755
E-mail: tuttle-sales@gol.com

Asia Pacific
Berkeley Books Pte Ltd,
130 Joo Seng Road #06-01/03,
Singapore 368357
Tel: (65) 6280 1330; Fax: (65) 6280 6290
E-mail: inquiries@periplus.com.sg
www.periplus.com

10 09 08 07
6 5 4 3 2

Page 1: Eight-panel interior screen, *huanghuali* and semiprecious inlay and pierced panels, eighteenth century, North China. Photo courtesy Peter Fung.

Page 2: A pair of horseshoe-back armchairs soften, yet complement, the cubist geometry and warm, natural colors of this soaring modern villa in China.

Page 3: Window screen with animal motifs, including bats, *changmu* (camphor), nineteenth century. Photo courtesy Oi Ling Chiang.

Pages 4–5: Contemporary adaptation of a Ming scholar's room by John Ang.

Page 6: A living scholar's studio. Inside Cola Ma's home in Tianjin.

TUTTLE PUBLISHING® is a registered trademark of Tuttle Publishing, a division of Periplus Editions (HK) Ltd.

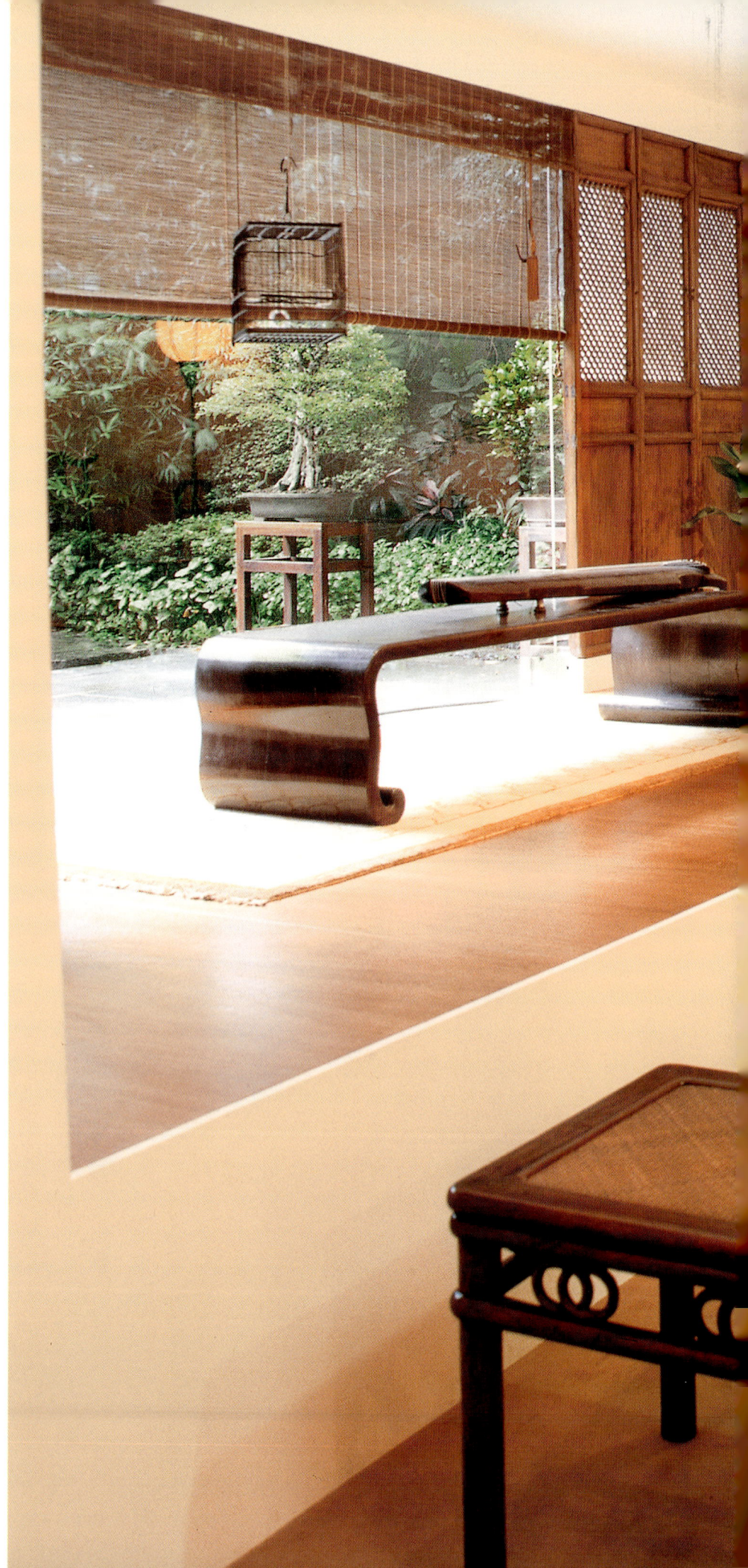

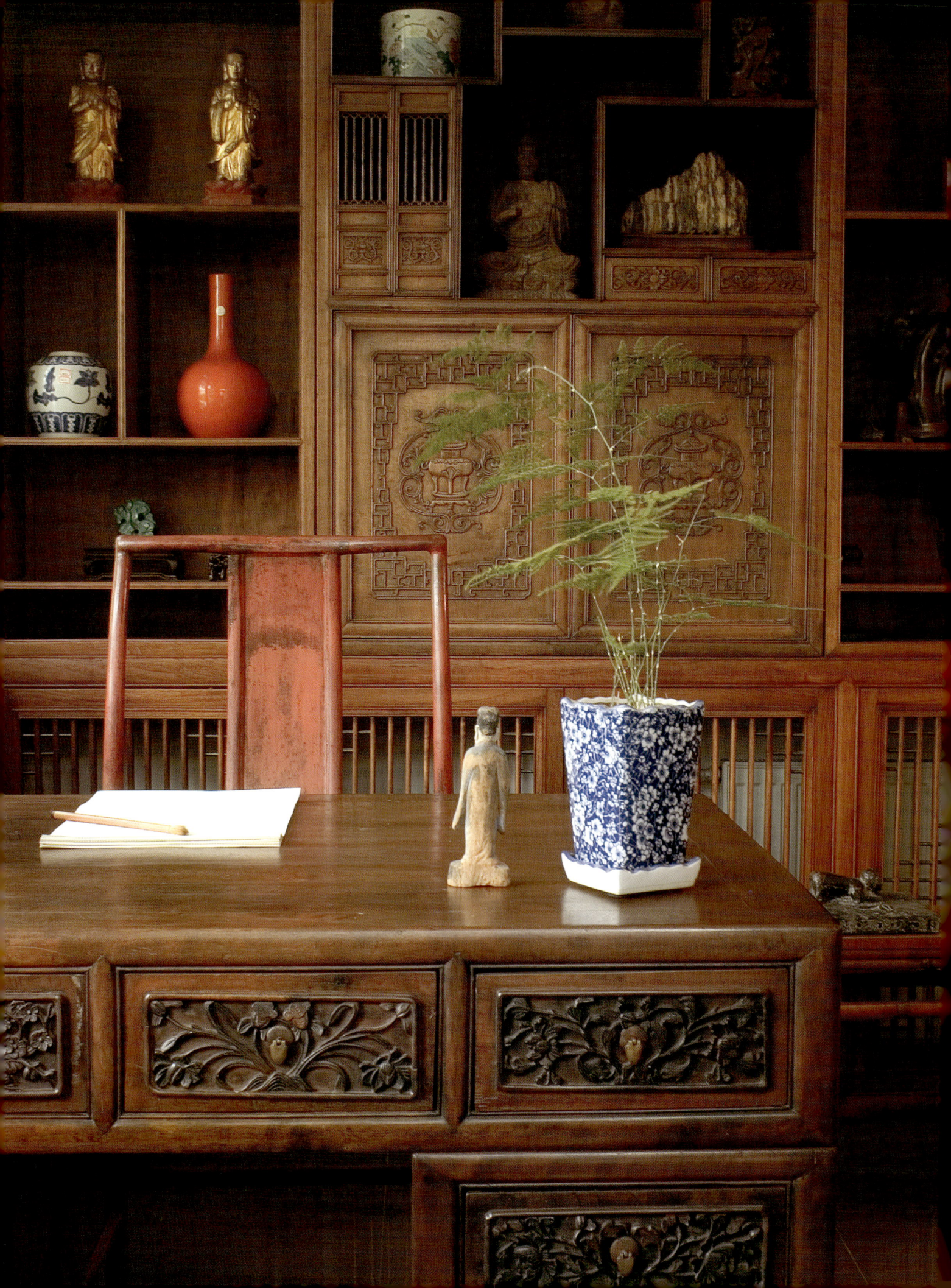

Contents

8 Chinese Furniture: A Renaissance

14 Evolving Styles

30 Classifying Chinese Furniture
Style 32
Wood 32
Types of Wood 34
Rarity and Age 37
Carving, Workmanship and Symbolism 41
Decoration in Chinese Furniture 42
Joints 47

48 Chairs
Yoke-back Armchairs 52
Southern Official's Hat Armchairs 54
Lamphanger Chairs 60
Rose Chairs 61
Horseshoe-back Armchairs 63
Folding Armchairs 67
Qing-style Armchairs 70
Western-influenced Chairs 71

74 Stools and Benches

88 Tables and Desks
Recessed-leg Painting Tables 90
Side or Wine Tables 93
Flush-sided Corner Leg Tables 95
Waisted Corner Leg Tables 96
Altar Tables 96
Square Tables 98
Kang Tables 99
High Tea Tables and Stands 102
Pedestal Tables 103
Coffer Tables 104
Round Tables 106
Qin Tables 108
Gaming Tables 108
Desks 109

110 Beds
Day Beds 113
Couch Beds 114
Canopy and Alcove Beds 116

120 Cabinets and Bookshelves
Square-corner Cabinets 122
Compound Cabinets 129
Sloping-stile Cabinets 130

Bookshelves 134
Display Cabinets 136
Lacquer Furniture 138

140 Doors and Screens

150 Household Accessories
Candlestick Stands and Lanterns 151
Braziers 155
Shrines 155
Garment Racks and Washstands 156
Mirror Stands 158
Clothing Chests 158
Tiered Boxes and Tea Containers 158
Document Boxes 160
Stationery Trays and Gaming Boards 164
Brush Pots and Scroll Pots 164
Display Stands 166
Toggles and Figurines 166
Miscellaneous Items 167

168 Classical Versus Vernacular

186 Regional Differences
Suzhou Style or Jiangsu Style 188
Canton Style 190
Zhejiang Style 191
Shanghai Art Deco 194
Northern Styles 197
Shanxi Style 199
Fujian Style 202

204 To Strip or Not to Strip

214 May the Buyer Beware!
The Meaning of "Styles" 216
What to Buy 216
Pitfalls of Collecting 217
Buying before Restoration 217
The Quality of Restoration 218
The Joints 218
Wear and Tear 218
Price Watch 218
Credible Dealers 218
Conclusion 219

220 Guide to Dealers

222 Bibliography

223 Acknowledgments

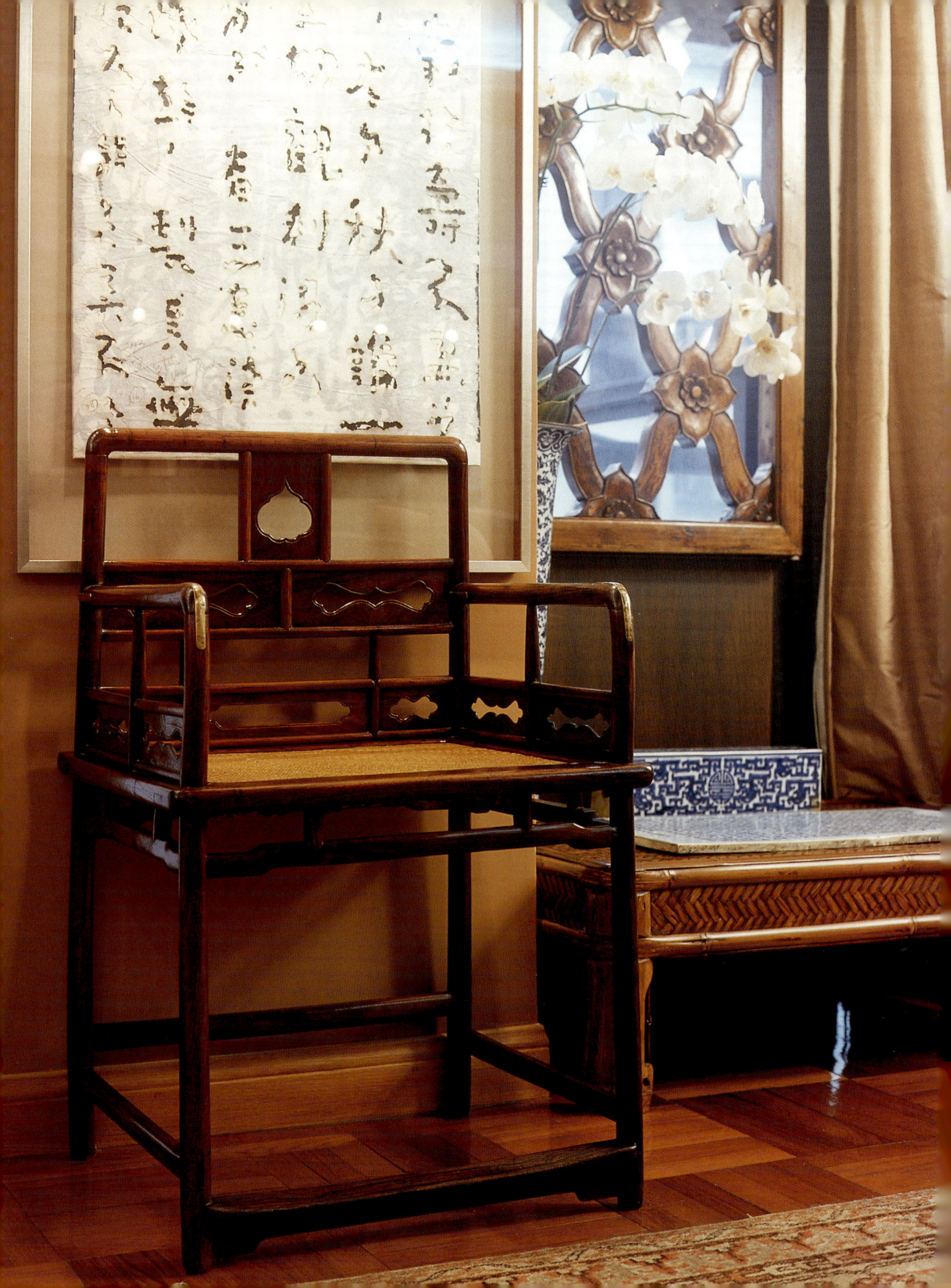

Chinese Furniture: A Renaissance

Of the various art forms to evolve in China, among them porcelain, lacquer and calligraphy, furniture craft was perhaps the least appreciated and the last to be collected. Now, carpenters, unsung heroes who once toiled anonymously in workshops, are venerated as true artisans whose masterpieces are worth hundreds of thousands of dollars. During the Ming and Qing dynasties, these talented craftsmen elevated furniture from the realm of functional to the realm of philosophical. By artfully incorporating wood grain patterns, experimenting with spatial dimensions, and innovating new forms of joinery, simple and pure tables and chairs came to represent something higher: the harmony and union between man and nature.

The best furniture on the market is animated. Enthusiasts look for dynamism and movement in the gentle curves and sweeps of the spandrels, aprons, braces and feet. Analogies range from lotus flowers to elephant trunks.

The appreciation of Chinese furniture on an international scale began in the 1930s when a group of American and European scholars living in Beijing and Shanghai started collecting fine antiques. Before the Communists seized power in 1949, much of the furniture owned by these scholars was spirited out of the country and into the US where they would later form the basis of major museum collections in Kansas City, Philadelphia and New York. For decades, as Red China remained closed, it was commonly believed that these museum artifacts were all that remained of Ming and early Qing dynasty furniture. They were considered the remnants of a lost culture that elevated carpentry to a high art. This assumption was, of course, wrong. In the backwaters of China, in isolated provinces such as Anhui and Shanxi, spectacular examples were gathering dust. While the country endured paroxysms of social change, scholars like Wang Shixiang were quietly scouring the Beijing markets in search of classical Ming-style furniture. During the Communist Revolution, he unearthed dozens of examples, disassembled them with the help of Beijing craftsmen, and compiled notes of his findings. It was a labor of love that was almost derailed during the Cultural Revolution (1966–76) when symbols of supposedly bourgeois conceit were confiscated and destroyed.

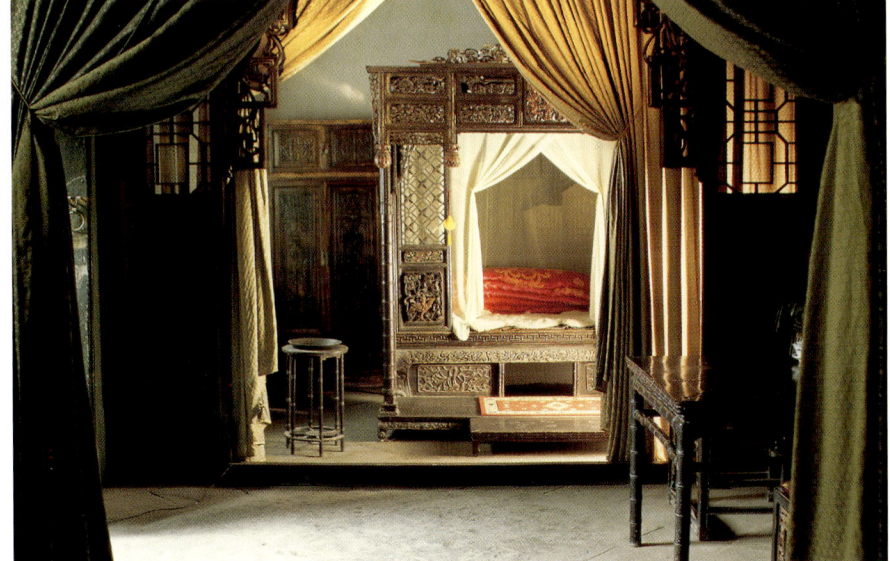

Fig. 1 (opposite)
Kai-Yin Lo has decorated her home with Chinese antique furniture such as this rose chair and window screen from Anhui province.

Fig. 2 (above)
The Kang family manor in Henan province was constructed in the late nineteenth century. The home escaped destruction during the Cultural Revolution because it was used for education rallies. It was later restored in the 1990s, and this large canopy bed, which once belonged to the house, was pulled out of storage and reinstalled in the bedroom of the last surviving matriarch.

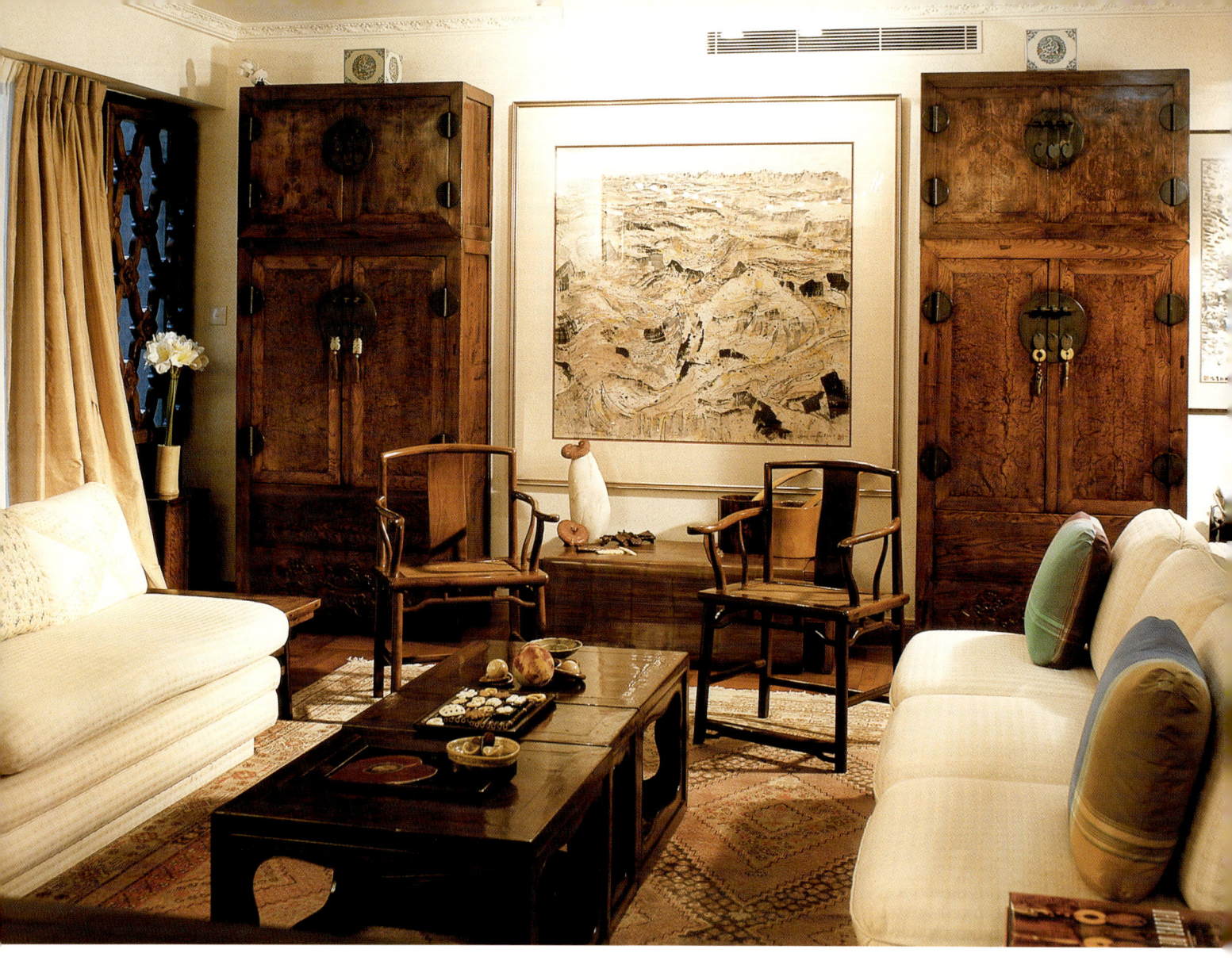

Fig. 3

Once coveted, Ming and Qing furniture became a symbol of loathing. During the Cultural Revolution, when chaos ruled and aesthetic beauty was derided, thousands of exquisite pieces were thrown into piles on the streets and burned or shipped in pieces to collection warehouses. The oral tradition of Chinese carpentry was threatening classical furniture from the Ming and Qing dynasties with extinction. Even during these darkest hours, however, pieces survived. Some were simply too far removed in the countryside to be directly affected by the tumult. Others survived because they were rescued by academics or conscientious Red Guards who ignored destruction orders and hoarded choice pieces in their homes after they were dumped into warehouses.

After the Cultural Revolution, there was some attempt at restitution. Wang Shixiang's stash was eventually returned to him and his collection donated to the Shanghai Museum after it was purchased by Quincy Chuang in Hong Kong. Much of the furniture stored in the warehouses, however, was simply sold off.

By the mid-1980s, as China's new economic policy kicked into gear, antique furniture began flooding out of China and inevitably surfaced around Hong Kong's famous "Cat Street." Dealers and collectors who recognized their worth snapped them up, including published collectors like Peter Fung, Robert Piccus, Mimi Hung and Dr Shing Yiu Yip. While most transactions occurred privately, the growing popularity of Chinese furniture became patently obvious when a 1996 auction at Christie's Hong Kong netted US$11.2 million—the highest total for an individual collection of Chinese art in a decade. The benchmark for individual items has been repeatedly surpassed.

The trend will probably continue as China's new rich rediscover their past. China's emerging art aficionados, such as Zhao Ping, a Beijing entrepreneur, are part of a new wave rekindling the Chinese passion for collecting *objets d'art*. He says, "I believe collecting can help me learn about Chinese history"—something he did not have time to appreciate in school when he was studying electronics. A new Cultural Revolution is transforming the market. Antique Chinese furniture is entering a period of renaissance.

Fig. 3
Dual compound cabinets frame two southern official's hat chairs in Kai-Yin Lo's Hong Kong apartment. Furniture that survived destruction during the Cultural Revolution in China has become *de rigeur* in the homes of the wealthy.

Fig. 4
Southern official's hat chair with a non-protruding crest rail, *huanghuali*. Photo courtesy Robert A. Piccus.

Fig. 5
A petite rose chair with scrolling grass pattern carved in relief on the apron, *huanghuali*, eighteenth century, North China. This chair is unusual because it lacks a backrest. Photo courtesy Peter Fung.

Fig. 6
Interior of Cola Ma's home in the city of Tianjin. Most of the furniture is from Shanxi province, a specialty of Ma, who has become an expert in softwood or vernacular furniture.

Fig. 7 (overleaf)
The "Hall of Benevolence," the principal formal room of the Shen family home in Luzhi, Jiangsu province, built in 1870. Typical of late Qing-dynasty residences, the room is richly ornamented with furniture, paneling, latticework, paintings and calligraphy.

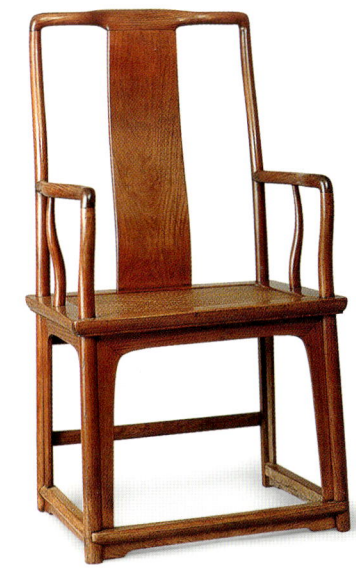

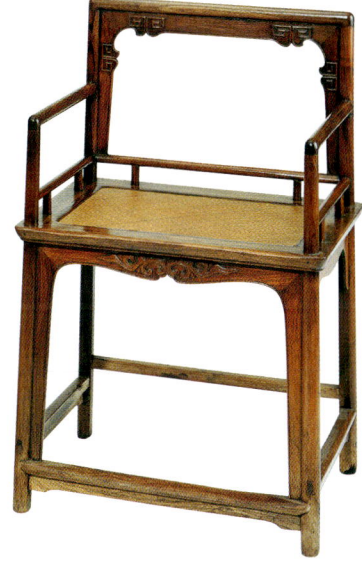

Fig. 4

Fig. 5

Fig. 6

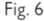

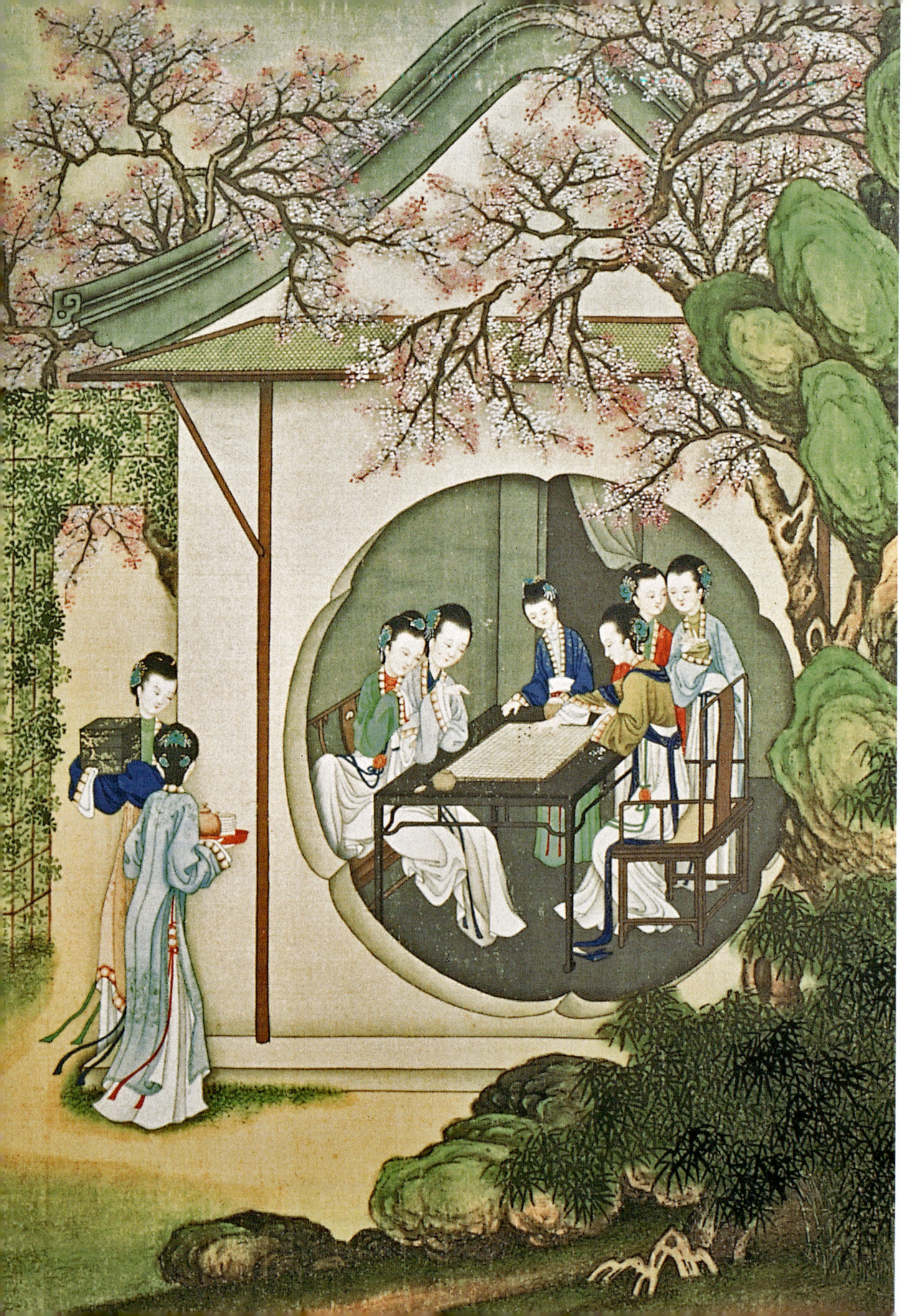

Evolving Styles

For centuries the Chinese, like the Japanese, had a mat culture. Resting, socializing and eating all occurred while kneeling, sitting cross-legged or reclining on woven mats on the ground surrounded by basic utensils and a handful of low-level furnishings. Chinese furniture, as we know it today, did not come into being until the Tang dynasty (AD 618–906). By the beginning of the Northern Song dynasty (AD 960–1127), high-level officials had graduated to tables and chairs. The new culture of sitting reached all levels of society by the end of the dynasty. By this time, too, the designs and techniques of making furniture had become established, and owning furniture was no longer the prerogative of the privileged few.

How Chinese furniture evolved is still a mystery. What we know is that over 2000 years ago, the ancients began constructing platforms to raise themselves off the cold earthen floors. The oldest known piece of furniture is a black lacquered bed found during the 1957 excavation of a tomb in Xinyang, Henan province, that dates back to the Warring States period (475 BC–AD 221). Scholars speculate that this intricately carved bed, made for a warlord of the southern kingdom of Chu, was not only used for sleeping but doubled as a ceremonial platform from which he ruled.

Fig. 8 (opposite)
"Palace Women," attributed to Leng Mei, a court artist living in Emperor Kangxi's reign during the Qing dynasty (AD 1644–1911), and active in the late seventeenth and early eighteenth century. The painting depicts a southern official's armchair and a square Eight Immortals table. Photo courtesy National Palace Museum of Taipei.

Fig. 9
Woodblock print of an informal scene of three people seated on drum-shaped stools made of rattan or draped in fabric around a square Eight Immortals table, from *The Story of Hong Fu*, published in the Wanli period (AD 1572–1620). Photo courtesy Grace Wu Bruce.

Fig. 10
Woodblock print of men on round waisted stools eating at a side table in a house of pleasure, from a chapter in the drama *A Pair of Fishes*, published in the Wanli period (AD 1572–1620). Photo courtesy Grace Wu Bruce.

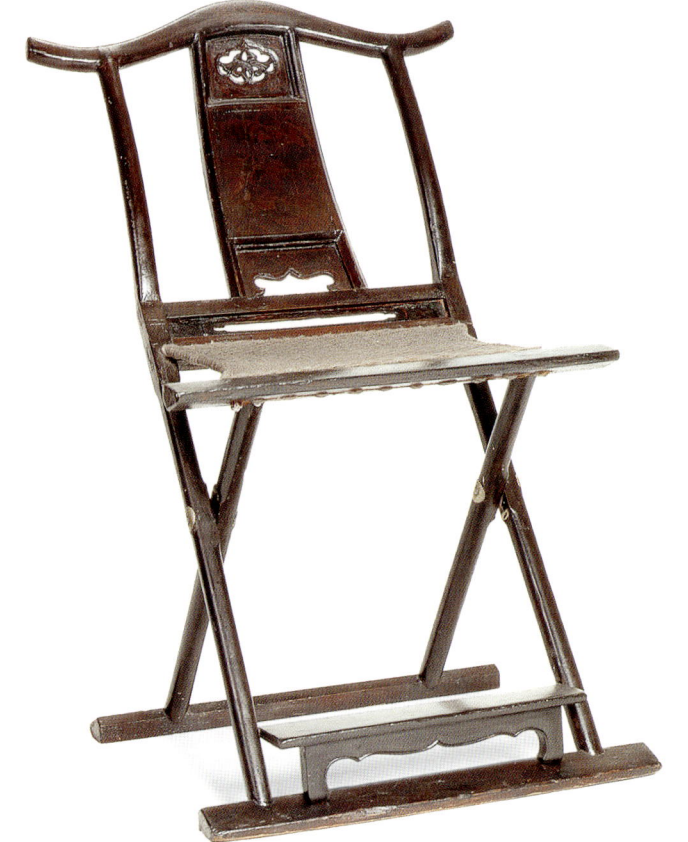

Fig. 11

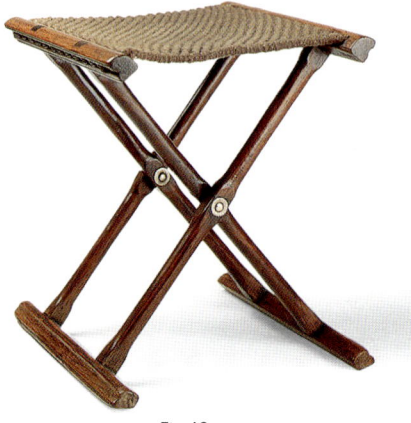

Fig. 12

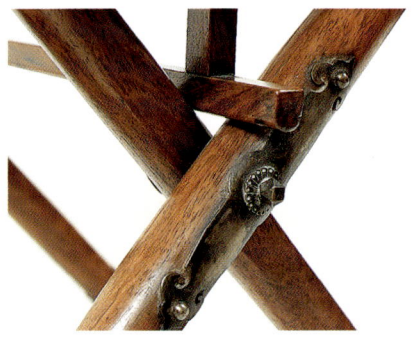

Fig. 13

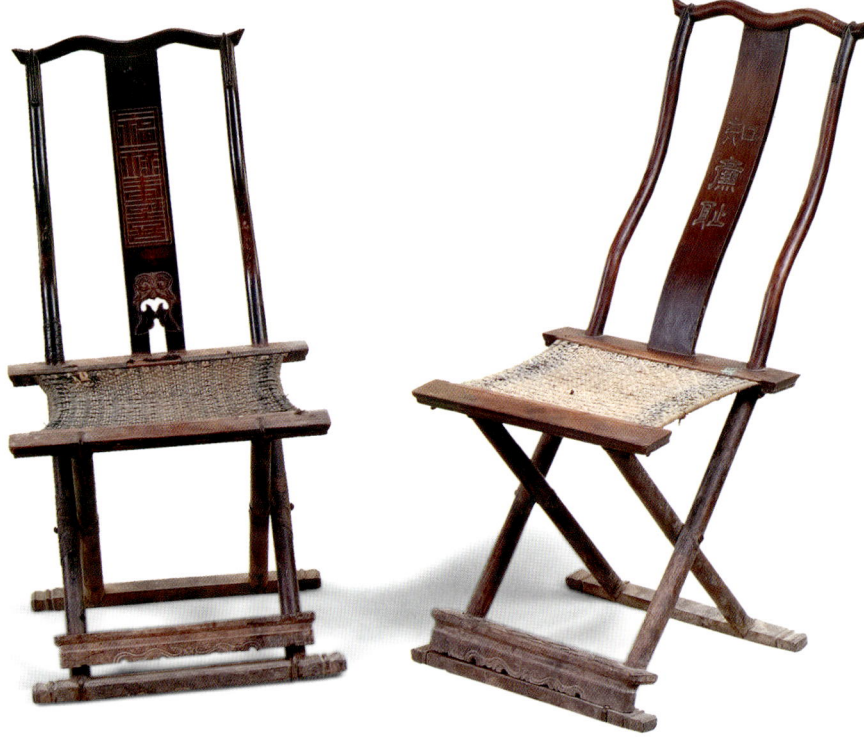

Fig. 14

Fig. 11
Folding yoke-back chair made of softwood and coated in a dark lacquer, seventeenth century. This chair—one of a pair—was once adorned with red lacquer ornamentation bearing writhing dragons. The opened carved panel at the top of the splat is a *ruyi*-shaped medallion. The decoration on the bottom of the splat is a *kunmen*-shaped opening. When folded, this chair measures only 7 1/2 inches (19 cm) wide. Photo courtesy Robert A. Piccus.

Fig. 12
Folding stool, *huanghuali*, ca. early eighteenth century. Photo courtesy Robert A. Piccus.

Fig. 13
The hinge at the junction of the crossed legs is called a *baitong*. These hinges are both decorative and provide stability for the folding stool. Photo courtesy Robert A. Piccus.

Fig. 14
During the Song dynasty, a backrest was added to the folding stool, creating one of the first forms of chair. Collection of Cola Ma.

Fig. 15
Folding horseshoe-back armchair, *huanghuali*, late sixteenth to early seventeenth century. There are fewer than twenty published examples of Ming folding chairs in *huanghuali* wood. The inset openwork panel is carved with a hornless dragon within a *ruyi*-shaped medallion. The central panel features the mystical beast *qilin* in a bed of clouds and trees. Yellow brass reinforces the joints. Collection of Dr S. Y. Yip. Photo courtesy Grace Wu Bruce.

16 Chinese Furniture

Bas-reliefs and murals found in Han tombs in Henan province showing cross-legged men on low couches or *ta* was further proof that raised platforms existed back then. These seats were most likely an adaptation of the brick platform known as the *kang*, which was warmed by flues and covered with thick mats and rugs to serve as a bed in cold weather.

The evolution from mat to chair did not occur overnight. There were many transitional forms of seating customs. Floor poses ranged from kneeling to a cross-legged position. Even when people took to elevated platforms, they reclined on them as if they were still seated on the ground. It took many centuries before people sat upright in their seats with their legs extended to the floor.

The history of furniture saw two parallel tracks of development. The prototype, which appeared sometime during the reign of Han Lingdi (AD 168–188), may have been borrowed from foreigners. This form of transportable stool or day bed was called a *huchuang* or barbarian bed, and it became a symbol of power. The oversized stool was simple: the front and back legs were hinged where they cross, and a seat was created by threading a rope across the top stretchers (Figs.12, 13). The sheer act of raised seating was designed to convey an impression of authority among underlings, particularly on the battlefield where it was used by commanders. The *huchuang*, however, was eventually domesticated and popularized, and used by prince and peddler alike. Once folded, it was easy to sling across a shoulder (Figs. 11, 14). By the Song dynasty (AD 960–1279), a backrest was added to the simple stool, creating a version of what we know as the British deck chair. These chairs were often constructed from light softwood and then lacquered. The curve of the back splat is nicely aligned with the rear stiles and legs, which are fashioned from the same piece of wood. Other versions of this chair emerged, including a folding settee that could seat three persons, and folding chairs with arms—the most regal being the folding horseshoe chair (Fig. 15).

The etymology of the *huchuang* is fuzzy. It is unclear just who the so-called "barbarians" were. It is unlikely they came from the Mongolian hordes in the north because there is no evidence that they used such seats. Instead, scholars speculate that the word "barbarian" was simply a catch-all term to describe any foreigner. Thus, the chair could have been inspired by the collapsible chairs of India, which were introduced along with Buddhism, or imported by Silk Road traders originally from Syria. The spread of Buddhism throughout the region during the Northern and Southern dynasties (AD 420–588) brought with it a variety of seats, including a straw-woven hourglass-shaped stool. In a cave painting dated to the Northern Wei period (AD 470–93), a teacher is perched on one such seat along with his students. Curtis Evarts speculates that the pedestal might have been inspired by the Greek pedestal carried by traders along the Silk Route. Ceremonial basins/braziers attributed to monks around 1189 were also incorporated into daily life.

A more sophisticated form of chair, known as the rigid frame chair or *yi*, appeared sometime during the Tang dynasty (AD 618–906). It is obvious from the archeological records that the evolution from low furniture to high was a slow, progressive one. But something finally crystallized during the Tang dynasty. As the popularity of Buddhism rose, the clashes that were prevalent during the Northern Wei dynasty waned. As peace took root, people had more time to spend innovating and tweaking luxury items such as furniture.

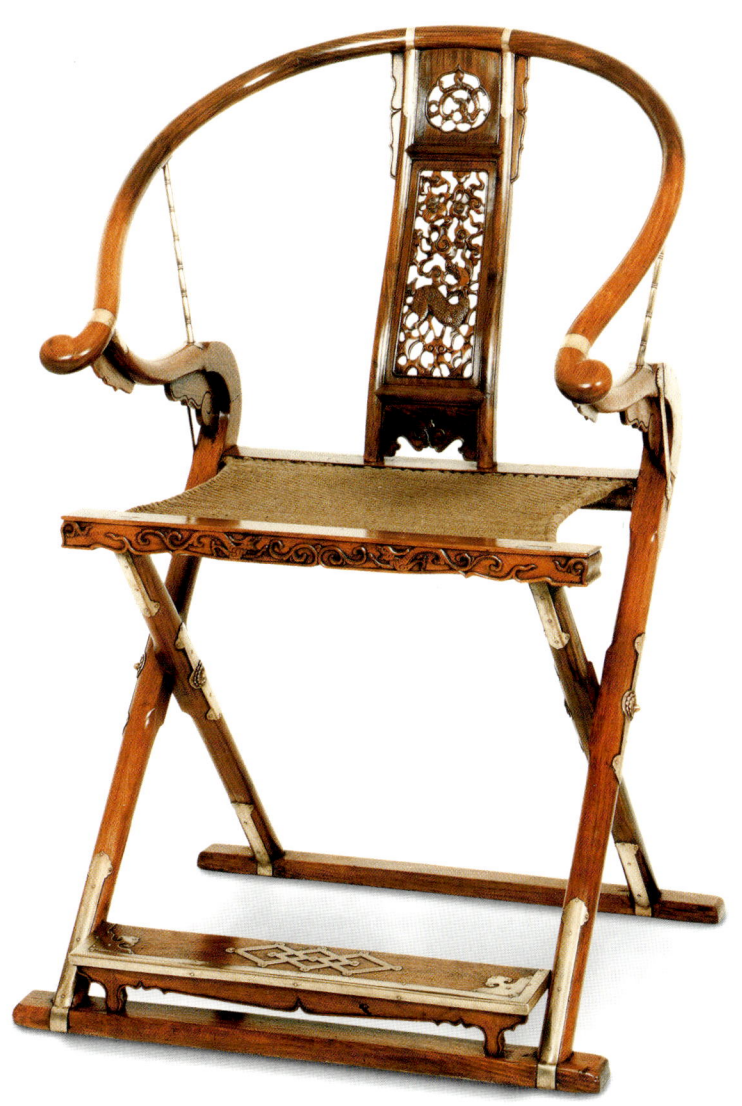

Fig. 15

Evolving Styles 17

Fig. 16

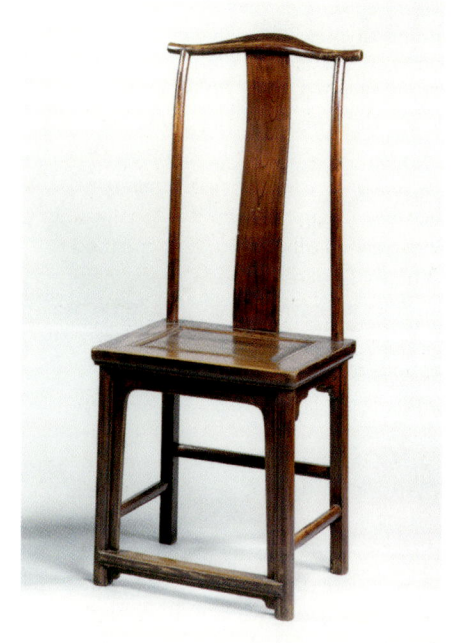

Fig. 17

The word yi, which is derived from the Chinese character "to lean," came into use in the tenth century. From the very beginning, the purpose of the yi was to facilitate leisurely contemplation. Although it may have been partly inspired by the barbarian chair, its frame more closely resembles chairs used in Byzantine Europe. Scholars speculate that officials of the outward-looking Tang courts, inspired by Egyptian and Roman customs, simply desired a more comfortable lounge chair for the garden.

What started as an indulgence of the élite was quickly popularized. The Japanese monk Ennin, who traveled in China between AD 838 and 847, noted in his diary the use of chairs by high-level officials. It was probably not long after his visit that wealthy merchants also began commissioning them.

By the tenth century, a painting entitled "Night Revels of Han Xizai" by Gu Hong Zhong shows guests sitting upon U-shaped couch beds surrounded with decorative railings, yoke-back chairs, high recessed-leg tables and standing screens. This was the first glimpse into the evolving world of Chinese furniture that would eventually morph into the armchairs, rose chairs and side tables which became fashionable at the beginning of the Song dynasty (Figs. 16, 17). This painting is also the first pictorial evidence that high chairs and tables were used by prominent statesmen in their fashionable homes during the early Song dynasty. For the Chinese upper crust, furniture was now in vogue. It was nothing short of a domestic revolution.

The Song style was dictated by functionality. Early examples followed architectural principles based on post-and-beam construction. Stability was key, and what developed was a brilliant form of joinery known as the traditional mortise-and-tenon. This form of joinery is what distinguishes Chinese furniture from other Western precepts (Fig. 18).

18 Chinese Furniture

Over time, however, zealous craftsmanship surpassed utilitarian intent. Woodblock prints from the eleventh century depict simple furniture showing true artistic enterprise. One basic square table has sturdy legs crafted to join the table top in a graceful arc and meet the ground as a delicate horse hoof-shaped foot.

The Song fashion was elegant but deceptively simple. Day beds and painting tables, such as the one featured in Liu Sung-nien's painting "Preparing Tea" (Fig. 19), initially retained a box-like platform shape common during the Tang dynasty. Innovation soon crept in. Some of the basic shapes that evolved include decorative waisted tables and scepter-shaped table legs as shown in "Morning Toilette in the Women's Quarters," attributed to Wang Shen (AD 1036–88) (Fig. 22). Other classic elements that can be traced back to this era include the round-legged recessed-leg table, curved humpback stretchers and square feet as seen in the Qing-dynasty painting "Palace Women" (Fig. 8, and Figs. 20, 21).

Not surprisingly, interior design became a preoccupation among the arbiters of taste—the scholarly class. As Lina Lin writes in the Taipei Museum catalogue *Special Exhibition of Furniture in Paintings*, furniture was freely adapted and arranged for individual needs during the Song dynasty.

The literati of the Yuan (AD 1279–1368) and Ming dynasties (AD 1368–1644) continued to build on the earlier Song traditions, but during the Ming era furniture handicraft reached new heights. The establishment of the new Imperial Palace in Beijing (AD 1402–23) led to the re-establishment of imperial workshops and the flourishing of high-quality products, including the carved altar table at the Victoria and Albert Museum in London. Whereas the Song scholarly class paid homage to decorative lacquer and curves, puritan successors developed a more austere aesthetic. The arbiters of taste preferred clean lines and silhouettes, and placed greater emphasis on the grain patterns of hardwoods such as *huanghuali*, a type of tropical rosewood now extinct.

There is consensus among scholars that Chinese furniture reached its apex between the Jiajing and Kangxi periods (AD 1522–1662) when nobles sought to acquire luxury goods, including furniture, illustrated books and calligraphy. During this time, craftsmen perfected minimalism

Fig. 18

Fig. 16
The folding chair gave rise to other forms of furniture such as the table.

Fig. 17
The rigid frame chair or *yi*, like this side chair with an elongated back, was developed sometime during the Tang dynasty. Photo courtesy Christopher Cooke.

Fig. 18
An original painting platform like the one depicted in "Preparing Tea" (Fig. 19) was the possible prototype of the classical tables found in paintings and woodblock prints dating to the Song dynasty. This diagram shows the evolution from Tang table to the more common scepter-shaped and cabriole-shaped legs found in the Song dynasty. Both the apron and the legs were reshaped in later centuries. The cusped openings of the Tang-style table became a simple curvilinear apron until the apron itself eventually straightened out. The ground stretchers joining the legs for stability were eventually phased out and their vestige was the scepter-shaped feet. Eventually, even the scepter design transmuted either into horse hoof feet that curve inwards or the S-shaped cabriole feet that curve outwards.

Fig. 19
"Preparing Tea." This painting is attributed to Liu Sung-nien (AD 1174–1224). In the Tang dynasty (AD 618–906), tea drinking was popular at court, at literary gatherings and at temples. Two attendants are seen preparing tea while a monk sits at a Tang-style painting table with cusped openings, stretchers and legs slightly curved in the shape of scepters. Next to the painting platform is a recessed-leg table with plain spandrels and round legs. Horizontal braces are also used to stabilize the table. According to Lina Lin in her Taipei Museum catalogue, *Special Exhibition of Furniture in Paintings*, the purpose of the small spandrels and apron is to increase the strength of the mitered tongue-and-groove joints. Photo courtesy National Palace Museum of Taipei.

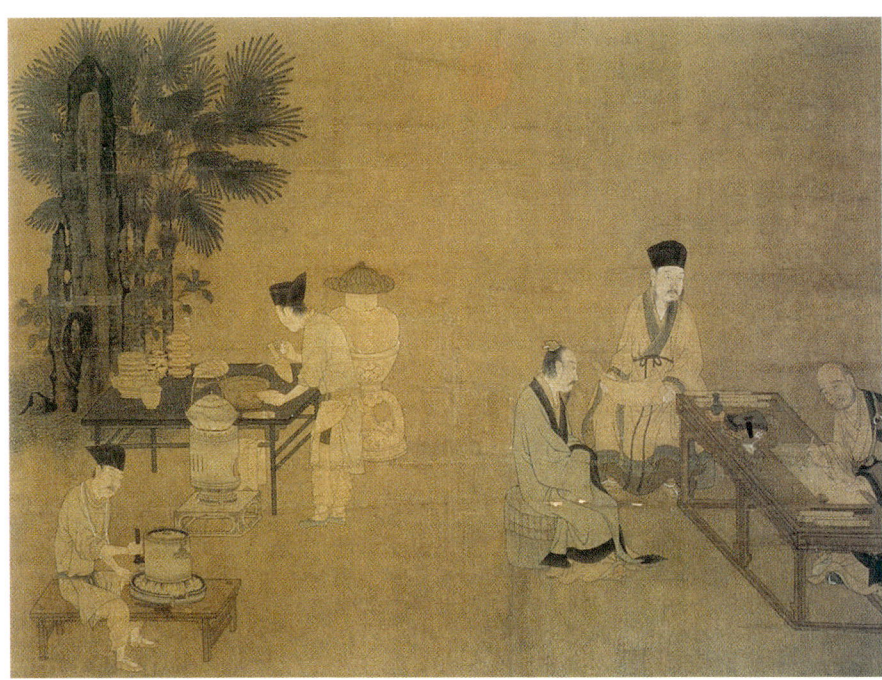

Fig. 19

Evolving Styles

Fig. 20
Table built in a traditional style with stretchers extending across the length and width, ca. fifteenth century, Shanxi province. This style, with its scepter-shaped feet, dates back to the Song dynasty. By the end of the Ming dynasty, the use of long stretchers between the legs disappeared as joinery techniques improved. The joinery at the top, allowing for corner indentations, is unusual. This is a good example of a softwood—*huaimu* (locust)—that is preserved in part due to its high density. Photo courtesy Cola Ma.

Fig. 21
Painting table, *zuomu* (oak), Shanxi province. The table has been stabilized by floor stretchers. The legs are slightly bulging and the corners are indented, much like the archaic tables from the Song and Yuan dynasties. Photo courtesy Cola Ma.

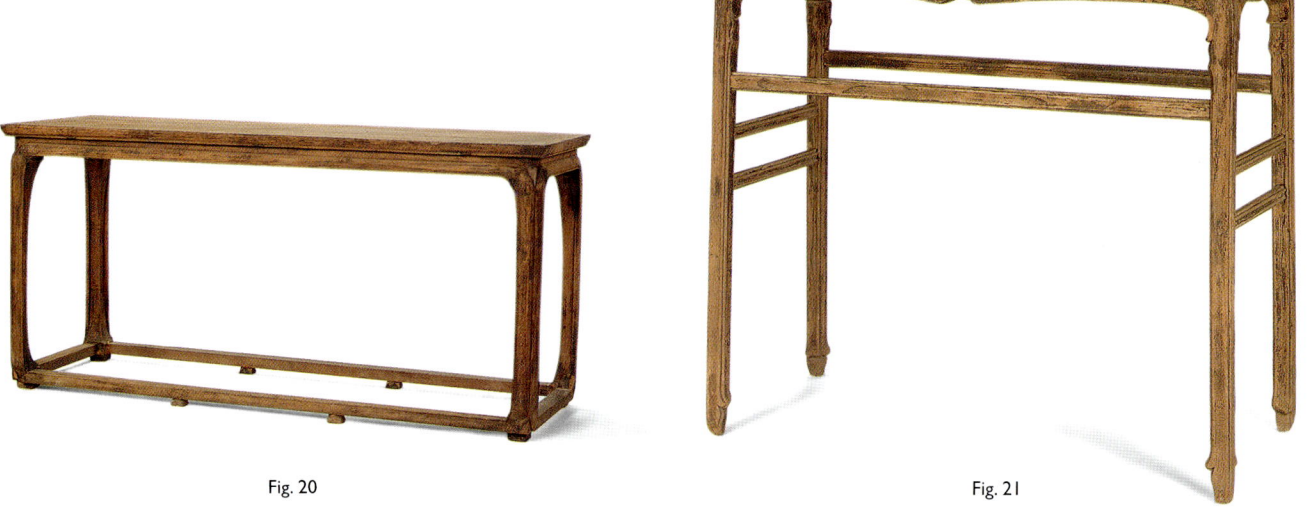

Fig. 20

Fig. 21

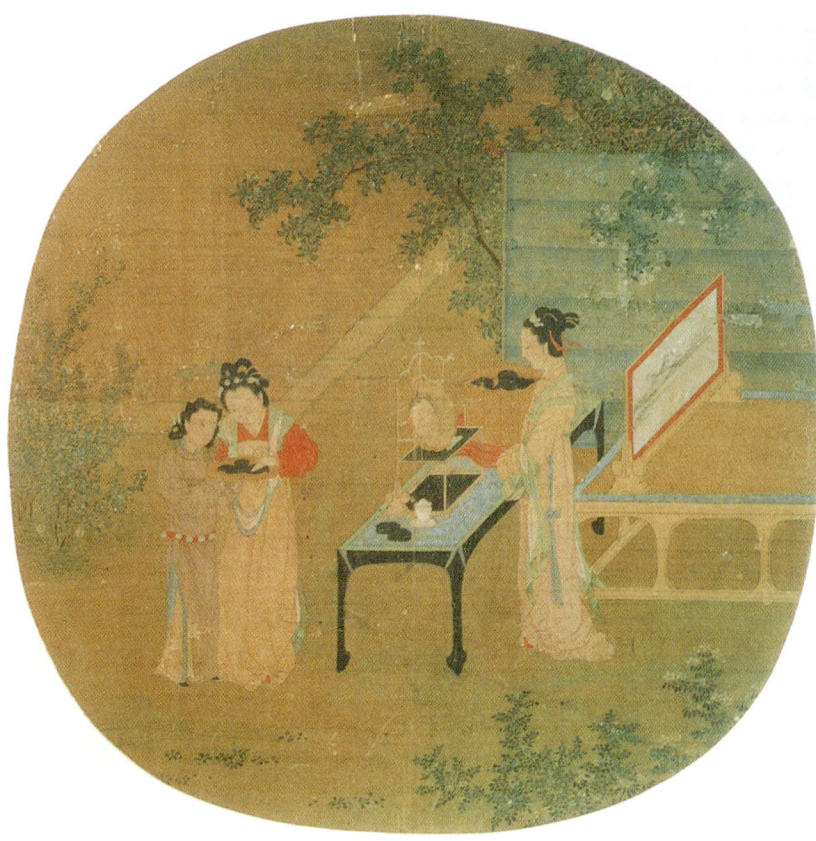

Fig. 22

by using the least amount of material to obtain both maximum function and aesthetic pleasure. Such purity of line, however, required discipline. Furniture makers during this period adhered to rigid rules governing proportion and size. These codes were diligently recorded in the fifteenth-century text, *Lu Ban Jing*. The book is essentially a construction manual compiled by three government officials who were in charge of recruiting artisans for the emperor's projects. Academics who have tried to make furniture by following the manual like a cookbook have failed. Scholars such as Craig Clunas speculate that the book is a bible, not a blueprint, reflecting the spirit with which furniture should be constructed. That said, it is clear that during various eras carpenters organized themselves into guilds. One such guild, the Sacred Society of Lu Ban, was established in the mid-1800s. Some of the best carpenters, including Huang De Ping who recently retired from Cola Ma's Tianjin workshop, say they still follow the directives taught by their fathers and grandfathers who apprenticed under the Lu Ban guild.

While not a perfect recipe, the laws governing carpentry as described in this ancient text are rooted in ritual and

superstition. There were auspicious days to fell trees or lay foundations, as well as special prayers, lucky charms and tricks to neutralize sorcery. Certain measurements were deemed favorable. For example, a table 1 chi 6 cun (which represents 1 1/2 feet in Chinese measurement and is today's standard's half meter) wide, corresponds to the measurement symbols that represent "white" and "wealth." Some increments represent good, while others bring about illness and harm. Bound by such rigid doctrine, carpenters were rather exacting with their rulers.

While the *Lu Ban* was obviously intended as an architectural guide, roughly one-third of its text is devoted to furniture design. The techniques used to create the angles, curves and joinery to build chairs and tables were adapted and refined from the principles applied to construct halls and homes. Even the decorative motifs found on partitions and banisters are replicated on table spandrels and chair panels. The origins of the *Lu Ban* are unknown, but scholars speculate that the section on furniture may have been supplied by the foreman of a large carpentry factory who kept an inventory of measurements. The existence of large production centers might explain why furniture proportions deviated little and standardization prevailed.

The center of production was Beijing, where the Imperial Palace workshops were situated. The provinces of Guangdong and Jiangnan (the region which now comprises Zhejiang, Jiangsu and Shanghai) were also major centers of furniture production, in particular the cities of Guangzhou and Suzhou. Suzhou was considered the cultural capital of China in dynastic times. It flourished as a trading and silk center in the early sixth century, but reached its apogee during the Ming and early Qing. While it was linked with the capital through the Grand Canal, it was far enough away from the political epicenter to be less conservative. Many officials and scholars purchased and planned their garden-residences here as retreats for their retirement years.

Although each region favored different styles, there was an enormous amount of cross-pollination among carpenters, which explains the systematization of measurements and styles during the Ming era. This has been attributed to the strict taxation scheme of the early Ming

Fig. 23

emperors, who regularly called upon the services of carpenters in lieu of payment of taxes. Tradition dictated that carpenters living in the capital were required to work in the palace workshop ten days each month, while those from other parts of the country worked three months every three years. This excessive form of tax was relaxed by the mid-fifteenth century, as artisans paid tax rather than serve time.

Carpenters in the region retained a relationship with the imperial workshops even after the Manchurian invaders ousted the Han Chinese and formed the Qing dynasty in 1644. For example, during the Qianlong era (AD 1736–96), a satellite workshop of the Imperial Palace opened in Guangzhou in order to make Southern-style furniture for the emperor.

Fig. 22 (opposite)
"Morning Toilette in the Women's Quarters," attributed to Wang Shen (AD 1036–88). The long lacquered table has no braces and has scepter-shaped legs that were popular during the Song dynasty. A small bed screen with marble inlay is placed on the sleeping platform behind the standing woman.

Fig. 23
The main hall of the Feng family residence in Langzhong, northeastern Sichuan province, decorated as it would have been in the early twentieth century when the family occupied it.

Evolving Styles 21

Fig. 24

Fig. 25

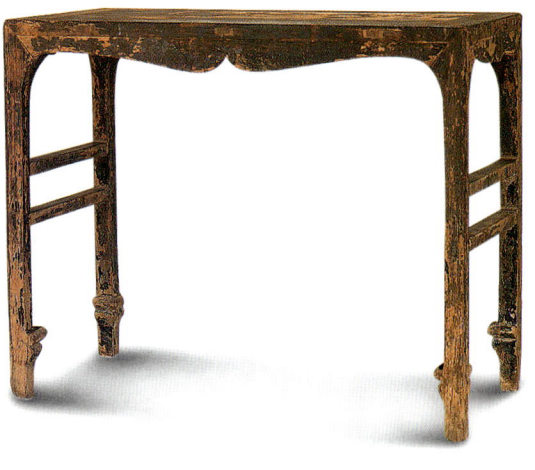
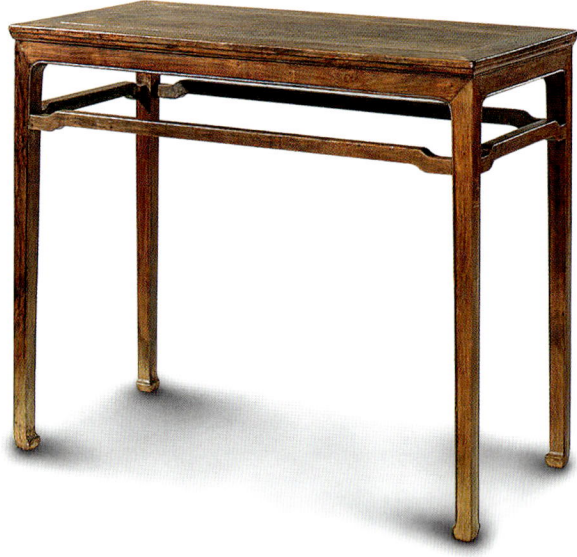

Fig. 26

Fig. 27

Fig. 24
Kang table with flush-side corners and vigorous horseshoe feet more typical of the Ming dynasty, red lacquer on *jumu* (southern elm), eighteenth century. Photo courtesy Albert Chan.

Fig. 25
During the Qing dynasty, carpenters designed higher and squarer feet.

Fig. 26
Classical *simianping* (four sides flat) side table or *qin* table, the legs terminating in inverted *ruyi* which are often seen in Ming paintings but are rarely found in furniture, ca. seventeenth century, Shanxi province. The frame is made of *huaimu* (locust) and the top panel is of *wutong* wood, a type usually reserved for the production of musical instruments. This means the table was probably used as a stand to play music. Photo courtesy Cola Ma.

Fig. 27
This side table with humpback stretchers is more representative of later Ming-style furniture with the vigorous low hoof and flat apron. Photo courtesy Charles Wong.

Fig. 28
Square-corner cabinet, *yumu* (northern elm), eighteenth century, Shanxi province. The decorative door panels, which are typical of the mid- to late eighteenth century, feature a coin-patterned lattice design. The large horizontal panel of this cabinet features five bats in clouds carved in relief, while the base apron is dressed with dragons and a longevity character. Collection of Cola Ma.

Fig. 29
Window screen with animal motifs, including bats, *changmu* (camphor), nineteenth century, Hubei province. Photo courtesy Oi Ling Chiang.

Fig. 30
Detail of carving. Photo courtesy Andy Hei.

22 Chinese Furniture

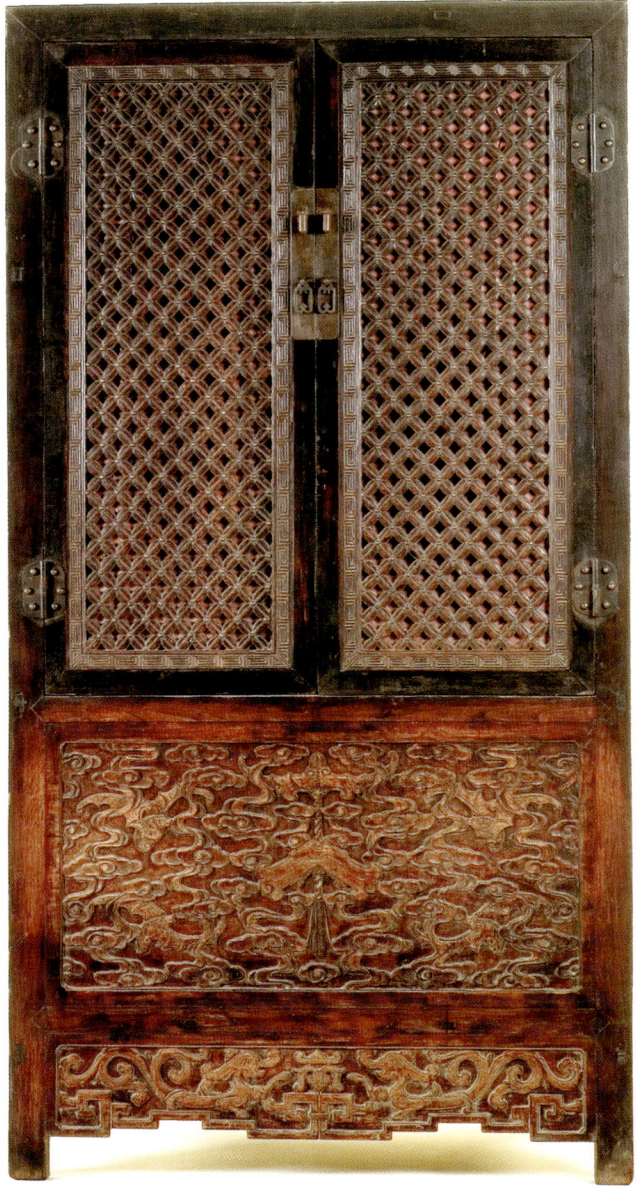

Fig. 28

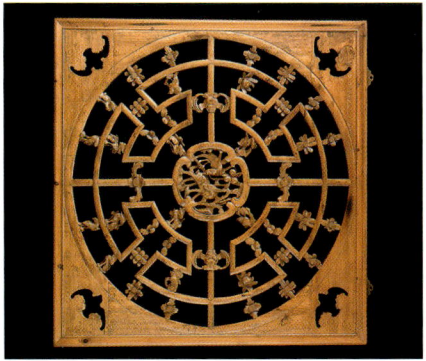

Figs. 29, 30

Throughout the centuries, stylistic innovation occurred gradually. The horse hoof evolved from a vigorous low foot in the sixteenth century to a high, square-shaped one in the nineteenth century; the curvilinear aprons of the early Ming were exchanged for straighter aprons, and propitious symbols such as the dragon became more elongated, heavier and less animated (Figs. 24–27).

The most radical style change, however, occurred in the mid-Qing dynasty when the Emperor Qianlong's taste for ornate carvings percolated from the imperial workshops in Beijing out to the regions (Fig. 28). As Curtis Evarts points out, Qianlong's taste for the ornate did not revolutionize furniture styles throughout the kingdom, but added another dimension to traditional styles.

Three hundred years later, the stylistic changes introduced by the Qing rulers were considered a step backwards by Western collectors. It was felt that the natural fluidity of line espoused by the Ming élite was sacrificed on the altar of symbolic decoration. Fussy carvings of dragons, qilin and bats interfered with the profile (Figs. 29, 30). In addition, furniture became weightier, aprons larger, curves tighter, and the back splats on chairs more vertical. The new aesthetic, driven by the fashion epicenter in Beijing, was embraced by workshops in Guangzhou and Suzhou. Only in the poorer provinces which remained rooted in old traditions, such as Shanxi, did some archaic forms survive (Fig. 33).

The Qing carpenters employed by the imperial workshops were technical virtuosos. Rather than making simple mortise-and-tenon joints, they indulged themselves by making complex joinery such as double miter, tortoise and tenon joints. According to Hong Kong's Albert Chan, the Qing joints were not necessarily more stable than the early Ming ones, but were certainly more creative.

Some emperors also took a personal interest in design. The eclectic Qianlong emperor played an active part in furniture manufacture to the point of dictating precise dimensions and styles, says Beijing scholar Tian Jiaqing. In particular, he revived the archaic jade carving motifs called *fanggu* and applied them to furniture. He also embraced the Guangdong style, which favored Dali (dream stone) marble from Yunnan province, later to become a fashionable inlay in ornate

Evolving Styles 23

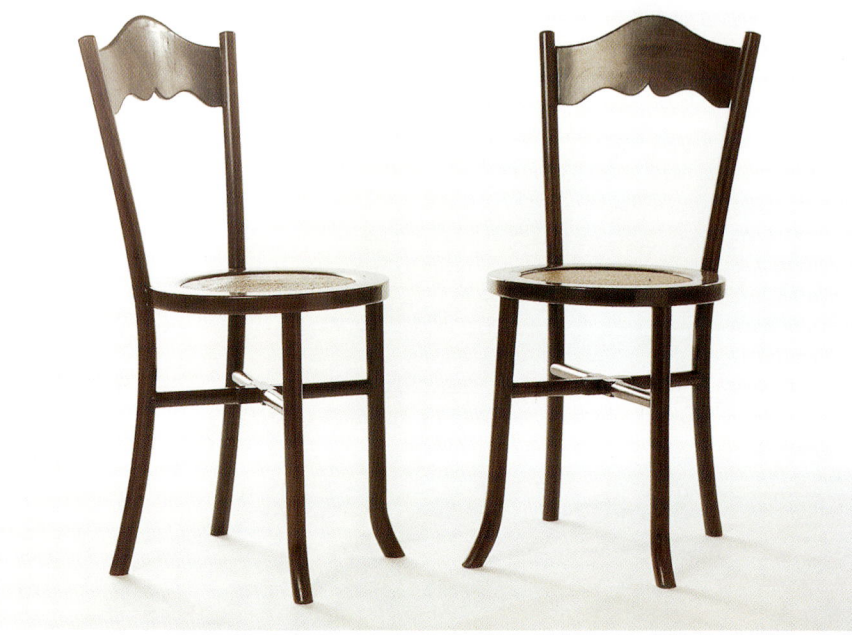

Fig. 31
Hongmu (blackwood) chairs inspired by Michael Thonet's famous bistro-style chair, Shanghai. These chairs were obviously made by copying European catalogues. Collection of Hannah Chiang.

Fig. 32
Kang table, *zitan*, eighteenth century, North China. This exhibits a court style from the mid-Qing period featuring *chi* dragons and angular scrolled hoofs. The relief carving also simulates designs found in archaic jades. Photo courtesy Peter Chan.

Fig. 33
Painting table in a typical Qianlong style with carved dragons and longevity symbols, *zitan*, eighteenth century. Possibly made in a Beijing city workshop but crafted by a Guangdong woodworker. The condition is excellent, indicating that the piece was once owned by a very wealthy or royal family over a long period of time. Photo courtesy Andy Hei.

Fig. 34
This archaic recessed-leg side table, owned by scholar Chen Zengbi, features both humpback stretchers and double stretchers across the legs. Possibly from Shanxi province.

Fig. 31

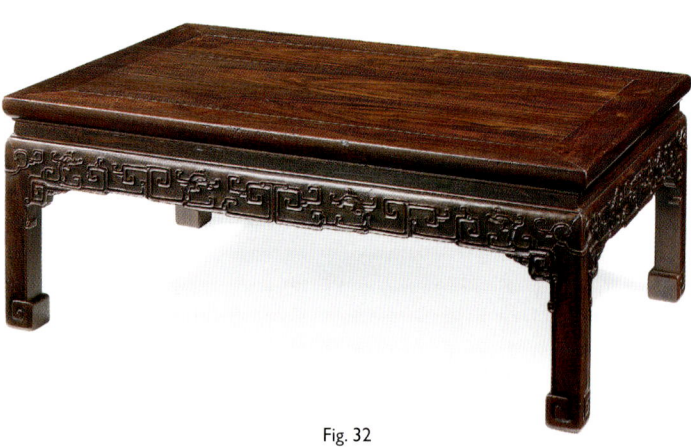

Fig. 32

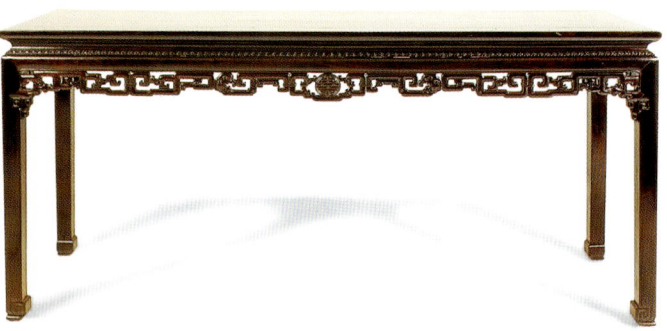

Fig. 33

furniture. Some pieces inadvertently lost their functionality because they were so highly decorated (Fig. 32). The Qing style lent itself more to pomp and circumstance than quiet study and contemplation. It was a reflection of the philosophical shift within the power élite.

As the Manchurian epoch came to an end in 1911, the era of the devoted craftsman wound down. The unstable political situation that followed the exile of Sun Yat Sen, the Japanese invasion and World War II all combined to stifle artisans. There were some pockets of innovative design. In Shanghai, the Art Deco scene was alive and well, and in Canton workshops churned out export furniture (Fig. 31).

As the quality of Chinese handicraft diminished, international appreciation of the classical forms grew. During the 1930s and 1940s, Westerners living in Beijing, who were influenced by Bauhaus styles, started researching and collecting classical Ming furniture. The most influential of these was Gustav Ecke who was hired, in 1923, as a professor of European philosophy at Amoy University in Fujian province. Inspired by collector Deng Yizhe, Ecke's own passion grew and in 1930, after moving from Beijing to teach at Furen University, he began to collect. Ecke directed his gaze to Ming-dynasty

huanghuali hardwood pieces, such as a testered bedstead and the high-standing coffer table his wife still owns. Ming furniture was not widely collected at the time, and even scholars who obtained pieces showed little interest in researching furniture. Ecke and friends like Laurence Sickman traveled around looking for attractive pieces. At one point, Ecke and his wife Tseng Yuhe, a painter and art historian, owned well over thirty pieces of Ming, as well as many pieces of export furniture from the early Qing.

In the 1940s, Ecke disassembled his collection of furniture to make precise measurements and drawings with the help of Yang Yao, and published a paper called "Chinese Domestic Furniture." During the Cultural Revolution, the measurements and drawings were kept under the bed of Chen Zengbi, a student of Yang Yao, a renowned academic. Their work was eventually published as a book and today remains an important reference for authentication (Fig. 34).

Before the Communists seized power in 1949, much of the furniture owned by foreigners was shipped out. Gustav Ecke was not so lucky. "The university gave us one year's salary and told us we had to make our own way out," says his wife Tseng. "We couldn't pack everything." Their priority was forty-five crates of books. "We had the finest library on Chinese art." After shipping out the books, there was no money left to ship out the furniture. Instead, they "deposited" one-third of their collection with the British Embassy, one-third with the American embassy and one-third with Yang Yao.

In 1949 they settled in Hawaii where Ecke taught Asian art. Eventually, the couple received a letter from Lionel Lamb, a former British attaché in China, to say that Ecke's abandoned furniture was still in the embassy, and that he could ship it out with his own possessions if Ecke sold them to him. Later, Ecke bought back nine pieces of furniture and had them shipped from Switzerland. Two more pieces eventually found their way back to Ecke, but most of it was simply stolen, and has since made its way into collections around the world. "If I was greedy, I could go and claim them as mine," says Tseng.

Ecke's contemporaries, academics like Laurence Sickman (who collected for the Nelson-Atkins Museum in Kansas city) and George Kates, managed to get out a

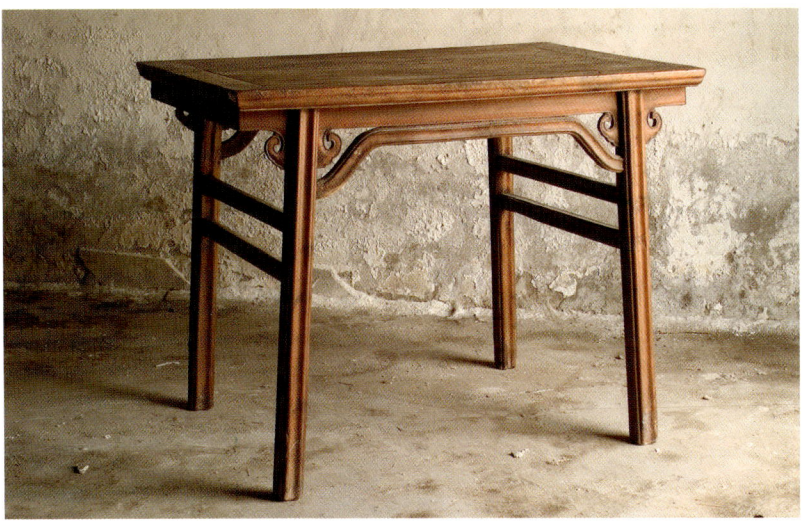

Fig. 34

lot of their furniture. Part of Kates' collection was given to the Brooklyn Museum, and the rest was sold in 1955.

For decades, as Communist China remained closed, "the conventional wisdom was that there was no more furniture left in China except what was saved by the expats," says collector Robert Piccus. He soon learned otherwise. This erroneous assumption was based on the fact that until the 1980s the only objects coming out of China were small scholarly objects. The original Beijing antique shops—Rong Xing Xiang, Yunbao Zhai and Lu Ban Guan—were closed, and very little was coming out of state-operated agencies. As Piccus later surmised, "At the time it seemed a mystery as to why it was possible to buy *huanghuali* brush pots in considerable quantity but not furniture." The answer was simple. There was still plenty of furniture squirreled away in China, it was just too difficult to get it out of the country. The Chinese government stopped issuing export licenses between 1951 and 1971, and even when some trade did resume there were tremendous hurdles in physically transporting furniture across the country. As a result, some types of furniture, including the horseshoe-back reclining armchair, were not represented in any major institutional collection prior to 1980. China's new economic policy in the late 1970s, and the work of local scholar Wang Shixiang, changed that perception. The resumption of trade to the outside world was like the bursting of a dam. Secret caches began flooding out—first Ming furniture made of *tieli* wood, followed by *huanghuali*. As the economic policy kicked into gear, "the border became a sieve for antiquities," says Piccus. The first pieces to surface on Hong Kong's famous antiques strip, "Cat Street," were old *tieli* pieces from the south. Piccus recalls paying HK$8,000 for a *tieli* side table in 1982. To his surprise and amazement, great *huanghuali* and *zitan* specimens followed (Fig. 37).

At first, only a handful of dealers and collectors knew the worth of these pieces, but the market was further stimulated when Wang's seminal book, *Classic Chinese Furniture*, was published in 1986. The book, together with Wang's personal collection, lent legitimacy to the notion that the old Chinese furniture within the country was indeed valuable. It also served as the ultimate reference guide.

The first wave of buyers sourced items from the government-run storehouses. Hong Kong-based Hei Hung Lu ventured into China on buying trips as early as 1972, but was only able to acquire furniture starting 1976. For the next decade, he bought mostly Qing-dynasty pieces from two enormous warehouses: the Peking Arts & Crafts Importing and Exporting Company and the China National Arts & Crafts Import and Export Company in Beijing.

In the early 1980s, Hannah Chiang and his mother started buying furniture from second-hand shops in Guangzhou, such as Rong Wah, which sold second-hand furniture. The store came under the authority of the Cultural Relics Bureau.

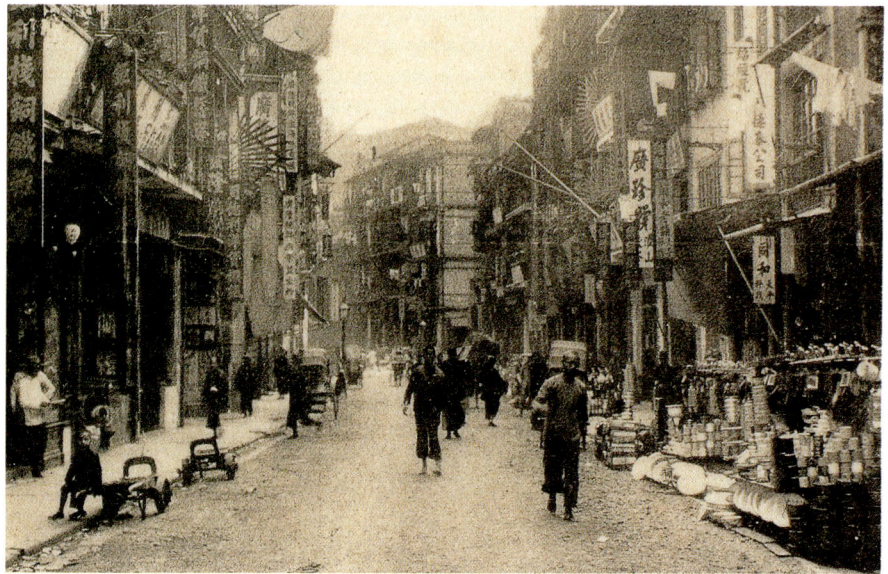

Fig. 35

Fig. 35
Hong Kong's Hollywood Road and Cat Street have long been famous for being the center of the antiques trade. This picture was taken at the turn of the twentieth century, but even today antique stores crowd along the narrow strip in Central. Photo courtesy Hong Kong Museum of History.

Fig. 36
This warehouse, near the Lu Jiaying Antique Furniture market (at the southern third ring road), is owned by Fan Rong, a "runner" who sources furniture in Shanxi province.

Fig. 37
Recessed-leg lute table with a plain apron and cloud-collared spandrels, *huanghuali*, ca. early seventeenth century, collected by Robert Piccus and his wife and sold at Christie's New York auction in 1992. Photo courtesy Robert A. Piccus.

Chiang would buy from these shops, but had to arrange an export license through the state-run Guangdong Antique Shop for a service fee. Initially, he bought blackwood furniture—all that the shops had in stock. Later the stores were able to source from "runners," people who would travel to remote villages to buy furniture from private individuals. Chiang eventually bypassed the shops to deal directly with the runners. He was able to ask them about other kinds of furniture that existed in private homes and collections. To his surprise, not only were Qing pieces available, but older Ming were unearthed in remote parts of the country, like Shanxi province.

By 1986 the floodgates had opened and Chiang was joined by other Hong Kong dealers such as Cola Ma, who also established a system of runners (Fig. 36). Buyers like Chiang and Ma were on the frontlines. The next layer of dealers were Hong Kong retailers like Grace Wu Bruce and Albert Chan, and his sister Ruby, based in New York. These top dealers developed relationships with key collectors. Mimi Hung and Gangolf Geis purchased much of their *huanghuali* collections from Albert Chan, while Dr Shing Yiu Yip relied almost exclusively on Grace Wu Bruce. Peter Fung, a Hong Kong collector with a taste for *zitan* furniture, teamed up with Charles Wong, a former restorer who now runs a shop on Elgin Street.

The relationship between dealer and collector is an important one. Coherent collections are formed through alliances. The symbiosis ensures that dealers and collectors who share a common vision stand united if the market challenges provenance, age or restoration techniques. Because furniture is very difficult to date and the origins of many pieces are murky, debates are frequent and collectors tend to take sides.

Despite this, the popularity of Chinese furniture has continued to rise steadily. Any fear that antique Chinese furniture could not command prices achieved by porcelain or jade was dispelled at the Christie's New York auction in 1996. The Fellowship of Friends, a religious organization that owns the Renaissance Vineyard and Winery in California that began collecting Chinese classical furniture in the late 1980s, sold its collection at auction for $11.2 million. At the time, it was the highest single sale of Chinese art.

Today, quality hardwood furniture continues to be snapped up by voracious buyers, but many shops now specialize in softwood furniture. Much of the furniture on the market now is from Ningbo (near Shanghai) or the northern province of Shanxi. During the Ming and Qing dynasties, Shanxi was a wealthy region and its merchant class built large numbers of courtyard mansions that needed furnishings. Until the Japanese occupation in 1937, workshops in southwestern Shanxi flourished. Isolated by the various mountains, including the Taihang Range in the east, Shanxi did not experience the same degree of warfare and destruction as China's southern coastal regions, so homes remained intact. Subsequently, during the Cultural Revolution, coal resources in Shanxi served as a buffer against cannibalization for fuel, whereas in other parts of China furniture was often broken up and used as firewood.

A lot of the furniture sold on the market today is heavily reconstructed. Throughout southern China, thousands of factories are churning out brand new or refurbished furniture and accessories that are passed off as antiques. The fakery is fueled by the booming international market for antique Chinese furniture, and by the fact that China is running out of genuinely old pieces.

There is, however, a silver lining. A huge proportion of furniture entering the US is from China, and while the majority of it is Western style for overseas clients, a growing number of furniture makers, some former dealers, are adapting traditional Chinese design. Now that antiques have dried up, and the market is wise to fakes, dealers have turned to making contemporary furniture using elements from classical Chinese furniture. Call it the new Ming. A handful of Asian designers, such as Hong Kong-based Barrie Ho and Taiwan's Art of Chen, are drawing inspiration from the classics to design contemporary Ming-style furniture for well-heeled clients. The furniture market has thus come full circle.

Fig. 36

Jin Culture

The former Jin culture (which is now Shanxi province) represents another branch—or offshoot—of furniture development. The Jin culture evolved more slowly and its furniture is considered very archaic with simple carvings featuring floral motifs. A wall mural from Shanxi province's Yanshan Temple (dating back to the Tang dynasty) and miniature furniture models excavated near Datong (dating back to the Jin dynasty, AD 450) feature cabinets, tables and low beds that can still be found today—an example of how little furniture evolved in this corner of the world.

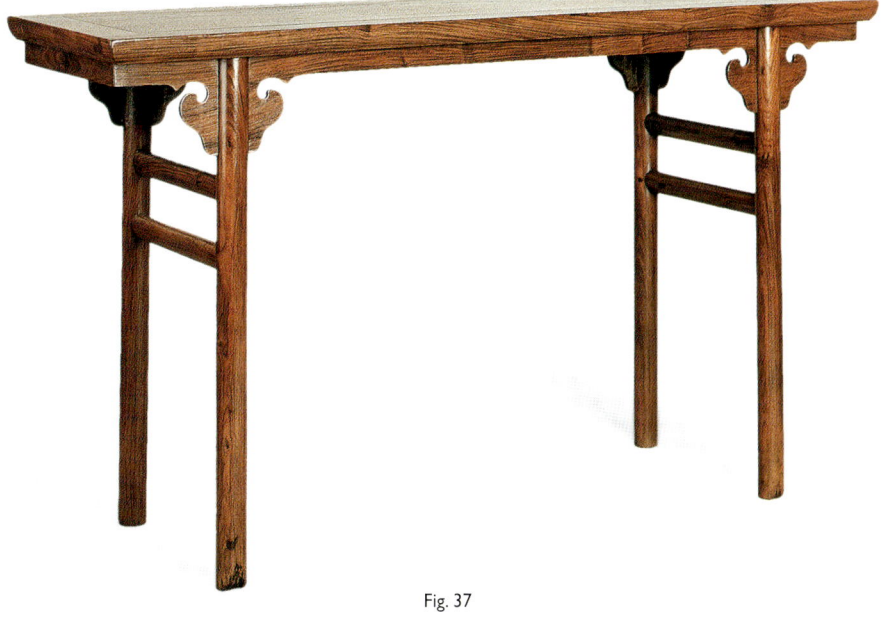

Fig. 37

Evolving Styles 27

Hei Hung Lu

"My grandfather and father sold archaic jade. When Communism came to Beijing in 1949, I left for Hong Kong. I was just 16 years old. My mother's brother set up a shop there catering to Californian dealers who had starting coming in 1948. We bought furniture in Beijing and secretly shipped it to Hong Kong. At first it was easy to get the goods out. Because of the Korean War, smuggling was rife, and there was no control over antiques. Sometime around 1953 or 1955, the flood turned to a trickle and we couldn't get the best things out. We began selling articles from refugees who had fled China to Hong Kong [in 1949] and were selling some of their possessions. As a result, there was a good internal supply of furniture for many years. In those days, nobody paid attention to softwood. They only had eyes for hardwood furniture and items no later than the Qianlong period [AD 1736–96]. *Kang* tables became popular as coffee tables. We often cut the legs off larger pieces to make tables. I once watched as carpenters cut the legs off of a beautiful side table for the former German Consul General of China.

"I worked day and night [for my uncle] until I finally set up by own business in 1970. I started selling small things: boxes, brush pots and jade by sourcing from local suppliers. I even went to Europe and the US between 1973 and 1979 on buying trips looking for curios. In the mid-1970s, I started buying small wooden items in Beijing. In 1976, I visited the government-operated Peking Arts & Crafts Importing and Exporting Company and the China National Arts & Crafts Import and Export Company near Chao Yang Men. These had big warehouses full of antiques. The dealers called them the 'three houses.' That same year, I bought a warehouse in Hong Kong so I could concentrate on furniture, and attended the Beijing Fair organized by the Hong Kong Chamber of Commerce of Arts and Crafts. The mainland desperately needed foreign currency and I needed stock. At the fair, I spent about US$100,000 on 40–50 pieces of furniture including several *laohuali* compound cabinets. Some of the Hong Kong dealers saw what I bought. Few people concentrated on classical Chinese furniture. I knew good pieces and quality and I was confident I could sell them. Bob [Ellsworth] was my connection to the American market. From 1976 until the mid-1980s, I continued to buy from the Peking Arts & Crafts shop. They had good things, but not early Ming. They didn't always know what was good. I purchased a Ming *tieli* cupboard for less than $500 in the late 1970s. I started stockpiling because I knew the craft would run out because China was just opening up, and more competition was coming in. It was a race.

"We started buying from local dealers in Guangdong who set up a system of runners who sourced furniture and came to me later. When the market opened up in 1985, the government didn't pay too much attention to furniture. Now everything is a hundred times more expensive."

Cola Ma

Cola Ma was born into the antiques business. Descended from two generations of antiques dealers, he was left behind when his father and grandfather moved to Hong Kong in 1949. During the Cultural Revolution, there was little for the teenager to do in the city of Tianjin. "As a student, I had no job," he says. There was no school either, so he stayed home and played the violin. Meanwhile, his father, T. K. Ma, had remarried in Hong Kong and opened the Tong Chung Peking Trading Company selling all kinds of antiques, but mainly furniture. When China opened up in 1979, Ma finally moved to Hong Kong looking for "new opportunities." He was 31, and had little experience with antiques. "At first, I worked for my father, but I realized I needed to learn a lot more." Instead of working within the confines of the family business, Ma offered his services to local dealer Ian McLean. The seasoned Hollywood Road dealer taught Ma two things: how to restore and refinish fine furniture, and how to appreciate the value of softwood. Four years later, Ma opened his own shop in Hong Kong.

"In the beginning, my father thought I'd never be able to succeed in the business," says Ma. But Ma attempted what few other Hong Kong dealers did in the 1980s—he set up a factory in China, based in his hometown of Tianjin. From here, Ma traveled frequently to Beijing to source antiques. In a small suburb in northern Beijing, he stumbled across a small community of furniture dealers from Shanxi province. These were the "runners"—poor men who knew nothing about furniture except that there was plenty of it in their villages and they could realize a profit by "running" in shipments from Shanxi and selling it to shopkeepers. Isolated for centuries, the once-wealthy province of Shanxi was loaded with beautiful hardwood and softwood furniture in archaic styles that dated back to the Song dynasty.

Ma quickly struck up a bargain with one dealer—Fan Rong from Xinjiang village. He established a good supply line and hoarded some of the best pieces from the region. A rare incense table he once purchased for 4,000 yuan is now worth roughly $40,000. In 1999, Ma, together with author Curtis Evarts, published his own book on Shanxi softwood furniture, thereby establishing his reputation as king of the vernacular.

Fan Rong

Sixteen years ago, Fan Rong was working as a laborer in an iron-producing factory. One day, on a trip to Beijing, he noticed that some of the markets were selling old furniture at fantastic prices. He thought the furniture from his province, Shanxi, was better than the things being peddled. Dipping into his savings, he made his way through the villages of Shanxi knocking on doors, asking to buy old furniture. Everyone asked him, "Why do you buy so much rubbish?" Fan did not let them in on his secret, but the *huanghuali* furniture he was purchasing for a pittance now sells for tens of thousands of dollars. "It was cheap and it was easy to collect," he says. His only shopping guide was scholar Wang Shixiang's book. "It took three years for others to catch on."

Fan and his older brother, Fan Kong, were the first furniture runners in southern Shanxi. At the beginning, Fan Kong used a bicycle to travel to a village a few miles away where he bought a table for $92 and sold it for twice that—a sum larger than anything he had every seen. That arbitrage has become the foundation for a thriving business for the Fan brothers and also for a network of runners they helped recruit from the village of Dong Niu. About a hundred men, almost a quarter of the entire village, now buy and sell furniture. The richest have built fortress-like homes and helped pave roads.

Over the years, the Fan brothers learned the fine art of convincing families to sell their heirlooms. "It's a battle of wits with the buyer," says Fan Kong. Not only do the best runners have to talk their way into the homes of suspicious villagers, they must employ a little trickery now and again. Fan once tiptoed stocking feet into the home of a blind woman to evaluate a table she did not want to sell. Once he realized its worth, he convinced her son to tote it away in the dead of night while the old lady was sleeping.

On a recent visit to Zhao Hailin's family in Gong village, Fan Rong discovered that a pair of old tables he had tried to buy for several years were now gone. Ms Zhao, an old client, had sold them because she needed to send her two daughters to school. For Fan, the loss of the tables is another sign of the shrinking market. "Now the number of wolves outnumbers the meat," he says. Adding to Fan's woes is the fact that television programs and newspapers routinely report on the auction and antiques trade. As villagers become educated, they are no longer satisfied with a few hundred dollars for a choice table. "When I first started, people weren't aware of the value of furniture, so it was easy to buy," says Fan. "For years, we tried to keep the prices secret. Only I and the buyer knew how much money he could get," he says. Not any more.

As availability shrinks on their home turf, Shanxi suppliers involved in the mad hunt in China's rural villages must look farther afield for fresh stock. Tales of frustrated runners breaking into homes after a deal goes sour are not uncommon. But there are still a few gems. "Eventually, if you push hard enough, and they are in a good mood, they will sell."

Chen Zengbi

Beijing academic Chen Zengbi remembers well the day he bought his first piece of antique furniture. It was the summer of 1972 and he was making his weekly pilgrimage to the Cultural Relics Bureau. Chen was a student in the architecture department of the University of Peking, and furniture was his specialty—his passion. But this was the period of the Cultural Revolution and to own antique furniture was to be labeled a capitalist roader. The Red Guards were breaking up beautiful pieces and dumping them into warehouses run, ironically, by the Cultural Relics Bureau. The broken bits were being recycled. It was a strange ritual, but as a young student Chen used to visit the warehouses regularly, circumambulating the pile of wreckage "to say goodbye." One day as he was paying his respects, Chen noticed the small round end of a table foot sticking out of the pile. It was the leg of a square table, but it was made of a very rare wood known as *heitanmu* (ebony). Intrigued, he asked the staff if they would mind if he dug around for some other bits of similar wood. The overseers obliged this regular visitor. From 9 a.m. to 2 p.m. Chen tore the pile apart looking for the matching pieces. By the time he had found all the parts, he was shaking. He had discovered a rare Ming-dynasty table but he was afraid he could not afford it. The warehouse sold wood by weight, and these heavy bits were going to cost 80 yuan. Chen's monthly salary was only 56 yuan and he did not have enough money to purchase the pile of wood he had assembled, so he ran around to his family and friends to borrow the rest. He carefully stacked the wood on to a tricycle, covered it with a blanket, and rode home. Back in his apartment, Chen assembled the pieces like a jigsaw puzzle. His heart was racing. He was thrilled, yet terrified. To possess such a piece was dangerous. But he could not resist showing his teacher, Yang Yao, a famous furniture scholar. Yang's jaw dropped. He had never seen such a good piece in all his years. Together they visited the home of Beijing's famous craftsman Li Jian Yuan. "His expression upon seeing it was similar to my teacher," says Chen. After sharing his treasure, Chen disassembled the table and hid it under his bed until the Cultural Revolution was over. After gathering his courage to save this piece, he managed to conduct some other rescue operations. Today, he owns hundreds of pieces, and is preparing a book on classical Chinese furniture.

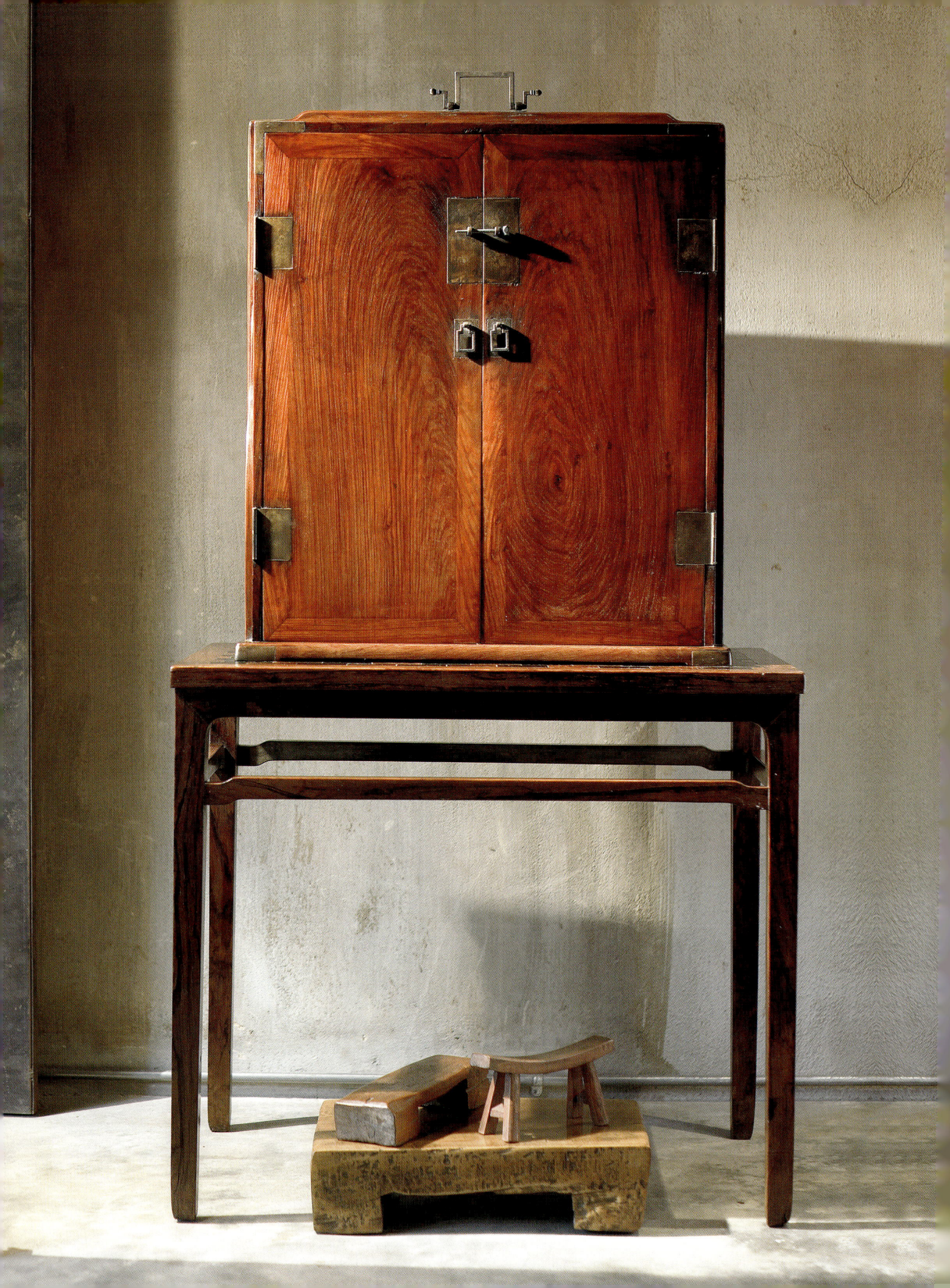

Classifying Chinese Furniture

When a piece of art is unsigned, and its date of production is unknown, how should it be classified? This is the conundrum faced by scholars of Chinese furniture. With its artisans relegated to anonymity, and individual styles sublimated, classifying Chinese furniture is a tricky business.

One obvious approach is to look at function. Using this method, there are nine basic groupings: chairs, tables, beds, cabinets, stools, screens, braziers, stands, and scholarly items. Another approach is to rank pieces by quality, but this lends itself to subjectivity. For example, if the benchmark is carving quality or craftsmanship, then ornate pieces from the Qing dynasty would rank high. But collectors, particularly in the West, favor minimalism and architecturally sculpted pieces, and carving ranks low among them. Thus, simple criteria are useless.

Instead, scholars have tried a more empirical approach to furniture classification. According to Beijing scholar Tian Jiaqing, several principles must be applied to assess merit. These include style, rarity, wood, age, workmanship, preservation and quality of restoration.

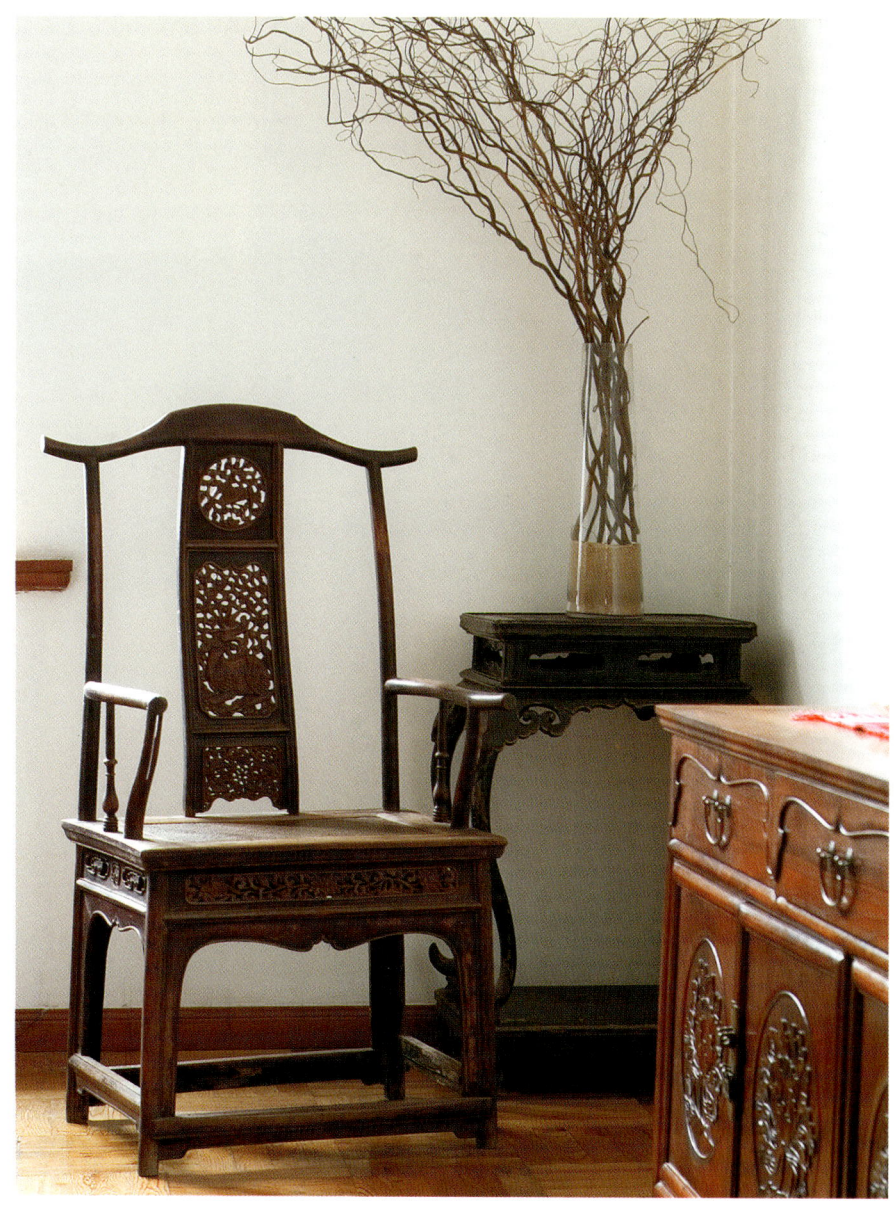

Fig. 38 (left)
Traveling apothecary's chest, *huanghuali*, seventeeth or eighteenth century, on top of a flush-sided corner leg table with humpback stretchers, *huanghuali* with a burl and marquetry top, seventeenth century. Beneath the table is a collection of armrests and stands. Private collection, Singapore.

Fig. 39 (right)
One man's vernacular is another man's treasure. This pairing of furniture is from the Tianjin home of dealer Cola Ma.

Style

Style is a difficult measure: after all, one man's treasure is another man's kitsch. Important collectors, however, agree that the most important criterion when assessing furniture is spatial equilibrium or proportion. The book of Lu Ban, the *Lu Ban Jing*, refers to *yin* and *yang*: balancing the dynamism and rhythm of lines generated by the convergence of legs, aprons, doors and spandrels with the quiet, open spaces between. Whether a piece of furniture is graceful, with elongated proportions, or squat and heavy, can be a decisive factor in determining its worth.

Is the beauty we find in certain proportions entirely subjective, or are we genetically programmed to prefer certain spatial relationships? The Golden Mean theory of architecture suggests that there is a close relationship between intuitive perception and reasoned mathematical ratios, and knowledge of these proportional systems is essential to the appreciation of art and nature. The Golden Mean has been calculated to be 1.61. Therefore, if the universal system of beauty exists, then a plain table 35 inches (90 cm) high should be about 57 inches (144 cm) in length—not unlike the proportions of many of the good Ming-style tables. The measurement of beauty, of course, is far more complex and must take joinery, spandrels, weight of timber and aprons into account. But it does provide some insight into why the austere, clean lines of the Ming style are generally preferred over the weightier, decorated designs favored by the Qing.

Wood

The type of wood used in a piece of furniture can also dramatically influence an appraisal. Hardwoods such as *huanghuali*, *hongmu*, *zitan* and *jichimu*—most of which were imported into China—are coveted by collectors. Further down the ladder are the indigenous softwoods such as *baimu* (cypress), *yumu* (northern elm), *nanmu* (which is related to the evergreen laurel family), *hetaomu* (walnut), *huaimu* (locust), *changmu* (camphor) and *taomu* (pear).

At least thirty-five important hardwoods and softwoods are used in Chinese furniture, and what may appear to be a straightforward classification system is not. Many of the varieties of trees culled for furniture no longer exist, making the scientific or botanical nomenclature of these species ambiguous. (While there was once a very good record and sample of each wood in the imperial library, according to Chan Rong, all these samples seemed to have disappeared during the Japanese aggression.) As a result, Chinese furniture is still identified by its old Chinese names, names which were assigned on the basis of aromatic quality, color and grain patterns. It is likely that

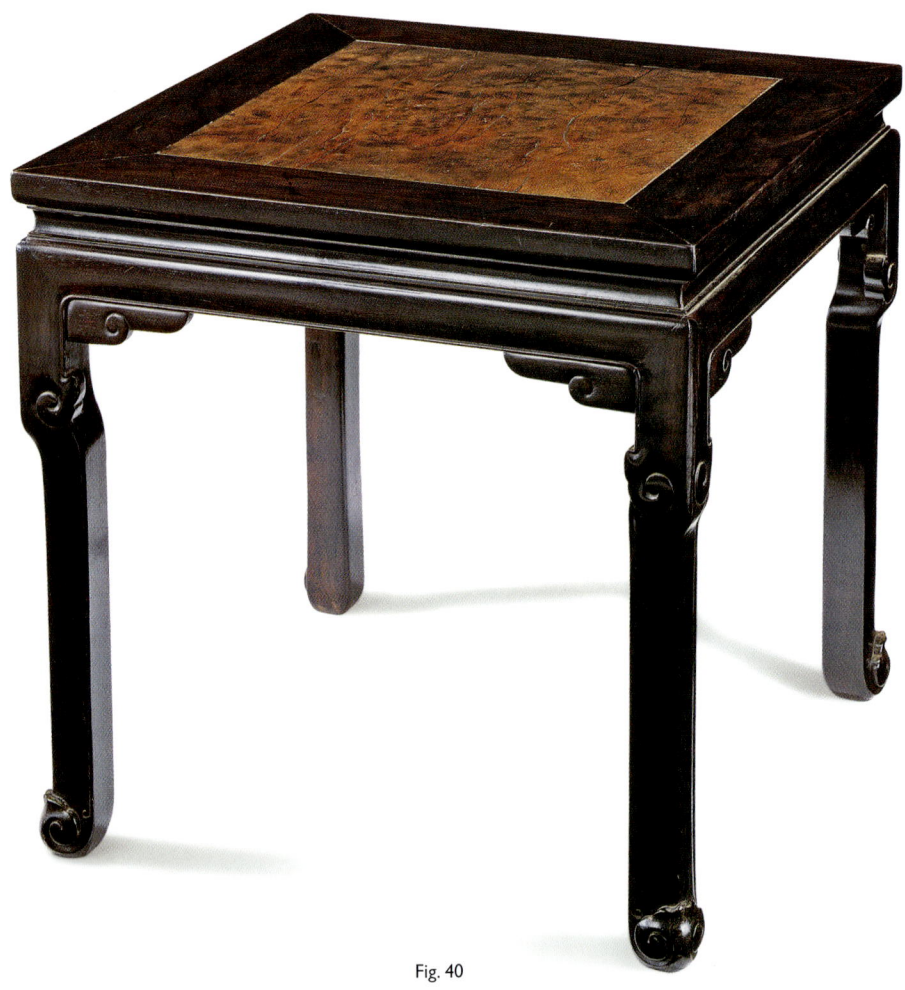

Fig. 40

many genera and species were grouped together if they displayed similar characteristics such as smell and grain. In fact, it appears that even timber from the same tree might have been marketed under different names depending on the cut (see pages 34–5).

Although much attention is paid to the hardwoods, the current hierarchy that separates hardwood and softwood did not exist during the Ming dynasty. The first treatise on furniture construction does not make the distinction and categorizes many of them under the general term *zamu* or miscellaneous. Only two kinds of softwood—*nanmu* and *changmu*—are mentioned in connection with furniture manufacturing. Early carpenters frequently mixed wood types during construction, using elm or locust for the sturdy frames and saving the fine-grained woods for decorative panels.

Tastes also changed over the years. *Zitan* was coveted by Qing-dynasty emperors, but by the end of the Qianlong dynasty supplies had dwindled. *Zitan* was in such demand that old pieces of furniture were recycled and *zitan* veneers were added to furniture made in the late Qing (Fig. 40). The first Western collectors were not particularly enamored of the dense, purple grain of *zitan*. They preferred the distinctive grain and mellow colors of hardwoods like *huanghuali* and collected it almost exclusively. *Zitan*, however, has made a comeback. At Christie's Hong Kong auction in July 2003, a set of *zitan* screens was sold for a record price (see Fig. 365, page 147).

Are *huanghuali* and *zitan* overrated? Dealers like Cola Ma would argue yes. "I don't think *huanghuali* is everything," he says. "The history and workmanship are more important than the material." To be a *huanghuali* snob means losing many good opportunities to really know Chinese furniture.

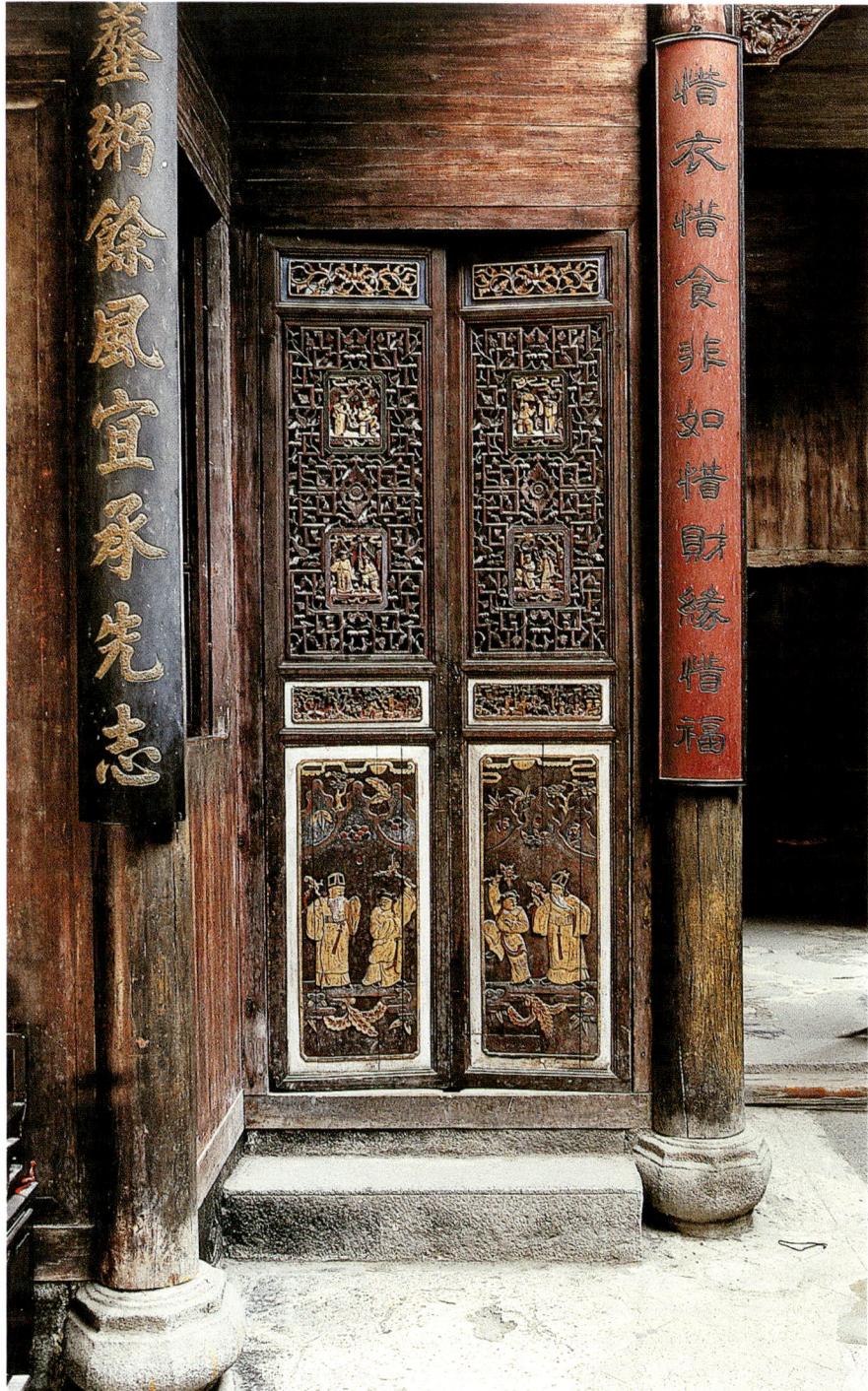

Fig. 41

Fig. 40
Square stool with articulated legs and spandrels carved with cloud scrolls, *zitan* and *nanmu* burl, eighteenth century, Jiangnan region. By viewing the spandrel and the carving of the upper leg as a whole, the shape looks like a *taotie* mask found in bronzes, according to scholars such as Curtis Evarts. *Zitan* wood furniture like this became popular during the eighteenth century.

Fig. 41
One of a set of eight doorways bearing images of the Eight Immortals that lead into small bedrooms in Cheng Zhi Tang or "Hall of Inheriting Ambition," built in 1855 in Hongcun village, Anhui. Like other Qing-period Huizhou-style houses, a plain exterior provides no clues to the intricately carved hardwoods in the interior of such houses.

Classifying Chinese Furniture 33

Types of Wood

Dozens of species of trees that were indigenous to China were used for making furniture, although only about fifteen species commonly occur. Regional identity and wood variety often go hand in hand. For example, *kang* tables from Mongolia were often made of pine. In Sichuan province, fine furniture was very often crafted from the red bean tree. Much of the walnut furniture can be attributed to Shanxi region. However, luxury hardwood, now coveted by collectors, was generally imported from Thailand and Vietnam. Identification of wood varieties in Chinese furniture is difficult, in part because wood was classified by visual means and there is no botanical consistency. For example, wood classified as *huanhli* may come from any of a variety of different species.

Fig. 42

Fig. 42
The deep grain pattern of this locust wood specimen gives clues to the age of the furniture.

Baimu, cypress or cedar (*Cupressus* L.) wood has a strong fragrance. It is slow to dry but highly resistant to rot and insect damage. It was categorized as a "miscellaneous softwood" during the Song dynasty. There are several cypress varieties in China. Weeping cypress from Sichuan province, which can reach two meters in diameter, is highly regarded for its timber.

Changmu or camphor (*Cinnamomum camphora*) ranges from a yellowish sand color to a warm yellow brown. It is not a popular choice for furniture production because it is easily bruised, but it is frequently used to make storage chests because its distinctive smell makes it resistant to insects.

Heitanmu is a very heavy, almost black wood derived from heartwood. Because of its hardness, it is normally used only for select items like knife handles or cabinet details.

Hetaomu or walnut looks a little like *nanmu* but its texture is more open-grained. It was usually sourced in Shanxi province and used on pieces with refined workmanship. There are several kinds of walnut. The true walnut, which is cultivated in the north, is reddish brown with a dark striated pattern. Manchurian walnut, also found in the north, has a lower density and is somewhat lighter in color.

Hongmu or blackwood resembles *zitan* but lacks its lustrous surface and unusual grain. There are no early references to *hongmu* although much of the dark Qing furniture from the south is made of it. Some varieties are virtually indistinguishable from *huanghuali*.

Huaimu or Chinese locust (*Robinia pseudoacacia* L.) is similar to northern elm but has a denser grain. It is a very strong timber that is resistant to dampness and insects, but its grain is unevenly textured and when dried it can develop large cracks.

Huamu or burl wood (also referred to as *yingmu*) is not a variety of wood, but rather is used to describe the tumor-like growths that bulge from trunks, or branches, and have a very distinctive grain pattern that resembles round curls. Certain species, such as camphor, elm and *nanmu*, are susceptible to burl growths. Burl *nanmu* wood is commonly used in furniture. But because shrinkage is unpredictable, it is used for table tops or cabinet doors and not employed for the main structural elements.

Huanghuali (*Dalbergia odorifera*) is considered the king of hardwoods. Prior to 1572, most furniture was made from indigenous softwood. The revision of trade policies in 1572, which permitted the importation of exotic timber from Southeast Asia, established the beginning of the hardwood furniture era. Much surviving furniture from the Ming dynasty and early Qing is made of *huanghuali*. It was seldom used after the mid-Qing period. This sought-after timber was favored for its color, which ranges from a honey to a purple brown, and its distinctive grain, which mimics the profile of a mountainous

34 Chinese Furniture

landscape. Its density also enabled carpenters to create complex but sturdy joints and fine carving. *Huanghuali*—now only found in parts of Vietnam—came from the genus *Dalbergia*, a type of tropical rosewood found in North Vietnam and Hainan Island in China. Although use of this wood dates back to the fifth century, it did not become popular until the mid-Ming dynasty. The wood was originally known simply as *huali* or "flowering pear" and the prefix *huang* (yellowish brown) was added in the early twentieth century to describe the old *huali* wood that had a yellowish patina due to aging.

During the Ming and Qing dynasties, no distinction was made between *huanghuali*, *laohuali* and *hongmu*—terms now used by many dealers. *Laohuali* is still botanically classified within the same genus, but because it has a coarser grain and many small knots, it is now believed to be from an inferior group of timber or a sapwood. *Hongmu* (also known as blackwood), is dark brown and less vigorously grained than *huanghuali* but is also from the genus *Dalbergia*. In later examples, from the nineteenth to the twentieth century, *hongmu* wood was often stained almost black to resemble *zitan*. There is no way of telling how many genera and species resembled each other in odor or appearance, and they were therefore marketed under the same name. Because of the confusion, *huanghuali* and *hongmu* are only marketed under their Chinese names rather than Latin or English labels.

Huangyangmu or boxwood is a compact wood with a straight grain, which ranges in color from whitish to orange amber. Because it grows as a small diameter tree in China, it is often used as inlay material and desk pieces.

Jichimu or chicken-wing wood (genus *Ormosia*) derives its name from the appearance of this timber's tangential grain, which resembles feathers. It has a variable color and is one of the Southeast Asian rosewoods although it is not as dense as *hongmu* or *huanghuali*. Various species exist on Hainan Island and in Fujian province. *Hongdou* (red bean) and *xiangsi* may also be other names for a related species, according to one dealer.

Jumu or southern elm (*Zelkova schneideriana*) is denser and stronger than its northern cousin and ranges in color from dark yellow to coffee brown. It was a popular timber in Suzhou region and has a refined ring porous structure.

Nanmu (*Phoebe nees*) has a fine smooth texture and is olive brown in color. It is frequently used for cabinets because it is highly resistant to decay. It is softer than walnut but very similar in appearance. Although it has a pungent aroma and is similar to cedar, it bears no botanical relationship. It was often used for cabinet construction and was referred to in Ming writings.

Shanmu or fir was popular in Fujian province. The grain of this wood is straight and even, and the color ranges from creamy white to pale brown. Although it is not a strong timber, it is resistant to decay.

Taomu or pear ranges in color from light gray to reddish brown. It is good for carving, and is often used for making musical instruments.

Tielimu (*Messua ferrea*), a dense wood, is often confused with *jichimu*, but it is more grayish black in color and its grain is coarser. In the south, where it grew, it was used for home construction and firewood, but in the north it was regarded as a desirable hardwood.

Yumu or northern elm (*Ulmus L.*) is yellowish brown in color with a distinctive wave-like grain pattern that resembles oak. The wood is difficult to dry and easily develops cracks, but is quite resistant to decay and easy to work with. There are more than twenty varieties of elm, and it is traditionally the most common softwood used in the production of furniture in northern China. The best timber comes from Japanese elm, which can reach one meter in diameter.

Zhu or bamboo is not commonly found today, but there are many images of bamboo furniture in Song-dynasty paintings. Bamboo furniture reached its apex during the late eighteenth and early nineteenth centuries when Europeans and Americans began looking to East Asia for inspiration in interior design. Foreigners purchased vast quantities of bamboo furniture, although the fanciful design of the export-quality bamboo furniture departed significantly from the classical lines of the early Song pieces.

Zitan (Leguminosae family, genus *Pterocarpus*, species undetermined) is a densely grained wood ranging in color from dark purple brown to reddish brown. Workshops used to subdivide *zitan* into three categories: gold star, cock's blood and *huanghuali* grain. *Zitan* may have originally grown in the southern provinces of Guangdong and Jiangxi, but excessive felling led to its extinction. Initially, it was used only for small luxury items like game boards, *weiqi* counters and musical instruments. During the Yongle period (AD 1403–24), *zitan* was stored for imperial use following the grand naval expeditions of Zheng He. During the Longqing reign (AD 1567–73), large quantities were imported from India and the South Pacific islands. Increased use of *zitan* for palace furnishing during the Qianlong period created a crisis in the court. As stocks dwindled, the emperor gave instructions to preserve it, but supplies continued to decline. By the end of the Qing dynasty (AD 1644–1911), supplies were nearly exhausted. Although identified under the genus *Pterocarpus*, no one knows how to classify it today. It is now believed that *zitan* does not come from a single species, but includes several species of rosewoods which vary in color and grain. The darker wood was probably an indigenous variety. By the mid-Qing dynasty, furniture made of *zitan* had a lighter hue.

Other secondary woods used in China include the light beige-colored *yangmu* (poplar), which was used for decorative panels, aprons and spandrels; *yunshan* (spruce), *songmu* (pine), *zuomu* (oak) and *huamu* (birch, not to be confused with burl).

读书卷石堆沧海

下笔微云起泰山

Rarity and Age

Acquiring a piece of furniture that is rare or unique is an obvious triumph for collectors, and pieces such as Robert and Alice Piccus's rare throne chair (Fig. 566, page 216) are highly prized. There are, however, dangerous pitfalls in dating Chinese furniture and, not surprisingly, scholars and dealers frequently clash when estimating age.

Dealers like Grace Wu Bruce believe that the dating game for classical Ming-style furniture is tricky. If a piece is made in *huanghuali* wood in the classical Ming design, and is of the period, it is usually dated to late Ming or early Qing, she says. "Present scholarship does not allow a more precise dating, and those two hundred years of the late Ming and early Qing are termed classical. In my view, it does not matter if they are late Ming or early Qing … it is the same period."

Another set of rules exists for other woods. The lack of distinct period styles, the few literary references, and the anonymous nature of furniture production make dating something of a guessing game. As dealer Hannah Chiang admits, "The more you know, the less you can say."

In the best-case scenario, an inscription of the kind found on the back of the memorial block in Fig. 44 can provide clues to age. These dedications are usually written in ink, and they often reveal something about the nature of the acquisition—who bought it, the price paid, and on what occasion it was purchased (Fig. 46). Occasionally, escutcheon draws, such as the one dating to the Song dynasty found on the coffer table in Fig. 45, were used as fasteners for drawer handles. Inscriptions and escutcheon coins are sometimes used to date furniture. While the coins used may be older than the actual piece of furniture, it was customary in dynastic times to use contemporary coins as draws so scholars sometimes point to them as a reference when dating. Curtis Evarts and Cola Ma have found several examples of coffer tables in which the inscription on the table and the date on the coin escutcheon match.

Inscriptions are rare. As a result, scholars generally take their cues from pictorial references found in woodblock prints or life-sized and miniature pieces excavated from tombs. However, dating by visual reference is problematic. While pictures

Fig. 44

Fig. 43 (opposite)
A square Eight Immortals table and two round stools in a little eating corner in the Shanghai home of author/dealer Curtis Evarts.

Fig. 44
Carved shrine box, *baimu* (cypress) and *changmu* (camphor), with an inscription dating manufacture to August 1840, Fujian province. Collection of Cola Ma.

Classifying Chinese Furniture 37

Fig. 45

Fig. 45
This coffer table is carved in vernacular style with figurines interspersed between a floral background. The escutcheon mount is a silver coin bearing the Zheng He inscription (AD 1111–18), a short period during Huizong's rule of the northern Song empire. These details, combined with the age of the coin, have led Curtis Evarts to conclude the table should be dated to the twelfth or thirteenth century—although others think this dating is too old. Up close, the symbolism carved into the front panels of the table shows a boy and a mermaid carrying a large lotus flower, while the central door features a carved rabbit, a symbol associated with fertility. Photo courtesy Cola Ma.

Fig. 46

Fig. 46
Altar table, *huaimu* (locust), from the Ming dynasty in the "Jin" style, sourced in Shanxi province. It was possibly carried around for special ceremonial occasions. The inscription (detail) belongs to a coffer table from the Shanxi region that dates back to the Chongzhen period and puts the table at 1633. That table (not shown) also bears an original coin from the Tianqi period (1621–7), which would have been in circulation at the time of the coffer's construction. Photos courtesy Cola Ma.

38 Chinese Furniture

Fig. 47
Details of a washstand, *huanghuali*, eighteenth century, Shanxi province. During the Qing dynasty, the dragon's nose became elongated and the number of claws was reduced. The finely carved openwork panel features bats, symbols of fortune or blessing, amidst clouds. Photos courtesy Charles Wong.

Fig. 47

found in carpentry manuals, paintings, books and even tomb frescoes offer insight into period styles, they are not definitive. The dates attributed to the artwork itself are questionable, and it was not uncommon for artists to paint old-style furniture out of reverence for the past. The other problem is that styles did not radically change and carpenters frequently reverted to old designs for inspiration. The general rule is that decoration increased over time, but there are many exceptions. Ornate and severe styles were often produced side by side. Chinese craftsmen paid homage to their predecessors by copying their designs.

That said, there are some basic criteria by which to judge age:

• The outline of Ming furniture is often more fluid; the corners are almost rounded in shape.

• The shape of the horse hoof foot is also different in the Ming and Qing dynasties. The Qing foot is more square and vigorous. The Ming hoof is lower and more delicately tapered.

• Carving design differs from one era to another. Ming craftsmen fleshed out more story when carving pictorial representations. In earlier times, the calligraphic fu symbol of fortune was popular, but by the Qing dynasty the bat motif was used to symbolize fortune. The mythological character which underwent the greatest transformation was the dragon. Dragons carved during the Ming dynasty had five claws, a shorter snout, and the upper and lower jaw was roughly the same size. By the Qing dynasty, the dragon had lost one claw and its nose had become so elongated it sometimes resembled an elephant's trunk (Fig 47, right).

• Earlier furniture resembles old architectural design. For example, the railings on the arms of Ming-dynasty chairs or canopy beds often mimic the old railings found on pavilions. The geometric openwork design featured on railings on some canopy beds is similar to the latticed balustrades carved into stone inside the Yungang Caves in Shanxi province. It is also found on the balustrade of a terrace in a painting attributed to the Song-dynasty painter Wang Chu-cheng. Later designs use floral motifs. Moreover, old pieces such as the small, square table with its curvilinear apron shown in Fig. 50 are a vestige of the box-like furniture found in Tang-dynasty tombs, which suggests that this table is old.

• The lacquer finish also offers clues to dating. During the Ming, clothing fabric was used as a lining between the wood and the layers of lacquer. The rough fabric—much like cheesecloth—was generally soaked in a paste (a mix of lacquer and shell, brick, bone or charcoal) and placed over the surface of the wood. Another layer of lacquer was then applied. During the Qing dynasty, fabric was rarely used as an underlay, and when it was used, the fabric was finely textured. The skin of the lacquer—its patina—can also be a helpful dating tool because it oxidizes at a predictable rate. Connoisseurs study the tones of old lacquer to determine its age.

Nails are not always a sign of recent construction. Nails were sometimes incorporated into designs, for example as the eyes or ears of an animal. They were also used to secure pieces to prevent loss during transportation, such as the table aprons or flanges on the table shown in Fig. 48). Nails in joints are unacceptable.

Fig. 48

Fig. 49

Fig. 50

Fig. 48
Altar table, *huaimu* (locust), with an inscription dating it to the Kanxi period, Shanxi province. Iron nails were sometimes used on softwood furniture for aprons and flanges for easy fixing. Collection of Cola Ma.

Fig. 49
Exploded joints and parts from a corner leg table. Photo courtesy John Ang.

Fig. 50
Flush-sided corner leg side table with foliated feet and curvy apron that is an anachronism dating back to the Yuan or Song dynasty, *yumu* (northern elm), carbon-dated to the seventeenth century. Photo courtesy John Ang.

Fig. 51
Exploded version of a stool with humpback stretchers depicting the mortise-and-tenon structure of Chinese furniture. Photo courtesy Andy Hei.

Fig. 51

Chinese carpenters were advanced in precision joinery. For dealers able to take apart furniture and examine the nature of the joints, there are ways to ascertain the manufacturing era. There are several basic joints used in Chinese furniture, including the mortise-and-tenon, miter, dovetail and tongue-and-groove. Ming joinery tended to be simpler, with carpenters relying heavily on mortise-and-tenon joints (Fig. 49). Wedge-shaped dovetail pegs were common in early Ming pieces, but are almost non-existent in the Qing era. In addition, hidden tenons and wood pins innovated 400–500 years ago were abandoned by the late eighteenth century. These pegs were usually found in the legs and apron work, and served as a lock through the mortise-and-tenon (Fig. 51).

At the end of the day, there are no guarantees except carbon dating. Recently, collector Edmond Chin challenged Taiwan dealer John Ang over the reputed age of a flush-sided corner leg table. Ang thought that judging from the conservative style, the table might be as old as the Yuan dynasty (AD 1279–1368), but the dating came back as mid-Ming (AD 1500–50). He attributes the confusion to the fact that the table was sourced in Shanxi province, which is known for its conservative styles. So why are more dealers not using the carbon dating method? Cost can be prohibitive. Others are not convinced it

is reliable. Carbon dating measures the time at which the tree was felled and not when the actual piece of furniture was manufactured. The carpenter could simply be using old timber. Moreover, carbon dating is only really accurate for organic material that is at least 250 years old. "So, even if we are trying to determine the authenticity of a piece of work that was made from new timber, the results would be difficult to interpolate," says academic Curtis Evarts. However, Evarts believes carbon dating of lacquer coatings could be used as a dating tool if the lacquer were original to the construction.

Carving, Workmanship and Symbolism

Wood carving was inspired by decorative ivory, bamboo, stone, lacquer and jade, in particular the carved lacquerware of the Yuan dynasty (AD 1279–1368) and bamboo carvings from the Ming (AD 1368–1644). It was used sparingly until the mid-Qing dynasty, when the courts of the Qianlong emperor indulged in "unnecessary and over elaborate formalities," by making massive furniture with ornate design, according to Beijing scholar Tian Jiaqing. Tacky symbols of wealth and rank were incorporated into the furniture. Dark, intricate carvings were now possible because interiors were brighter, thanks to the widespread use of glass windows. The Qing rulers were also partial to shell inlays, sculptural effects, painting and gold tracery, and designs featuring dragons and phoenixes, and cloud and thunder patterns (Fig. 52). When there is no ornate carving, it is usually easy to determine the quality of a piece by the beading along the edges of aprons or along the legs. A good carver can bring three-dimensionality to an otherwise austere piece of furniture.

While composition and knife work are of obvious importance to carving, all these elements are moot unless the carver can skillfully polish his final product. A smooth, even surface adds luster and heightens color. Polishing is considered one of the highest forms of craftsmanship, and the skill of the polishers in the early and mid-Qing dynasty has never been surpassed. This art form has long since died out. The muscle work required has been overtaken by wax and lacquer. But shine does not a good polish make.

Fig. 52
Half-moon waisted side table, black lacquer on *yumu* (northern elm), seventeenth century, Xian, Shaanxi or Shanxi province. This is an example of intricate carving depicting cloud patterns as well as unusual leg features, including an elbow carving and a rare articulated foot. Carving was used sparingly until the Qing dynasty. Photo courtesy Hannah Chiang.

Fig. 52

Classifying Chinese Furniture 41

Decoration in Chinese Furniture

There are roughly six categories of decoration in Chinese furniture.

Archaic designs During the Ming dynasty it was fashionable for the literati to mimic archaic designs from old bronze, jades, and stone carvings. These carvings appear usually in bas-relief. A favorite archaic style is the double-coin motif which symbolizes the character for "doubled happiness" (Fig. 53).

Geometric designs and rhythmic patterns When it comes to screens and doors, types of geometric patterns range from curves and circles to triangles, squares, lozenges and trapeziums. Simple designs involve squares and hexagons—such as those called star and windmill patterns when referring to screens. These symbolize lasting and unbroken prosperity. Other simple designs include the "cracked ice" pattern. Furniture with geometric designs similar in form, structure and material tended to originate from the artisan workshops of the Suzhou area. A popular design, particularly on canopy beds, is the repeated *wanzi* motif, which symbolizes unending multiplication of happiness, wealth and longevity (Fig. 54).

Animal motifs These range from the mythical to the real. One of the most popular mythical icons—the dragon—symbolized royal authority and male fertility and as a result is frequently found on the back splats of stately chairs or the aprons of couch beds. The imaginary beast known as the *qilin*—a half lion, half dragon—is a symbol for fecundity. The phoenix, the mythical bird, on the other hand was considered a harbinger of good fortune (Fig. 55). The design of the beast is often a good dating tool. In the early Qing periods of the Ming dynasty, dragons were lean and animated, but by the latter half of the Qing dynasty, they were heavy and clumsy looking and had an additional toe (Figs. 58–60). Depictions of deer or rabbits are less common, but when they do appear they are meant to represent longevity; whereas the crane symbolizes wisdom and the father–son relationship.

Botanical motifs Not surprisingly, the Chinese attached virtues to botanical motifs. The *ruyi* symbol (Fig. 64) is one of the most common on Chinese furniture, along with repetitive cloud patterns. Although used throughout China, the wish-fulfilling *ruyi* was especially popular in Shanxi. (*Ruyi* are closely associated with auspicious clouds and the magical *lingzhi* fungus which symbolize good fortune and longevity.) Floral motifs are also common. Peony scrolls symbolizing wealth and high rank and plum blossoms representing beauty are often found on beds. Another popular pattern is the "three friends of winter" prunus, pine and bamboo, which some poets ascribe to mean "an emblem of constant and unyielding spirit." Some floral patterns, such as scrolls, the rose and large shells, resemble decoration found on the eighteenth- and nineteenth-century furniture of the European courts. Much of the furniture is in the Canton style, characterized by extravagant use of material and the addition of a cap (Figs. 62, 63, 65). The persimmon is associated with long life, protection, resilience and beauty. One of the earliest motifs used in China, it dates back more than 1800 years.

Calligraphic designs These became more popular in the Qing dynasty, often with incised calligraphy inlaid with gold or lacquer, or carved in relief. Many items with calligraphic carving escaped destruction during the Cultural Revolution by being stored for safekeeping in the Grand Mosque in Xian. The most popular symbol is the *fu* character, often translated as happiness, but better rendered as good fortune, blessing or luck, according to cultural historian Ronald Knapp. It can be depicted in numerous forms: the character itself or a carving of a bat is common. Another common symbol is *shou* which means longevity and the *wan* (inverse swastika) which means

Fig. 53

Fig. 54

Fig. 55

Fig. 56

Fig. 57

Fig. 53
Double-coin pattern. Photo courtesy John Ang.

Fig. 54
Detail of latticework in the *wanzi* pattern (the character for 10,000), a repeated symbol suggesting infinity. Photo courtesy Cola Ma.

Fig. 55
Screen with pierced carving of a phoenix, late Qing, Guangdong province. Collection of Just Anthony.

Fig. 56
Detail of a phoenix from a window screen. Photo courtesy Oi Ling Chiang.

Fig. 57
Table stand featuring bats, symbols of fortune or blessing. Photo courtesy John Ang.

Classifying Chinese Furniture 43

Fig. 58
Carved dragon head, the terminus for a top rail from the *huanghuali* throne chair in Fig. 566, page 216. Photo courtesy Robert A. Piccus.

Fig. 59
Carved coiling dragon on the splat of a *huanghuali* continuous arm horseshoe-back chair, seventeenth century. Photo courtesy Robert A. Piccus.

Fig. 60
Close-up of a lacquered dragon head carved along the crest rail of a southern official's armchair, seventeenth century, Shanxi province. Photo courtesy Oi Ling Chiang.

Fig. 61
Spandrels from a *huanghuali* table in the shape of a stylized phoenix with a crest, scrolling trail wings and hooked beak. Photo courtesy Robert A. Piccus.

Fig. 62
Flower motifs are common features in old-style cabinets from Shanxi province. Photo courtesy Cola Ma.

Fig. 63
Roundel carving of lotus and scrolling leaves, typical of the mid- to late Qing style, from the board railing of a couch bed, *yumu* (northern elm). Photo courtesy Cola Ma.

Fig. 64
Table stand featuring *ruyi*-shaped carving symbolizing good fortune and longevity. Photo courtesy Art of Chen.

Fig. 65
Lotus carvings. Photo courtesy Robert A. Piccus.

Fig. 58

Fig. 59

Fig. 60

Fig. 61

Fig. 62

Fig. 63

Fig. 64

Fig. 65

Classifying Chinese Furniture 45

immortality. Overlapping curves of the *wan* symbol, or the "running *wan*," represents infinity and is common on latticework (Fig. 66).

Human depictions These are usually based in historical fact or fiction. A popular depiction is that referred to as the Eight Immortals: Taoist fairies who were respected by people of later ages. Other immortals include Maitreya from Buddhism, the God of Longevity Shou Lou and the God of Wealth Tsai Shen. Sometimes carvings are simply based on the four different classes of people—scholars, artisans, merchants and farmers—or characters in vernacular novels such as *Dream of the Red Mansion* or *Water Margin*. Even dramas dating back to the Yuan dynasty were a source of inspiration. The characters featured on doorways and screens were similar to the images seen in the woodcuts used to illustrate the dramas and novels that were produced in the Xinan school of Anhui, the Jinling school of Jiangsu as well as schools in Zhejiang and Fujian province, according to author Ma Weidu. These characters were popular on doorways and screens carved by the merchant class in the southern regions of China, particularly in the regions where woodcut schools were based.

Figs. 66, 67

Fig. 66
Stylized calligraphy on the back splat of a horseshoe chair.

Fig. 67
Stylized calligraphy of a *fu* symbol on the back splat of a folding chair from Henan province.

Fig. 68
Pierced carving featuring scenes from a vernacular novel. This panel was inserted into a Fujian cabinet (Fig. 534, page 202). Collection of Cola Ma.

Fig. 68

46 Chinese Furniture

Fig. 69

Joints

Chinese furniture is exceptional for its precise integration (Figs. 69, 70). Every piece of wood is calculated to interlock in a seamless way that not only provides structural strength but also enhances the beauty of the design. Although joints date back to the Warring States period, it was during the Song period that more elaborate joints—miter, mortise-and-tenon—were developed. The standard construction, which couples joints with floating tongue-and-groove panels, is ingenious because it allows for expansion and contraction caused by humidity. Table tops and aprons can be secured without glue and readily disassembled. In Chinese furniture, metal nails and glue were used sparingly and were generally considered unacceptable.

During the Qing dynasty, carpenters showed off their skills with fancy woodwork. During this period, joints became increasingly complicated, such as the double miter, tortoise and tenon joints. Although creative, these joints are not necessarily more stable, as it is generally a rule of thumb that the greater the surface area, the better the joint. No doubt the hidden artistry was a form of professional showmanship.

Fig. 70

Fig. 69
Typical table joinery showing mitered joints.

a mitered frame with transverse brace
b mitered frame, floating panel and transverse brace showing joints
c double miter mortise-and-tenon joint
Source courtesy Curtis Evarts.

Fig. 70
Four examples of bridle joints, proving just how complex and variable joints can be.

a butt joint with loose tenons
b single spandrel head with half-lap miters
c two-piece spandrel heads with half-lap miters
d two spandrel heads with half-lap miters and dovetail keys
Source courtesy Curtis Evarts.

Classifying Chinese Furniture

Chairs

The earliest chair was portable. It was a symbol of authority on the battlefield and a makeshift throne outside the palace walls. It rose from humble beginnings to become an impressive feature in the homes of the wealthy. When the folding chair took shape sometime during the late Tang or early Song dynasty, its seat was made of cane or rope and it had a functional backrest. Its physics were unique: the weight of a man leaning against the backrest created a torque that kept the splayed legs in place and the seating surface taut. Portability was not the only reason this chair was so popular. It was also created to save space.

Folding chairs fell into disuse until the late Ming dynasty when they were reincarnated, not just for battle, but because they were convenient for moving around the garden or taking on trips. During the seventeenth century, an adaptation of the so-called "barbarian chair" was reinvented as an early lawn chair for the leisure class. Unfortunately, few examples have survived. The complexity of its architecture made it more susceptible to wear and tear than other pieces of furniture (Figs. 75, 76).

From the start, a hierarchy of sorts was established among the folding varieties. The traveling chaise of the emperors, generals and dignitaries had a horseshoe-shaped backrest. These dignified traveling thrones, complete with elaborate metal mounts, are the rarest. In 1996, two *huanghuali* examples were sold at auction for more than $400,000. However, there are a few hardwood rectangular chairs

Fig. 71 (opposite)
Vernacular chairs such as these horseshoe-back armchairs are attracting more interest from collectors.

Fig. 72
Woodblock print from *The Story of the Red Pear*. This features a formal sitting room where the host and his guest sit in yoke-back armchairs. A massive screen is placed behind them. Photo courtesy Grace Wu Bruce.

Fig. 73
A matchmaker introducing a prospective couple from the Chongzhen novel *The Golden Lotus*. In the formal sitting room there are yoke-back armchairs, while a hanging scroll is placed above a *qiaotouan* or altar table. Photo courtesy Grace Wu Bruce.

Fig. 72

Fig. 73

Fig. 74

Fig. 75

Fig. 76

50 Chinese Furniture

with straight arms remain in private collections, and some softwood pieces are still in the hands of dealers.

During the Ming dynasty (1368–1644), now considered the apogee of classical Chinese furniture, the homes of the rich and ruling classes were all equipped with chairs and tables. The most popular seat was the lamphanger or side chair. It was both decorative and functional, and was often placed beside an altar table in the main entrance hall. It was regal enough for ceremonial purposes but comfortable enough to be used for examining scrolls, practicing calligraphy or entertaining guests (Fig. 72). For the most part, historians rely on interior scenes depicted in old diagrams to understand how furniture was used. Chinese academic Fu Xihua's book, *Selected Woodblock Illustrations to Classic Chinese Literature*, published in 1978, is a good source.

In the thirteenth century, interior decorators were consulted for banquets and special occasions. Their role was to ensure that such events followed established rules of etiquette. In formal settings, tables and chairs were arranged in a linear fashion—parallel to the walls and at right angles to each other. There were rules for seating and the placement of textiles over tables (Fig. 73). Distinctions were drawn between official and private events. For example, horseshoe-shaped chairs were often employed for solemn occasions, whereas the rose chair was frequently found in bedchambers. Despite these distinctions, the Chinese often rearranged furniture to accommodate guests or activities, and often reorganized the interior every season and on different occasions for amusement. This practice among the upper class continued up to the late Qing period. Grace Wu Bruce, who has examined over 6000 woodblock prints, believes interior decor was quite fluid during the Ming and Qing periods. This is the opposite of the static European approach to interior design where furniture is positioned precisely so it never has to be rearranged.

There is no perfect approach to classifying Chinese furniture. The easiest and most common approach adopted by scholars is to look at form. By this definition, there are nine different types of Chinese chairs: high yoke-back armchairs with protruding ends or official's hat chairs; writing chairs or southern official's hat armchairs; side chairs or lamphanger chairs; meditation chairs; rose chairs or low-back armchairs; horseshoe-back chairs or grand tutor chairs; folding armchairs; Qing-style armchairs and Western-influenced chairs. There is also a low-back version of the high yoke-back armchair.

Fig. 74
Children's chairs, *hetaomu* (walnut), Qing dynasty, Shandong province, arranged around a *kang* table. This arrangement is purely a Westernized approach to design. Collection of Christopher Noto.

Fig. 75
Front view of a reclining chair with pull-out footrests, *yumu* (northern elm), eighteenth century. This reclining chair was most most likely used in a garden. Photo courtesy Oi Ling Chiang.

Fig. 76
Side view of a reclining chair, *yumu* (northern elm), late eighteenth century. Photo courtesy Oi Ling Chiang.

Fig. 77
The earliest chair was portable. This chair, photographed in Cola Ma's Tianjin warehouse, is an elegant example of a vernacular piece of furniture with lovely calligraphic carving along the back splat.

Fig. 78
High yoke-back armchair, Shanxi province. Chairs from this province often feature a thick, curving crest rail. The three-dimensionality of this top rail suggests it was made for a wealthy family.

Fig. 79
The homes of the rich and ruling were all equipped with chairs, including high yoke-back armchairs.

Fig. 77

Fig. 78

Fig. 79

Fig. 80

Fig. 81

Fig. 80
The various components of a yoke-back armchair.

Fig. 81
Yoke-back armchai with cane seat, *yumu* (northern elm), seventeenth century, Shanxi province. This regal chair, although made of softwood, resembles some of the best hardwood yoke-back chairs with its elegant S-shaped splat. Photo courtesy Cola Ma.

Fig. 82
Yoke-back armchairs. Photo courtesy Christopher Cooke.

Fig. 83
Chair with heavily decorated back splat, *zitan*, eighteenth century, Beijing. Photo courtesy Andy Hei.

Fig. 84
Continuous arm yoke-back armchair, *huanghuali*, seventeenth century. Photo courtesy Robert A. Piccus.

Fig. 85
Yoke-back armchair with long, curvilinear flanges along the splat and vase-and-bamboo armrest supports, *huanghuali*, seventeenth century, North China. Similar chairs are depicted in late Ming woodcuts. The backrest is pierced with a *fu* character and has a burl wood insert. Photo courtesy Peter Fung.

Yoke-back Armchairs with Protruding Ends or Official's Hat Chairs

The high yoke-back chair with protruding ends and arms, commonly referred to as the official's hat chair, is the most successful of Chinese chair designs and one of the earliest styles to emerge. Versions of it are depicted in the wall murals of the Dunhuang caves in Shanxi province, dated AD 538. It is recognized by its broad, flat back yoke and curved arms that protrude beyond its supporting posts. Although the chair appears suddenly in the sixth century, with no evidence of earlier models, historians like Sarah Handler postulate that it did, in fact, evolve over time.

The oldest surviving example of the yoke-back armchair dates to the Ming period (AD 1368–1644) after its form was already well defined. Not only does its presence in old paintings signify common usage, but it can be safely said that this chair was extremely popular during the Song dynasty. It began as a throne for deities and royalty, but was later embraced by the élite.

The mystery of the chair lies in its name. Although academics refer to it as a yoke-back armchair, it was commonly called an official's hat chair because of its resemblance to the wing-like brimmed hat known as the *putou* worn by early government officials. This term, however, is not found in Ming texts. The only description of the form is *chan yi*, a term used to describe a meditation chair.

As generous as the seat is, the chair was not used for personal contemplation. Its very profile suggests a more distinctive role in the Chinese home: to receive guests in the main hall or to be used by scholars in their studies. This is a chair meant to confer entitlement and importance. A man who sits against its high back is forced to assume an erect position, thus appearing tall and dignified. The sweeping lines of the chair, including the exaggerated arches of the top crest rail and the C-curved back splats, create a sense of movement. This infusion of energy gives the chair its aura of power. The carpenter who could blend these dynamics could create a truly impressive seat.

Although the back is the most significant element of the chair, it was also important to infuse good *qi* in the armrests. Many arm supports are wavy, a sign of good energy. The placement of the stretchers in the lower half of the chair also carries symbolic importance. The footrest, placed between the two front legs, is the stretcher closest to the ground. There are also side stretchers and a back stretcher between the legs. These three supports, however, are each positioned further up the leg. This three-tiered placement is called *bubugao*, literally a "step higher." The not-so-subtle meaning is that the chair represents career advancement.

While carpenters rarely altered the classic proportions of the yoke-back armchair, some did take creative license when carving designs on the aprons, back splats or arm supports. The decoration on these three elements gives historians clues about age or the area of manufacture. The top of a good crest rail should have a slight tilt or be angled upwards. If the crest rail is so flat that there is a visual lift, the chair was probably made by a carpenter from an outlying region. Chairs from the Shaanxi–Shanxi border region have thick crest rails with vigorous roller coaster curves, whereas classical pieces from

Fig. 82

Fig. 83

Fig. 84

Fig. 85

Chairs 53

Fig. 86
This yoke-back armchair, set on a platform, was used as a sedan chair for officials, nineteenth century. Photo courtesy Oi Ling Chiang.

Fig. 87
Yoke-back armchair with an openwork back panel and carved apron, possibly from a portable sedan chair, *huanghuali*. Collection of Philip Ng.

Fig. 88
Yoke-back armchair, *jumu* (southern elm), late Qing dynasty, Shanxi province. Collection of Just Anthony.

Fig. 89
Pair of yoke-back armchairs with an unusual cane back and inset panels below the crest rail. The chairs have horse hoofs and are waisted—another unusual element. Photo courtesy Grace Wu Bruce.

Fig. 90
Yoke-back armchair, *huanghuali* with stone inlay and burl wood in splat, seventeenth century, Jiangsu province. Collection of Philip Ng.

Fig. 91
Pair of yoke-back armchairs with cane seats, *jumu* (southern elm), nineteenth century. Collection of Philip Ng.

Fig. 86

Fig. 87

Fig. 88

Suzhou have more subtle humps. Back splats also vary from region to region. Some show elegant curvature and are plain. Others are notable for their intricate carving. Chairs with a tri-partitioned design on the back virtually became a standard for *hongmu* chairs made in Southern China.

While most extant chairs have straight legs joined by stretchers, there was a type of chair to emerge during the Ming dynasty that had horse hoof feet and was waisted.

Southern Official's Hat Armchairs or Writing Chairs

When armchairs have high rectangular backs without protruding crest rails and the arms do not extend beyond the front posts, they are known as southern official's hat chairs. In the city of Suzhou these chairs are referred to as "writing chairs" because they were frequently used in the studies of poets, painters and scholars. Artisans from Jiangsu province were the first to make well-balanced Ming-style furniture, and it is believed this type of chair originated here and gradually spread northward to other regions—hence the term "southern." Like the rose chair, the continuous curves of the southern official's armchair may be an attempt to copy the bent corners of bamboo chairs.

Fig. 89

Fig. 90

Fig. 91

Chairs 55

Fig. 92

Fig. 93

Fig. 92
Short-backed southern official's hat armchair, *hongmu* (blackwood), nineteenth century. Photo courtesy Albert Chan.

Fig. 93
Short-backed southern official's hat armchai with cane seat, *huanghuali*. Photo courtesy Grace Wu Bruce.

Fig. 94
Southern official's hat armchair. Photo courtesy Christopher Cooke.

Fig. 95
Southern official's hat armchair with a hard seat and elegant vase-and-bamboo posts intersecting the armrests, red lacquer on *yumu* (northern elm), eighteenth century, Shanxi province. Photo courtesy Cola Ma.

Fig. 96
Pair of short-backed southern official's hat armchairs, *huanghuali*. Photo courtesy Charles Wong.

Fig. 97
Southern official's hat armchair with cane seat and backrest inlaid with mother-of-pearl (originally semi-precious stones), *huanghuali*, seventeenth century, Jiangnan region. Since this picture was taken, this chair has been re-restored with semiprecious stones. Photo courtesy Peter Fung.

Fig. 94

56 Chinese Furniture

Fig. 95

Fig. 96

The yoke-back chair is the most vertical of Chinese chairs, according to Sarah Handler, and because of this, it "imparts honor, dignity and power." Because of its ability to convey status, it "penetrated the social ranks of Chinese society as thoroughly as chopsticks and rice."

That said, while most examples are upright, there are reclining versions of this chair (Fig. 99). This is an unusual example of an early lounge chair. Another version of the official armchair is the meditation chair. In Ming texts, there is no term for the official armchair. The term *chan yi* or meditation chair is described in the *Lu Ban Jing* (Classic of Lu Ban). Today, we take a literal interpretation. A meditation chair is an oversized official's armchair wide enough for a man to comfortably sit in cross-legged (Figs. 101–104).

The classic form of the southern official's hat chair mirrors the British-designed Queen Anne chair. With its splat back, curved yoke and cabriole legs, it is regarded as a reinterpretation. It is possible that the British plagiarized the shape by lowering the seat and elongating the backrest.

Fig. 97

Chairs 57

Fig. 98
Pair of short-backed southern official's hat armchairs with a relief-carved archaic dragon on the back splat, *hetaomu* (walnut), eighteenth century. Photo courtesy Albert Chan.

Fig. 99
Reclining southern official's hat armchair, *yumu* (northern elm), eighteenth century, Shanxi province. Photo courtesy John Ang.

Fig. 100
Pair of southern official's hat armchairs, *yumu* (northern elm), eighteenth century, Shanxi province. The basket-like lattice under the armrest is seldom seen. The style of this chair is called *wenye* or a refined scholar's chair. Photo courtesy Oi Ling Chiang.

Fig. 98

Fig. 99

Fig. 100

Chinese Furniture

Fig. 101

Fig. 102

Fig. 103

Fig. 104

Fig. 101
Meditation seat, *hetaomu* (walnut), eighteenth century, Shanxi province. Collection of Hannah Chiang.

Fig. 102
Meditation chair, *baimu* (cypress), eighteenth century, Shanxi province. Collection of Hannah Chiang.

Fig. 103
Meditation armchair with reclining cane back and comb-style posts along the arms, *huanghuali* and cane, seventeenth century, Zhejiang province. Photo courtesy Charles Wong.

Fig. 104
Meditation chair with adjustable reclining back, *jumu* (southern elm), 1750 to 1850, Jiangsu province. While the posts for this reclining position are visible, the back splat is missing. Collection of Philip Ng.

Chairs 59

Fig. 105

Lamphanger Chairs or Side Chairs

This is a yoke-back armchair without arms (Figs. 105, 106). Such chairs were depicted as formal seats for feasting couples in Jin-dynasty tombs found in Jishan, Shanxi province. The chairs were termed "lamphanger chairs" in Beijing during the twentieth century because they were similar in shape to bamboo wall lamps commonly hung next to the kitchen. As Sarah Handler points out, because these chairs were light, they were easy to carry around the house and so were useful if someone wanted to sit in the garden or needed some extra chairs in the main hall for receiving visitors. When used for formal banquets, silk runners known as *kesi* were often draped down the back splat to lend a more dignified air to the occasion. When dining, these chairs were neatly aligned in a row.

Lamphanger chairs resemble Queen Anne chairs designed in the early eighteenth century. Several scholars have suggested that stylized lamphanger chairs, a few of which may have made their way to London, may have influenced designers working in England.

Fig. 105
Side chair with humpback stretchers and an unusual footrest, *huanghuali*, seventeenth century, Suzhou. Photo courtesy Andy Hei.

Fig. 106
Pair of side chairs with elongated proportions and thick, curved crest rails, Hubei province. Photo courtesy Oi Ling Chiang.

Fig. 107
Rose chair with cracked ice motif, *huanghuali*, eighteenth century. Photo courtesy Albert Chan.

Fig. 108
Spindle-back rose chair, *huanghuali*, early nineteenth century, Jiangnan region. This is typical of the Suzhou style of the mid- to late Qing period and was more commonly produced in *hongmu* (blackwood). Unlike a traditional rose chair, the backrest is shaped with a subtle arch. Photo courtesy Peter Fung.

Fig. 109
Hexagonal low-back armchair, *huanghuali* and *huamu*, seventeenth century. A classical piece of furniture. Collection of Lu Ming Shi. Photo courtesy Grace Wu Bruce.

Fig. 106

Fig. 107

Fig. 108

Rose Chairs or Low-back Armchairs

How the rose chair received its appellation is a mystery. The term suggests that these delicate chairs were made for women. Certainly, old woodblock prints often depict them arranged in the women's private chambers. That theory has now been debunked. Instead, scholars believe that the encircling stretchers and curves that give the chair its "feminine" appearance are simply homage to old lightweight bamboo furniture. Indeed, there are many examples of low-back chairs carved to imitate bamboo.

There was no division of usage. Men as well as women used them. While they show up frequently in bedrooms, other illustrations show sets of rose chairs lined up and facing one another in entrance halls of official and domestic buildings. Clearly, this light and portable chair was considered an informal piece of furniture that could be moved around the home. The low-back rose chair style

Fig. 109

Chairs 61

Fig. 110
Pair of rose chairs with high humpback stretchers, *tielimu*, eighteenth century, Shanghai. Photo courtesy Charles Wong.

Fig. 111
Rare rose chair, *hetaomu* (walnut), eighteenth century. Private collection. Photo courtesy MD Flacks.

Fig. 112
Rose chair with inset carved backs with double-sided carving of hornless *chilhulong* dragons and a central shaped medallion inscribed with a poem, *huanghuali*, seventeenth century. Collection of Lu Ming Shi. Photo courtesy Grace Wu Bruce.

Fig. 110

Fig. 111

Fig. 112

62 Chinese Furniture

was common in Suzhou—the city of gardens and windows. A high-back chair could block a view, whereas a rose chair could sit under a window.

Unlike the official's armchair with its extended back, the rose chair has a low rectangular back that barely scrapes above the armrests (Figs 107–112). Its square design is possibly based on a Song style of chair whose sides and backrest are equal in height. Low-back chairs rarely have a central back splat. Instead, the chair is distinguished by a series of support spindles along its back and sides. Some have elaborate decoration, including fine carved openwork panels with the "three friends of winter" motif. In fact, this form of chair tends towards more elaborate carved frames, struts and stretchers. Some even sport latticed designs within the back frame (Fig. 112).

What is most obvious about this particular chair is that it is generally uncomfortable to sit in. The straight top digs into the middle of the back.

Horseshoe-back Armchairs or Grand Tutor Chairs

This chair is a powerful symbol of Chinese culture and was referred to as the "Grand Tutor chair" or *taishi yi*. According to historian Craig Clunas, such chairs could be converted into light, open sedan chairs in the sixteenth and seventeenth centuries by simply installing two poles along the side. Travel, however, was by no means the chair's sole purpose. Its role in society was largely ceremonial; it was a seat of honor. What better way to impress than to place a pair of these imposing pieces in a meeting hall?

The chair's generous proportions are exaggerated by the semicircular armrests, and although it appears overly spacious, it remains one of the most comfortable chairs ever designed in China. Its prototype is the curvy armrest depicted in Chinese paintings of the Buddhist saint Weimo (1049–1106). The anatomy of the chair is far more complex. The back arch is created by five separate pieces of curved wood and joined together by half-lapped pressure peg joints—a feat in carpentry.

While the classic horseshoe chair has numerous joints, vernacular versions using flexible softwood were common, such as willow chairs from Shandong.

Fig. 113

Fig. 114

Fig. 113
Pair of horseshoe-back armchairs covered with fabric-clay lacquer, *zuomu* (oak), Shanxi province. The original bamboo veneer on the footrest still remains. Photo courtesy Oi Ling Chiang.

Fig. 114
Bent-arm horseshoe-back armchair, *zuomu* (oak), nineteenth century, Shangdong province. Collection of Hannah Chiang.

Chairs 63

Fig. 115
Components of a horseshoe-back armchair.

Fig. 116
Horseshoe-back armchair with a cane insert on the back slat and a cane seat, *jumu* (southern elm), seventeenth to eighteenth century. Private collection. Photo courtesy MD Flacks.

Fig. 117
Horseshoe-back armchair, *huanghuali*, seventeenth century, Suzhou region. The backrest features three sets of carvings: a central panel decorated with blossoming plum branches, a *ruyi* in a vase and a rock on a stand. The armrests end with scrolled hand grips. Photo courtesy Peter Fung.

Fig. 115

Fig. 116

Fig. 117

64 Chinese Furniture

Fig. 118

Fig. 119

Fig. 120

Fig. 118
Vernacular horseshoe-back armchair, eighteenth century, Hebei province. Collection of Hannah Chiang.

Fig. 119
Continuous arm horseshoe-back armchair, also known as a *quanyi*, with fine carving along the apron, *zitan*, nineteenth century, Jiangsu province. Collection of Philip Ng.

Fig. 120
Continuous arm horseshoe-back armchair, *jichimu* (chicken wing), eighteenth century. The detail shows the arm joint. Photo courtesy Robert A. Piccus.

Fig. 121
Continuous arm horseshoe-back armchair with humpback stretchers and a coiling *chi* dragon carved into the S-shaped slat, *huanghuali*, seventeenth century. The tapering side posts have a sensuous curve. Photo courtesy Robert A. Piccus.

Fig. 121

Chairs 65

Fig. 122

Fig. 123

Fig. 124

Fig. 125

Fig. 122
Horseshoe-back armchair, *zuomu* (oak), late Qing dynasty, Shanxi province. Collection of Just Anthony.

Fig. 123
Horseshoe-back arm chair, *zuomu* (oak), late Qing dynasty, Shandong province. Collection of Just Anthony.

Fig. 124
Horseshoe-back armchair with unusual apron carving of a *ruyi* and cloud-head lappet (see detail), *huanghuali*, seventeenth century. This chair was purchased as a solo piece, but one year later the collector was offered the matching piece. Photo courtesy Robert A. Piccus.

Fig. 125
Horseshoe-back armchair with a pierced carving of a dragon on the backrest and fine beading on the bottom humpback stretchers, *nanmu* coated with thin black lacquer, eighteenth century, Shanxi province. This chair was used for people of high status and rank, but the dealer also believes it might have been a chair used for intercourse. Photo courtesy Cola Ma.

66 Chinese Furniture

Folding Armchairs

Judging by frequent depictions in Ming-dynasty woodblock prints, the traditional collapsible armchair was once commonplace. However, few folding chairs have survived because they were frequently made of softwood, which made them easier to carry, but they were therefore subjected to much wear and tear. The legs of the folding chair cross over in the shape of an X and are secured with metal pivots wrapped with a *baitong* band for reinforcement. The seats are usually woven. Interestingly, the regal horseshoe-back folding armchair, with its generous back, curving splats and attached footrests, was not practical to fold.

A chair of this sort would have been reserved for the head of a family—or an emperor. While hardwood examples fetch top prices at auction, lacquered armchairs were also popular. The Emperor Qianlong owned a sumptuous black lacquer and gold specimen, and the Victoria and Albert Museum has a magnificent dragon-carved cinnabar lacquer piece that was probably intended for imperial use. Other members of the élite might have used them while working at a writing desk or formally receiving visitors, and it is even possible

Fig. 126

Fig. 126
Vernacular folding chair with replaced rope seat, *hetaomu* (walnut). Collection of Christopher Noto.

Fig. 127
Folding chair, *taomu* (pear), early nineteenth century, Yunnan province. Photo courtesy Cola Ma.

Fig. 128
Folding chair, probably used for hunting or traveling, with metal hinges and refined cast-iron joints, *huaimu* (locust), Ming dynasty, Shanxi province. Photo courtesy Cola Ma.

Fig. 127 Fig. 128

Chairs 67

Fig. 129

they were dragged into the garden on occasion for an impromptu game of chess, according to Sarah Handler. Nevertheless, the folding armchair was a status symbol—even in death. There are numerous examples of them among tomb figurines and they are also frequently depicted in ancestral portraits.

The yoke-back folding chair was also extremely popular and was actually designed to be folded. When collapsed, some chairs can be reduced to seven inches wide. The first version dates back to the Song dynasty painting, "Spring Festival along the River." The King of Spain owns a pair, probably purchased from Chinese traders in the sixteenth century. Other more basic folding forms that collapse like old British desk chairs have been discovered in Yunnan province by Cola Ma.

A more relaxed version of the folding chair, commonly dubbed the "drunken lord's chair" or *zuiwengyi*, was also very popular during the Ming dynasty, particularly among scholars. This reclining chair may be the most comfortable classical seat ever built and was depicted in the painting "Reading Quietly in the Shade of Pawlonia Trees" by Chi'iu Ying (1494–1552) (Fig. 130).

68 Chinese Furniture

Fig. 130

Fig. 131

Fig. 132

Fig. 129 (opposite)
Folding horseshoe-back armchair, *huanghuali*, late sixteenth to early seventeenth century (see also Fig. 15, page 17). Collection of Dr S.Y.Yip. Photo courtesy Grace Wu Bruce.

Fig. 130
A "drunken lord's chair" is shown in the painting "Reading Quietly in the Shade of Pawlonia Trees" by Chi'iu Ying (1494–1552). Photo courtesy National Palace Museum of Taipei.

Fig. 131
Folding horseshoe-back armchair with a dragon design carved into the back splat, *huanghuali*, seventeenth century. Collection of Philip Ng.

Fig. 132
Folding horseshoe-back armchair. Photo courtesy Minneapolis Institute of Arts.

Chairs 69

Qing-style Armchairs

This new form of solid square seat came into vogue during the Qing dynasty (AD 1644–1911) (Figs. 133, 134). The chair looks like a cross between a low-back bed and a throne, and is made up of two parts: a waisted stool and an upper back-rest that resembles a screen panel. The back panels often feature marble insets. In the homes of the wealthy, this type of armchair was a status symbol and given priority in the main hall. They were often found in pairs and were arranged with a tea table in between. Examples of these chairs are still found in old homes and temples in China, particularly the Suzhou area (see pages 12–13).

Fig. 133

Fig. 133
Qing-style armchair, *hongmu* (blackwood). This armchair looks like a cross between a throne chair and a stool, and is bulkier than the earlier rose chair style. The densely carved back splat is offset from the cloud scroll pattern shown on the rest of the back. Photo courtesy Charles Wong.

Fig. 134
Qing-style armchair with marble panels, *zitan* and Dali marble, late eighteenth to early nineteenth century, Zhejiang/Fujian province. These chairs look like large stools with railings attached. The marble panel inserts are designed to resemble mountainscapes. Such chairs were popularized during the eighteenth century. Photo courtesy Peter Fung.

Fig. 134

Western-influenced Chairs

As far back at the 1600s, Chinese workshops were catering to foreign clients. China regulated its trade closely, but warehouses belonging to the Dutch, English, Swedish and French occupied a choice strip of waterfront in Canton (now Guangzhou). While black tea filled up the cargo holds of most ships heading for Europe, raw silk and export porcelain were also a regular part of the trade. However, because the captains and top officers of the ships belonging to the East India Company were allowed to engage

Fig. 135

Fig. 135
Corner chair with open-carved floral motif, *hongmu* (blackwood) inlaid with Dali marble, late nineteenth to early twentieth century, Guangdong province. The chair is adapted from a Western love seat. Photo courtesy Albert Chan.

Fig. 136
Western-style armchair, *jumu* (southern elm), Republican period (inscription dated 1933), Shanghai. Photo courtesy Curtis Evarts.

Fig. 136

Fig. 137

Fig. 137
Lamphanger side chair with cabriole legs and open-carved scrolled foliate design, *hongmu* (blackwood) inlaid with Dali marble, late nineteenth to early twentieth century, Guangdong province. This is a free adaptation of a Queen Anne chair. Photo courtesy Albert Chan.

Fig. 138
Corner chair with round back and curved splats, black lacquer on unknown wood, early twentieth century, Shanghai. Photo courtesy Curtis Evarts.

Fig. 138

Chairs 71

Fig. 139

Fig. 140

Fig. 141

Fig. 142

Fig. 143

in private trade, many took on other curios from China, including lacquerware, wallpapers and wood furniture. Thanks to these seafaring entrepreneurs, trade in these commodities created "a revolution in perception, affecting all fields of art and design," according to Craig Clunas.

Europe's love affair with the Orient meant increasing demand for Chinese goods. The Jingdezhen kilns were busy pumping out export porcelain and Nanjing silk factories adapted patterns to suit European tastes. Chinoiserie (European copies of oriental handicrafts) also became popular in the West in the eighteenth century, and fueled the market for new forms of imported furniture. Little is known about the factories that manufactured export furniture in the late Qing dynasty. Dealer Albert Chan possesses old catalogues from the Ng Sheong factory in Canton that manufactured elaborate blackwood furniture. Canton, however, was not the biggest center of production for such furniture by the late nineteenth century. More popular still were the port towns of Shanghai and Ningbo when China opened more ports to foreigners after the opium wars in the 1900s. For years, Canton was a huge export market and home to ornate carving. By the turn of the twentieth century, Shanghai was flooded with foreigners who were buying furniture for themselves.

This meeting of East and West had mixed results. While some furniture ingeniously combined symbols and carving techniques, proportions often skidded offside: seat backs were shortened relative to seat widths and arm lengths. The chairs often appeared dumpy. During the Republican era (1912–49), much furniture crafted in Shanghai and environs showed Western influence, including a chair in the home of Cola Ma (Fig. 144). Large cabinets were obviously influenced by the Arts and Crafts movement of the West. But while craftsmanship was solid, some of the designs bordered on tacky (Fig. 141).

The best cultural confluence was undoubtedly the lacquered inlay chests or the Art Deco-inspired *hongmu* (blackwood) chairs, encouraged by the foreign expatriates bored with traditional Shanghai or Zhejiang province styles. Blackwood was the perfect material to highlight the angular Art Deco profile (Fig. 142). Suddenly, a range of dressing tables, desks with convex proportions and sweeping angles were introduced to the market.

72 Chinese Furniture

Fig. 144

Fig. 145

Fig. 139
Set of four side chairs, *zuomu* (oak), nineteenth century, Shanxi province. Photo courtesy John Ang.

Fig. 140
Art Deco armchair, blackwood and leather, ca. 1930s, Shanghai. Photo courtesy Curtis Evarts.

Fig. 141
Republican-era horseshoe-back chair with Western proportions, *yumu* (northern elm), early twentieth century. The bottom half of the chair looks like an adaptation of the nineteenth-century upholstered chair by John Henry Beller. Collection of Cola Ma.

Fig. 142
Imitation of an Arts and Craft chair, *tielimu* (chicken wing), twentieth century, Shanghai. Collection of Hannah Chiang.

Fig. 143
Lounge chair, *hongmu* (blackwood) and canvas, early twentieth century, Guangdong. Photo courtesy Curtis Evarts.

Fig. 144
Republican-era chair in a Westernized style. Collection of Cola Ma.

Fig. 145
Circular side chairs with floral design, *yumu* (northern elm), nineteenth century, Shanxi province. These are adapted from the traditional European bistro-style chair designed by Michael Thonet. Photo courtesy John Ang.

Fig. 146
Bentwood rocking chair, introduced by Westerners during the mid- to late Qing dynasty, nineteenth century, Shanghai. Photo courtesy Charles Wong.

Fig. 146

Chairs 73

Stools and Benches

There is a culture of sitting in China. It can be found in the chaotic metropolises and rustic villages across the country. Everywhere you turn, someone is sitting on a low makeshift perch, whether it be a wooden stool or bench, piles of bricks, or a discarded stuffed armchair. Today, the lowly stool is a sign of poverty, unemployment or sheer boredom. Although most examples fall into the category of vernacular furniture, even the most commonplace examples have a sculptural beauty that transcends their humble roots (Figs. 149, 150).

However degraded today, the stool was not always the inferior cousin of the chair. Stools made of hardwood and lacquer were always found in the homes of the upper classes. The stool is the perfect interior accessory—easy to move around and as comfortable in a formal reception hall as it is in a lady's chamber. For informal occasions, stools would be pulled up to square tables at mealtimes, as shown in woodblock prints (see Figs 9, 10, page 15). When comfort and warmth were needed, stools could be covered with cushions or textiles. They could be carried outside to the courtyard or garden, used as tables or stands for objects, or even employed as stepladders.

The original stool—known as the barbarian bed—is thought to have originated in the second century. Only the top commanders, directing troops in battle, were allowed to use it. Conceived for military use, this functional seat was later adapted by peddlers and the leisure class alike. The stool showcases the economy of material, clarity of construction and convenience that epitomizes classic Chinese furniture. There are few surviving examples of the folding stool; however, one fine example was sold by Christie's in the Robert Piccus Collection (1992). Rather than the typical woven seat found in stools (Figs. 153, 154), this one has wooden slats, which possibly suggests that in addition to being used as a traveling seat, it doubled as a horse mount.

Fig. 148

Fig. 147 (opposite)
Round waisted stools with cabriole legs, fretwork aprons and marble insets in a sitting area in the Kang family manor, Gongyi, Henan province.

Fig. 148
Bench, *yumu* (northern elm), eighteenth to nineteenth century, Shanxi province. Private collection, Singapore.

Fig. 149

Fig. 149
Typical recessed-leg stool, Yunnan, 1997. Photo courtesy Michael Wolf.

Fig. 150
Simple recessed stools and benches with stretchers, Wenzhou, 1998. Photo courtesy Michael Wolf.

Fig. 151
Vernacular folding stool, *nanmu*, nineteenth century. Private collection, Singapore.

Fig. 152
Simple stool with stretchers. Private collection, Singapore.

Fig. 153
Vernacular folding stools, unknown wood, typical of those on the market, particularly in Shanxi province. Collection of Philip Ng.

Fig. 154
Portable stool, eighteenth century, not unlike the prototype which appeared around AD 168. The difference is this one is made of expensive *huanghuali* wood and has a footrest with a metal mount. Photo courtesy Charles Wong.

Fig. 150

76 Chinese Furniture

Fig. 151

Fig. 152

Fig. 153

Fig. 154

Stools and Benches 77

Fig. 155

Fig. 156

Fig. 157

Fig. 158

Fig. 159

Fig. 155
Drum-shaped stool with overhanging top, black and red lacquer, Henan province. Photo courtesy Art of Chen.

Fig. 156
Drum stool or *zuodun*, *huanghuali*, late seventeenth century. Photo courtesy Robert A. Piccus

Fig. 157
Stool shaped like a wine jar, made from a single piece of unknown wood, ca. seventeenth century, Shanxi province. Three openings have beading along the edges. Photo courtesy Cola Ma.

Fig. 158
Square stool in imitation bamboo style, *huanghuali*, seventeenth century, Jiangsu province. Collection of Philip Ng.

Fig. 159
Stools with rounded humpback stretchers attached to rounded legs, *huanghuali*. Photo courtesy Andy Hei.

Although the first depiction of a stool is inscribed in a bronze vessel from the Eastern Zhou (770–221 BC), it was not until the sixth century that stools were regularly used by the wealthy, as evidenced in tombs discovered near Luoyang. What makes the stool so versatile is the shape and size it comes in: rectangular, square, rounded, lobed and bow-legged, to name a few. Some of the earliest examples were rounded or drum-shaped. There are images of Tang-dynasty (AD 618–906) ladies sitting on hourglass-shaped stools. The vernacular lacquered drum-shaped version with overhanging top in Fig. 155 is from Henan province.

In the Song dynasty, barrel- and drum-shaped stools were popular, as shown in woodblock prints of the time (Figs. 9, 10). Rounded stools with cabriole legs or globe-like versions featuring oval openings along the sides were also popular (Fig. 156). The latter was most likely copied from old cane stools that were formed by bending cane strips into four circles and fastening them together to create the sides. Although the rounded stool is the most common seat in paintings and woodblock prints, the stools that survived are square or rectangular (Figs. 158, 160). A Ming-style favorite is the recessed-leg stool, with splayed legs and double-stretchers for support. It looks much like a shrunken wine table. However, the standard stool for the élite was the one-piece waisted apron stool with a high foot. While stools such as the waisted one from Robert Piccus's collection shown in Fig. 160 have no accessories, humpback stretchers were common (Figs. 159, 161). The basic waisted stool from Zhejiang province shown in Fig. 163 has a coarser design.

Although craftsmen were slaves to standardization, there were occasional creative flourishes. During the Ming

78 Chinese Furniture

Fig. 160

Fig. 161

Fig. 160
Waisted rectangular stool, *huanghuali*, seventeenth century. Photo courtesy Robert A. Piccus.

Fig. 161
Meditation stools with straight legs and fretwork spandrels, *huanghuali*, seventeenth century, Zhejiang province. Photo courtesy Charles Wong.

Fig. 162
Square stool with modified *shou* character between the apron and humpback stretchers, *huanghuali*, Jiangsu province. Collection of Philip Ng.

Fig. 163
Simple waisted vernacular stool, Zhejiang province. Photo courtesy Art of Chen.

Fig. 164
Drum stool, *huanghuali*, seventeenth century. Private collection. Photo courtesy MD Flacks.

Fig. 162

Fig. 163

Fig. 164

Stools and Benches　79

Fig. 165

Fig. 166 Fig. 167 Fig. 168

Fig. 165
Pair of rectangular waisted stools with scrolled hoofs, *zitan*, eighteenth century, North China. The leaf carving is in a style that reflects Western decorative styles. Photo courtesy Peter Fung.

Figs. 166, 167
Vernacular three-legged stools, *yumu*, late Qing dynasty, Shanxi province. Collection of Just Anthony.

Fig. 168
Round recessed leg stool, burl wood top, eighteenth century, probably made in Beijing. Photo courtesy Oi Ling Chiang.

Fig. 169
Scene from a bedchamber from the Tianqi novel *Forgotten Tales from Zen Adherents*. Note the high rounded stool compared to the very low recessed stool the maid is perched on to wash the baby. Photo courtesy Grace Wu Bruce.

Fig. 170
Pair of hexagonal stools with unusual overlapping *lingzhi* fungus design in the shape of the double-coin or doubled happiness symbol, Zhejiang province. Photo courtesy Art of Chen.

80 Chinese Furniture

dynasty, scholars with severe notions of aesthetics loved to exploit natural wood formations, particularly knotty roots, to create rustic seats (Fig. 168). During the Qing, the simple seat could be enhanced with elaborate carving and flourishes (Fig. 165). Hexagonal stools such as the one shown here from Zhejiang province were also popular in the late Qing (Fig. 170). Regional craftsmen and farmers also took artistic license with the form, such as tall three-legged stools and innovative barber's seats (Figs. 166, 167).

Size, however, determines class. Stools used by servants in a wealthy home would always be closer to the ground than those used by their masters. The woodblock print from *Forgotten Tales from Zen Adherents* shows decorated drum-shaped stools used by women for their toilette while the nursemaid squats on a narrow rectangular seat with stubby legs (Fig. 169). We can also compare a square *huanghuali* stool 20 inches (50 cm) high with one of soft locust wood that reaches only 14 inches (35 cm), or a basic peasant perch recently purchased in the market which is only 9 inches (22 cm) off the ground.

With each step down the social ladder, the stool drops lower to the ground (Figs. 171, 172). Perhaps the most poignant example of stool size and hierarchy can be seen in the multiple stool in Fig. 173 which was possibly used by a servant to squat on in order to bind the feet of

Fig. 169

Fig. 170

Stools and Benches 81

Fig. 171

Fig. 172

Fig. 173

her lady who would have placed her disfigured "lotus buds" on the upper stool for ministrations.

Headrests were another innovation (Figs. 174, 175). A headrest looks like a stool, except it is very small, low to the ground and features a dip in the center to accommodate the neck. The legs of headrests are often splayed for support. While classic headrests like the Ming-style *zitan* example shown here are revered for their simplicity, ornate headrests crafted during the Qing dynasty also exist. Comfort was not an issue for this particular *zitan*, cloud-patterned headrest.

Contemplation or meditation stools were another type of seat (Figs. 176, 177). These large square seats are low to the ground and sometimes feature backrests or armrests. They are meant to accommodate a monk in the lotus position.

The uninitiated might assume that the bench was a common seat around a food table (Fig. 179). This was not so. Although some benches may have been used for dining purposes, the bench was conceived for more romantic functions: it was built for love and music. A musician playing a *qin* might sit on a low bench while his admiring audience sat on the floor (Figs. 180–184).

82 Chinese Furniture

Fig. 174

Fig. 175

Fig. 176

Fig. 177

Fig. 171
Plain contemporary stool, Yunnan, 1996. Photo courtesy Michael Wolf.

Fig. 172
Headrest in the shape of a bench, *hetaomu* (walnut). Private collection, Singapore.

Fig. 173
Double-stool, possibly used for footbinding, *zitan*. Collection of Philip Ng.

Fig. 174
Pillow carved in a cloud pattern, *zitan*, eighteenth century, Beijing. This pillow was probably once owned by a descendant of the royal family in the Beijing area. Photo courtesy Andy Hei.

Fig. 175
Pillow, *zitan*. This pillow is the favorite of dealer Hei Hung Lu and is part of his personal collection. Photo courtesy Andy Hei.

Fig. 176
Square meditation stool, *huanghuali*, eighteenth century. Photo courtesy Robert A. Piccus.

Fig. 177
Meditation stool with rounded cusp apron and legs that have a right-angle section cut out of the inside corner, *huanghuali*, seventeenth century, Shaanxi province. Photo courtesy Charles Wong.

Stools and Benches 83

Benches were also used by families seated together for theatrical performances (Figs. 185, 186, 189). Such benches date back to the Song dynasty, such as the settee for two pictured in a painting by Zhang Zeduan entitled "Spring Festival along the River." As far back as the Ming dynasty (AD 1368–1644), and recorded in the *Lu Ban Jing*, high-back benches with rustic carvings were made for opera house patrons (Fig. 191). These elaborate seats look much like church pews. Shanxi province was famous for its many outdoor activities, including plays, ceremonies and musical performances, and as a result this kind of furniture, along with folding chairs and stools, was popular here. Most surviving examples are made of local softwoods and have solid seats (Fig. 190).

Gate benches were also popular in China until very recently (Figs. 187, 188). They were usually made of softwoods, such as *baimu* (cypress) or *yumu* (elm), but the examples shown here are made in the more valuable hardwood *laohuali* (see page 34, *Huanghuali*). It is rare to find hardwood pieces. These benches are an example of how some forms of seating crossed the class divide.

Figs. 178

Figs. 179

Fig. 178
Waisted Eight Immortals table and two benches. Collection of Christopher Noto.

Fig. 179
Table and benches in a typical Ming form with small spandrels, table of *huaimu* (locust), benches of *yumu* (northern elm), eighteenth century, Shanxi province. These were not a set but were put together by dealer Oi Ling Chiang. Photo courtesy Oi Ling Chiang.

Fig. 180
Carved bench, *yumu* (northern elm), late Qing, Shanxi province. Collection of Just Anthony.

Fig. 181
Bench in a classical Ming style with a concave waist and curvilinear lines seeping into the legs in a graceful manner, *huanghuali*, seventeenth century. Photo courtesy Peter Fung.

Fig. 182
Waisted Eight Immortals table and benches in the Tian Yuan Kui inn in Pingyao, Shanxi province.

Fig. 183
Gate bench with splayed legs, *jumu* (southern elm), nineteenth century, possibly from Jiangsu province. Collection of Philip Ng.

Fig. 184
Bench, *jumu* (southern elm), nineteenth century, Jiangsu province. Collection of Philip Ng.

84 Chinese Furniture

Fig. 180

Fig. 181

Fig. 182

Fig. 183

Fig. 184

Stools and Benches 85

Fig. 185
Four-seat bench, inspired perhaps by a Queen Anne-style settee, late Qing, Hubei province. Collection of Just Anthony.

Fig. 186
Three-seat folding chair, probably used at music and opera performances, unknown wood, eighteenth or nineteenth century, Shanxi province. Some folding chairs seat two, others four, and are unique to Shanxi province. Photo courtesy Cola Ma.

Figs. 187, 188
Gate benches, *laohuali*, late eighteenth or early nineteenth century, northern style. These were usually placed in front of homes and used for seating on hot summer days. Photo courtesy Andy Hei.

Fig. 189
Opera bench, *yumu* (northern elm), late Qing, Shanxi province. Collection of Just Anthony.

Fig. 190
Bench for multiple seating, *yumu* (northern elm), eighteenth century, Shanxi province. Photo courtesy Altfield Gallery.

Fig. 191
Opera bench used by wealthy clients, *huaimu* (locust), eighteenth century, Shanxi province. Photo courtesy Cola Ma.

Fig. 185

Fig. 186

Fig. 187

Fig. 188

86 Chinese Furniture

Fig. 189

Fig. 190

Fig. 191

Stools and Benches 87

Tables and Desks

As chairs grew in height, so did tables. At first, they remained low to the ground, and men were forced to lean out of their seats to eat from them. By the eleventh century, however, the humble table had reached a more appropriate height, ranging from 31 to 35 inches (80 to 90 cm). The styles remained frozen for centuries. Once perfect proportions were achieved, carpenters did not take liberties with the form and the table remained a constant during dynastic times (Fig. 194).

The table was the anchor of most rooms in the Chinese home—the study in particular. Here, a large painting table was used as a desk and positioned in the center of the room. It was the dominant artifact, with cabinets filled with books and a day bed pushed along a wall for relaxation. The altar table was also the focus of the main hall. It was usually flanked by smaller side tables and a square table was often positioned in front of it.

The architecture of the Chinese table comes from two sources: ancient bronze offering tables or platform boxes, and the simplified post-and-rail structure found in traditional Chinese buildings.

The earliest tables and the simple *ta* or low couch have profiles that are similar to offering platforms dating back to the ancient Bronze Age culture known as the Shang dynasty (1766–1050 BC). Similar wooden platforms were discovered in excavations from the Spring and Autumn period (770–476 BC). The decorative arches found on these ancient offering tables were eventually mimicked by carpenters who made tables for dining during the Tang dynasty. As Tang tables evolved, and their dimensions stretched, these distinctive arches morphed into flanges and the horse hoof-shaped feet popularized during the Song Dynasty, which can still be found on surviving Ming tables.

Construction took a giant leap forward when carpenters began building furniture based on elements found in architecture (Fig. 195). The post-like legs of the classic painting table are stabilized by support braces and aprons which simulate architectural rails. Parallels can also be found in the rounded, recessed legs

Fig. 192 (opposite)
In this room in the Qing-dynasty Kang family manor in Gongyi, Henan province, a learned scholar would have tutored the family's sons. The boys would have practiced calligraphy on slates at the low table and learned to recite classic texts. The teacher's square table is made of bamboo.

Fig. 193 (above)
The stone-floored, lattice-windowed study of the celebrated and eccentric Ming-dynasty literary polymath Xu Wei (AD 1521–93), Shaoxing, Zhejiang province, complete with a large painting table and a yoke-back chair.

Fig. 194

Fig. 195

Fig. 194
Scene from a formal banquet in the Wanli drama *A Thousand Ounces of Gold*. The long, narrow tables and chairs are covered with fabric. Side chairs or yoke-back chairs without arms are used to sit on. Photo courtesy Grace Wu Bruce.

Fig. 195
Components of the two main types of table.

Fig. 196
Recessed-leg painting table, *yumu*, Qing dynasty, flanked by lamphanger chairs and with a small *kang* table in front. Collection of Christopher Noto.

that gently splay from a table top. They mimic old architectural pillars that join roof beams at a slight tilt. Ming builders used support brackets to stabilize roofs. Ming carpenters copied the technique when they added corner spandrels to reinforce tables.

Drawing on principles of Chinese construction, influential Wang Shixiang divides tables into two distinct categories: when the legs are inset or recessed into the table top, they are referred to as *an* tables. When the legs are flush to the corners, Wang refers to them as *zhuo* tables. He makes one further distinction: tables with waists, and tables without.

Another way of categorizing tables is to consider their function. Using this approach, there are a number of table types, including recessed-leg painting tables, side or wine tables, altar tables, square Eight Immortals tables, *kang* tables, incense stands, coffer tables and desks. However, even this approach can be misleading because different forms have multiple purposes. The best way to describe tables is to use a combination of function and form.

Recessed-leg Painting Tables

During the Song dynasty, this table was the mainstay of the homes of the élite. It is simple in design. The legs are set back from the edge of the table top and are slightly splayed to provide stability, a style that requires special joints. The apron is usually straight and a pair of stretchers extends across the legs to provide additional support.

Like most Chinese furniture, these tables were multipurpose: they served as domestic altar tables within homes or were employed as work tables. Large versions of these tables are often referred to as painting tables because they doubled as scholars' desks and were used for calligraphy, painting and writing. So prized were these studio fixtures that famous scholars and collectors sometimes engraved or painted colorful inscriptions on them. A table included in Wang Shixiang's *Classic Chinese Furniture* bears an inscription written by its last owner, Prince Pu Tong, in 1907, that lists the table's provenance dating back to roughly 1713 (Fig. 204).

The tops of some painting tables are constructed from a single plank of wood. The majority, however, feature a single floating panel. The floating panel was more popular because it was constructed so as to allow for shrinkage and expansion due to heat and humidity.

There are always adaptations found in the marketplace, including a double table with legs inserted in the middle for additional support (Fig. 201).

Fig. 196

Fig. 197

Fig. 198

Fig. 199

Fig. 197
Painting table, exceptionally wide with single top panel, *huanghuali* and striped ebony, seventeenth century. The detail shows a simple spandrel from the table. Photo courtesy Robert A. Piccus.

Fig. 198
Solid top painting table with single stretcher. Photo courtesy Christopher Cooke.

Fig. 199
Recessed-leg painting table with a solid top with unusual carving along the sides and details along the stretchers. Photo courtesy Oi Ling Chiang.

Fig. 200
Painting table with recessed legs and a single panel of *nanmu* burl, *huanghuali* and *nanmu*, seventeenth century. The slightly splayed legs have concave beading and are joined by double stretchers. The spandrels are carved as a stylized phoenix with crest. Photo courtesy Robert A. Piccus.

Fig. 200

Tables and Desks 91

Fig. 201

Fig. 202

Fig. 203

Fig. 204

Fig. 205

Fig. 206

Fig. 207

Fig. 201
Double table with inserted central legs, black lacquer over *yumu* (northern elm), eighteenth century, Shanxi province. Photo courtesy Altfield Gallery.

Fig. 202
Painting table with large bracket-like spandrels decorated with a *ruyi* pattern, *huanghuali*, late seventeenth to early eighteenth century, Jiangnan region. The openings between the legs are framed to simulate bamboo. Photo courtesy Peter Fung.

Fig. 203
Painting table with support braces and decorative spandrels, *yumu* (northern elm), nineteenth century, Shanxi province. Photo courtesy Altfield Gallery.

Fig. 204
Waisted side table with giant arm braces, *huanghuali*, seventeenth century. Collection of Philip Ng.

Fig. 205
Painting table with double stretchers and *ruyi*-shaped spandrels. Photo courtesy Christopher Cooke.

Fig. 206
Painting table with unusual decorative arches, lacquered *yumu* (northern elm), eighteenth century, Shanxi province. Photo courtesy Altfield Gallery.

Fig. 207
Painting table with double-coin design, *huaimu* (locust), ca. eighteenth century, Shanxi province. Photo courtesy John Ang.

Side or Wine Tables

A side table or wine table is usually a small recessed-leg table. This type of table was singled out from the "recessed leg" category by Beijing carpenters because it was frequently used for serving food or wine. Although there are side tables in which the legs are flush against the sides, these are less common. Many feature stone insets because they were easier to clean. The weight of the stone, however, meant that the legs had to be thicker and sturdier, or that double stretchers had to be inserted between the legs. Humpback stretchers were also common features as they gave additional support for this style of table. Collectors favor these tables because they are easily placed between two chairs and used to serve tea. There are occasional side tables that have a bottom shelf perhaps to hold cards or games (Fig. 210). Occasionally, one comes across side tables built with wood such as *wutong*, which is famous for its resonant qualities. In these instances, the table may have doubled as a stand for a musical instrument such as the seven-string instrument known as the qin or zither.

Fig. 208
Flush-sided corner leg side table with a serpentine stone top (see detail), *jichimu* (chicken wing), eighteenth century, Fujian province. Photo courtesy John Ang.

Fig. 209
Waisted side table, *zitan*, eighteenth century. Private collection. Photo courtesy MD Flacks.

Fig. 210
Side table with shelf, *huanghuali*, seventeenth century, Zhejiang. Photo courtesy Charles Wong.

Fig. 211
Waisted side table with humpback stretchers, with a single plank *huanghuali* top, seventeenth century, Jiangsu province. Collection of Philip Ng.

Fig. 212
Wine table, *nanmu* burl wood on top, early style late sixteenth century, Shanxi province. Collection of Andy Hei.

Fig. 213
Black lacquer wine table, late Ming dynasty, Shanxi province. This table has retained its original lacquer and paint design and has never been disassembled. Photo courtesy Andy Hei.

Fig. 208

Fig. 209

Fig. 210

Fig. 211

Fig. 212

Fig. 213

Tables and Desks

Fig. 214

Fig. 215

Fig. 216

Fig. 217

Fig. 214
Side table, *jichimu* (chicken wing) with *huaimu* (locust) inset in the Yuan-dynasty style, late Qing, Jiangsu province. Collection of Philip Ng.

Fig. 215
Wine table with recessed legs, *zitan* with *huaimu* (locust) central panel, eighteenth century. Photo courtesy Robert A. Piccus.

Fig. 216
Side table, *huanghuali*, seventeenth century, Jiangsu province. Collection of Philip Ng.

Fig. 217
Waisted side table with unusual curvilinear apron, *huanghuali*, seventeenth century, Jiangsu province. Collection of Philip Ng.

Fig. 218
Side table with two small drawers and molded legs, *baimu* (cypress), early nineteenth century. Collection of Philip Ng.

Fig. 219
Flush-sided waisted side table, *huanghuali*. Photo courtesy Charles Wong.

94 Chinese Furniture

Fig. 218

Fig. 219

Flush-sided Corner Leg Tables

The legs of this starkly simple table are set flush against the end of the table top, which is usually made from a solid piece of timber. Many of the tables found in this form are either used as side tables or altar tables. Although these tables look strong, they are actually less stable than a recessed-leg table. As a result, supporting arm braces or humpback stretchers are often constructed between the legs. While recessed-leg tables are clearly inspired by architectural designs, the prototype of the flush-sided corner leg table is the box-like platform of the Tang dynasty. The oldest form of these tables, common during the Ming dynasty, had straight stretchers lengthwise and double stretchers widthwise. By the late Ming dynasty, Curtis Evarts writes, the use of long stretchers had almost disappeared as a result of new joinery techniques.

Flush-sided corner leg tables are less stable than other forms of table but their simple style makes them extremely popular among today's collectors.

Fig. 220

Fig. 221

Fig. 220
Side table with high waist and three drawers, *huanghuali*, seventeenth century, Zhejiang. Photo courtesy Charles Wong.

Fig. 221
Close-up of a flush-sided corner table. Photo courtesy John Ang.

Fig. 222
Waistless side table with corner legs, also referred to as a flushed-leg table, with a single plank top, *huanghuali*, seventeenth century. Photo courtesy Robert A. Piccus.

Fig. 223
Flush-sided altar table, black lacquer, nineteenth century, Shanxi province. Photo courtesy Altfield Gallery.

Fig. 224
Painting table with solid plank top and everted edges, *huanghuali*. Photo courtesy Charles Wong

Fig. 225
Painting table with round corner legs with humpback stretchers and posts, *huanghuali*, seventeenth century, Zhejiang. Photo courtesy Charles Wong.

Fig. 222

Fig. 223

Fig. 224

Fig. 225

Tables and Desks 95

Fig. 226

Fig. 226
Waisted carved altar table with cabriole legs and elaborate carvings (see details), late Qing, Hubei province. Collection of Just Anthony.

Fig. 227
Altar table with waist and cabriole legs (see detail), wood unknown, ca. eighteenth century. Photo courtesy John Ang.

Fig. 228
Pair of high stands in a decorative style mid- to late Qing dynasty, *zitan*, early nineteenth century, Tianjin. The high waist is pierced with cloud designs and the aprons are carved with five bats flying about scrolling clouds to symbolize good luck. The floor stretchers have been replaced. Photo courtesy Peter Fung.

Waisted Corner Leg Tables

Scholar Wang Shixiang draws a distinction between two kinds of table: one with a waist and one without. The recessed waist created between the table top and the aprons provides more stability to the corner leg table. These tables are often used for serving tea. A formal style of the waisted corner leg table is known as an altar table and is only found in temples. These massive tables are placed before icons, and are equipped with long drawers for the storage of incense sticks (Fig. 227). It is thought they are derived from ritual sacrificial tables dating as far back as 722–481 BC.

Altar Tables or Tables with Everted Flanges

In the formal central hall of a traditional Chinese home, a long narrow table with everted flanges became the focal point. It was frequently positioned against the back wall of the main hall, in front of some hanging scrolls, and flanked by two chairs. During the late Qing dynasty, the formal placement of these tables was altered. The table remained pushed against the back wall, but a small square table and two side tables were normally placed in front of it.

In devout Confucian households, these tables were used as domestic altar tables for ancestor worship. Folk culture holds that when a person dies, part of the soul (the *hun*) resides in the ancestral tablets and has the power to bring either good fortune or disaster to descendants. Not surprisingly, those who practiced Confucianism placed these tables in the central part of a room, along with their spiritual icons and incense burners. The very rich would build a special shrine or temple to house their ancestral tablets and ritual accouterments.

Although these tables were used for worship, the term "altar table" is somewhat misleading because many of these flanged tables were also used as a display surface for heirlooms and trinkets. Smaller versions were also found in bedchambers where they were pulled alongside couch beds and used as side tables.

Fig. 227

Fig. 228

96 Chinese Furniture

The curved edges of this table are akin to the low ritual offering tables that date to the Zhou dynasty (ca. 1027–256 BC). Over time, the height of the curves varied dramatically. These tables are also recognizable by their carved aprons and spandrels. A popular motif that is repeated in the side panels of these tables is the lingzhi fungus of immortality. This distinctive spade-like shape can either be carved within an arched openwork frame or into a solid side panel. Cloud motifs in open relief on spandrels are also popular.

Fig. 229

Fig. 230

Fig. 231

Fig. 232

Fig. 229
Altar table or side table, *huanghuali*, seventeenth century, Anhui province. This solid plank top has everted ends and bracket-like aprons that extend through the legs and serve as supports. The spandrels are carved with scrolling grass and *ruyi* heads, as are the open carved side panels. Photo courtesy Peter Fung.

Fig. 230
Recessed-leg altar table with bottom stretchers and an unusually high upper stretcher placed near the spandrels. Collection of Andy Hei.

Fig. 231
Altar table with recessed legs, everted flanges and floor stretchers and solid plank top, *ruyi* decoration along the spandrels and latticed swastika side panels between the legs, *yumu* (northern elm), Qianlong period, Shanxi province. Photo courtesy John Ang.

Fig. 232
Altar table of speckled bamboo and *yumu* (northern elm) with box-like pedestals of bamboo, eighteenth century, Shanxi province. The lattice design is created by lashing together small pieces with caning. Photo courtesy Cola Ma.

Fig. 233
Altar table with everted ends and bracket-like spandrels, solid table top and open carved panel, *huanghuali*. Photo courtesy Charles Wong.

Fig. 234
Altar table with flush sides and everted flanges, *tielimu*, eighteenth century, Fujian province. Photo courtesy John Ang.

Fig. 233

Fig. 234

Tables and Desks

Square Tables

The square table is also multipurpose. It was often found at the center of social activity, placed in the middle of a main room where stools or benches could be pulled alongside so that families could share a meal or entertain friends. These tables also show up in boudoirs as dressing tables, or were used for gaming. Whereas Western diners usually prefer a formal rectangular eating table, square tables are favored by the Chinese because communication is easy around it, or as Sarah Handler says, "at the square Chinese table, eating is a shared social experience."

Vernacular square tables were depicted in the twelfth-century painting "Qingming Festival on the River," which illustrates a typical day along a busy riverbank, with workers and merchants dining in the restaurants and teahouses that line the busy waterway. This is the period when Chinese cuisine developed and, as a result, so did the accouterments. The custom of eating around one square table as opposed to small individual tables on

Fig. 235

Fig. 236

Fig. 235
Square Eight Immortals table with two small stools, *baimu* (cypress), eighteenth century, Shanxi province. This table is miniaturized but has not been altered. Photo courtesy Oi Ling Chiang.

Fig. 236
Summer–winter table, *yumu* (northern elm), late Qing dynasty, Shanxi province. This table could double as an eating table in the warmer months and become detached as a *kang* table in the colder months. Collection of Just Anthony.

Fig. 237
Pair of square tables with high humpback stretchers and horseshoe feet, *huanghuali*, seventeenth century, Suzhou. Photo courtesy Charles Wong.

Fig. 238
Square table simulated to look like bamboo, *yumu* (northern elm), eighteenth century, Shanxi province. Photo courtesy Oi Ling Chiang.

Fig. 239
Square table with openwork spandrels, *jichimu* (chicken wing), eighteenth century, Zhejiang or Suzhou province. Photo courtesy Charles Wong.

Fig. 240
Square table with openwork spandrels that resemble some of the early latticework found in architecture, Zhejiang or Suzhou province. Photo courtesy Charles Wong.

the floor became the norm. Tea drinking also became a common daily ritual, making tea tables necessary.

Early depictions of square tables show them with straight stretchers for support, but over time high humpback stretchers that allowed more room for people's legs evolved. According to Handler, the largest examples, sometimes referred to as "Eight Immortals" tables, could seat as many as eight people. However, most of them are smaller and comfortably seat four people.

Fig. 237

Fig. 238

Fig. 239

Fig. 240

Fig. 241

Fig. 241
Kang table with scrolled ends, *yumu* (northern elm), nineteenth century, Shanxi province. Photo courtesy Altfield Gallery.

Fig. 242
Folding *kang* table used for traveling, *huanghuali*, sixteenth century, Shanxi province. The legs are joined with double stretchers and hinged to fold under the table top. The carving on the aprons is of winged dragons and lotus blossoms. The cabriole legs end with lotus-shaped pads with small *ruyi* carvings. Photo courtesy Peter Fung.

Fig. 242

Kang Tables

During the cold winter months in northern China, domestic life was centered around the *kang*, a hollow brick platform that was heated in winter by hot air running through a flue system connected to a stove. Mats or carpets were thrown over elevated bricks so that people could comfortably recline, and a profusion of small low tables—known as *kang* tables—were made to accommodate leisurely life on the toasty platform. In a sense, the mat culture never really died in China, it was merely reinvented. The *kang* table was an innovative piece of furniture used to complement this age-old custom.

These low-level tables, which rarely reach higher than 12 inches (30 cm), are often low-waisted, with cabriole legs, and were common in northern China by the Qing dynasty. Miniature versions were even placed on couch beds and day beds for carrying out various activities.

This table is not mentioned in the *Lu Ban Jing* (Classic of Lu Ban) or in the literature of the early connoisseurs, according

Tables and Desks 99

Fig. 243

Fig. 244

Fig. 246

Fig. 245

Fig. 243
Kang table with strong claw cabriole legs, animal masks at the corners of the table and dragons with scrolling tendrils carved into the apron, *huanghuali*, seventeenth century. Photo courtesy Robert A. Piccus.

Fig. 244
Kang table with decorative stone panels and large cleft feet carved as cloud scrolls, *huaimu* (locust), ca. eighteenth century, Shanxi. Photo courtesy Cola Ma.

Fig. 245
Kang table with curvilinear apron and short cabriole legs, *zitan*, seventeenth century, North China. Photo courtesy Peter Fung.

Fig. 246
Scrolled-end stand or *kangji*, *hongmu* (blackwood), atop a contemporary Edra "flap" sofa. Private collection, Singapore.

to Clunas. Its absence in the literature may simply reflect its commonality. People reclining on a *kang* used the tables for eating and drinking, playing games, and even to paint calligraphy or read. Not surprisingly, many *kang* table tops have rims to stop water spillage.

The most common *kang* table is rectangular in shape. This is also the shape favored by collectors today because it can easily serve as a coffee table in a contemporary home. Shapes other than the rectangle exist. Square versions sometimes feature extendable or removable legs so that they can double as garden dining tables during the summer (Figs. 242, 262). This style of *kang* is once again indicative of how Chinese furniture was constructed for multiple uses. There is also a style of *kang* table known as a scroll table which was used as a study desk. These could also have doubled as lute tables for playing music (Figs. 252–254).

100 Chinese Furniture

Fig. 247
Kang table with black lacquered *yumu* (northern elm) top and bamboo decorative sides, nineteenth or twentieth century, Shanxi province. Photo courtesy Altfield Gallery.

Fig. 248
Kang table with drawers for storing cups of gaming sets and unusual horse hoof feet, *huanghuali*, eighteenth century, Shanxi province. Photo courtesy Andy Hei.

Fig. 249
Kang table, *huanghuali*, seventeenth century. Private collection. Photo courtesy MD Flacks.

Fig. 250
Elongated *kang* table in an early traditional style with everted ends and legs with sharply hooked flanges, persimmon, ca. eighteenth century, Shanxi province. The carving on the apron is a lotus. Photo courtesy Cola Ma.

Fig. 251
Folding *kang* table, *huanghuali*, seventeenth century. Collection of Lu Ming Shi. Photo courtesy Grace Wu Bruce.

Fig. 252
Kang table or possibly a lute table, *hetaomu* (walnut), nineteenth century, Shanxi province. Photo courtesy Cola Ma.

Fig. 253
Low scroll or *qin* table, *huanghuali*, seventeenth century, Beijing. The three solid boards are assembled with invisible dovetail joints. Photo courtesy Peter Fung.

Fig. 254
Scroll table for the study used on top of a *kang*, Shanxi province. The symbol carved into the side represents longevity. Photo courtesy Oi Ling Chiang.

Fig. 247

Fig. 248

Fig. 249

Fig. 250

Fig. 251

Fig. 252

Fig. 253

Fig. 254

Tables and Desks 101

Fig. 255

Fig. 256

Fig. 257

High Tea Tables, Incense Stands and Flower Stands

Incense has always played an important role in Chinese worship and life. It was not only used for devotional prayer, but also considered necessary to enhance creativity, be it for sexual seduction, poetry or playing the qin. For centuries the incense burner was simply propped up on small tables next to an image of the Buddha or other deities. Elevation and exhibition was the primary function of the classic incense stand. Low-lying incense stands changed with the times.

When people moved from sitting on the floor to using chairs and tables, it was necessary for the incense holder to be elongated so that the fragrant smoke could waft throughout the room. By the Yuan dynasty, the stands featured long, curved cabriole legs resting on a circular base stretcher (Fig. 257).

Because incense tables were often placed in the middle of the room rather than pushed against a wall, they have a more three-dimensional style, so they can be appreciated from every angle according to Sarah Handler. The history of these small tables is a classic tale of adaptive usage. The earliest stands from the Tang dynasty were square, but round incense stands were more common during the Qing dynasty and are more commonly found in collections today.

During the Ming dynasty, tall tea tables were popularized. These tables have high arching legs and a waisted top. They were often made as matching pairs and used for serving tea, whereas the smaller versions were still used as incense burning stands. By the late Qing dynasty, the tables were strategically placed in homes to serve as flower stands or to show off scholar stones and bronzes. They were sometimes placed outdoors.

102 Chinese Furniture

Fig. 255
Tall rectangular stand with humpback stretchers, possibly used for supporting an embroidery frame, *hongmu* (blackwood), eighteenth century. Photo courtesy Albert Chan.

Fig. 256
Pair of display stands with lower shelf. Collection of Christopher Noto.

Fig. 257
Round incense stand, *huanghuali*, seventeenth century. Collection of Dr S. Y. Yip. Photo courtesy Grace Wu Bruce.

Fig. 258
Tall rectangular stand, *huanghuali* and *huaimu* (locust), early seventeenth century. Collection of Lu Ming Shi. Photo courtesy Grace Wu Bruce.

Fig. 258 Fig. 259 Fig. 260

Pedestal Tables

Large pedestal tables with separate plank tops did not exist in Western collections prior to the 1980s. Western collectors initially confused the pedestals of these old tables, when separated from their plank tops, with candle and lantern stands. A pair of such stands was once incorrectly labeled in an exhibition at the Nelson-Atkins Museum of Art in Kansas City. Very few remain today because the pieces were easily separated and the stands were often mistaken for simple incense stands.

These long narrow tables often served as altar tables, but in later periods people often added secret drawers to hide keys and other valuables, according to dealer Albert Chan. Drawers developed along the pedestals. Smaller versions of these tables were sometimes referred to as medicine practitioner's tables as they were used in doctors' offices as well.

Fig. 261

Fig. 259
Incense or flower stand, *huanghuali*, eighteenth century. Private collection. Photo courtesy MD Flacks.

Fig. 260
Display stand, black lacquer, nineteenth century, Shanxi province. This is an adaptation of the incense stand or flower stand. Photo courtesy Altfield Gallery.

Fig. 261
Large pedestal table or trestle, *huanghuali* with original lacquer surface, seventeenth century. Private collection, Singapore.

Fig. 262
Pedestal table with drawers. This kind of table was also referred to as a medicine practitioner's table. Photo courtesy Christopher Cooke.

Fig. 262

Tables and Desks 103

Fig. 263

Fig. 264

Fig. 265

Coffer Tables

The table shown in Fig. 265 looks a bit like a Western dresser with its set of small top drawers and large bottom cabinets. It was frequently used as a family altar but might also have served as the family storage chest for such things as bulky winter clothing or robes for special events. Many coffer tables were built with hidden chambers to store jewelry and other valuables. These tables were often commissioned as part of a dowry and frequently bear inscriptions. In his book, Cola Ma features one such locust and poplar wood coffer that bears a lengthy inscription in a concealed storage space; it states that the table was purchased in the 24th year of the Kangxi period for ten *liang* of silver by Chang Yun. "As coffers were frequently presented as part of a dowry, it may be possible that the 'auspicious occasion' that brought the male family members together was a betrothal," writes author Curtis Evarts.

The most photographed table in the collection of the Victoria & Albert Museum's Far Eastern series is a carved red lacquer table that dates back to the Xuande reign of the Ming dynasty (AD 1426–35). Former curator Craig Clunas argues that it is a transitional piece of furniture which shows how the coffer evolved from a simple table into a table with drawers and a deep storage space at the bottom.

There is little written about coffer tables, and it has been suggested that the lack of description is due to the fact that they were used primarily by women and servants to store clothes and everyday utensils, and were not worthy of a scholar's attention (Fig. 268). In fact, some dealers refer to the less refined versions as kitchen cabinets.

It is also believed that coffers were used for family worship, which is why many have flanged tops. In addition to various large coffers used in family halls, there are smaller versions of the coffer than were used on the *kang* during the winter months (Figs. 263, 267).

104 Chinese Furniture

Fig. 266

Fig. 267

Fig. 263
Small coffer table or chest, Shanxi province. Photo courtesy Art of Chen.

Fig. 264
Altar coffer table, black lacquer over *yumu* (northern elm), eighteenth century. This is a classic style of northern furniture although this particular item was sourced in Hebei province. Photo courtesy Altfield Gallery.

Fig. 265
Altar coffer table or cabinet, *hetaomu* (walnut), late nineteenth century. The three top drawers and bottom cabinet were designed to hold household items or incense. The lack of carving and the wide side panels is indicative of Gansu province. Photo courtesy Altfield Gallery.

Fig. 266
Coffer table with provincial characteristics, *huaimu* (locust) and *baimu* (cypress), seventeenth century, Shanxi province. Its table-like form has drawers and a concealed storage compartment fitted between the legs. The drawer fronts are carved with mythical heavenly stallions. Other motifs include a water buffalo and floral motifs which possibly reflect motifs of northern nomads. Photo courtesy Cola Ma.

Fig. 267
Kang coffer table, *yumu* (northern elm), early nineteenth century, Shanxi province. Photo courtesy Altfield Gallery.

Fig. 268
Storage coffer, black lacquer, eighteenth century, Shanxi province. Photo courtesy Altfield Gallery.

Fig. 269
Coffer table with drawers in a simple style, *huanghuali*, seventeenth century, Zhejiang province. Photo courtesy Charles Wong.

Fig. 268

Fig. 269

Tables and Desks 105

Fig. 271

Fig. 270

Round Tables

There were very few round tables prior to the mid-Qing period, although half-moon tables which graced receiving halls could often be pushed together to form a single round one. These tables were usually found in gardens and served as a base for heavy ritual objects. The smaller round tables emerged in the early nineteenth century, and their proportions gradually grew larger. In gardens in Suzhou, a large round table sometimes served as a reception table where tea was served. An example of this can be seen in the Humble Administrator's Garden, a house and garden that have been preserved in Suzhou, where a round table with a decorative apron is nicely situated in the reception hall surrounded by round stools. An adaptation of this table is the pedestal table, in which the legs are replaced by a single supporting column in the middle.

Often round tables were actually two half-moon or "D-shaped" tables that were pushed together. It was not uncommon during the late Qing dynasty for the legs of these tables to be unusually shaped. One particular example has scrolled legs with feet like a curled-up lotus leaf. Round table versions such as the *hongmu* (blackwood) style in Figs. 274 and 275 were obviously influenced by Western design or intended for the export market.

106 Chinese Furniture

Fig. 270
D-shaped table with double aprons in the *ruyi* design apron on top—which is typical of the region—and open panel design below (see details), *hetaomu* (walnut), eighteenth century, Shanxi province. Collection of Hannah Chiang.

Fig. 271
Half-moon table with low stretchers and small decorative features. The detailing is rather archaic although the table is from the eighteenth century. The wood—possibly pear wood—is very dense and takes the carving well. This table was sourced from three different families in Shanxi province. Photo courtesy Oi Ling Chiang.

Fig. 272
Pair of half-moon tables. Photo courtesy Charles Wong.

Fig. 273
Half-moon table with unusual detail on the leg, black lacquer on *hetaomu* (walnut), eighteenth century, Southern Shanxi province. The cabriole leg ends in a scroll with a foliate leaf extending from the scroll (see detail). The leg is also propped on a wooden rest. Used in reception halls next to the side doors. Collection of Hannah Chiang.

Fig. 274
Hexagonal incense stand with an unusually high waist, the two-part apron decorated with carved cloud patterns and stylized scrolling tendrils, *huanghuali*, ca. seventeenth century. This highly carved Ming piece might have been commissioned by a merchant rather than a scholar. Photo courtesy Grace Wu Bruce.

Fig. 275
Round table with marble inset and legs that end in a curled *ruyi* design, *hongmu* (blackwood), Jiangsu province or Shanghai. This table is a cross-pollination between East and West. Collection of Philip Ng.

Fig. 272

Fig. 273

Fig. 274

Fig. 275

Tables and Desks 107

Qin Tables

Tables that were surfaced with gray-colored bricks were said to give the seven-string *qin* a pure tone. Although they may once have been common, the brick *qin* table is rare today, particularly those made with tomb bricks such as the one in Fig. 276, which is decorated with diagonal "elephant eye" lozenge patterns. In the olden days, people used brick, but the tables now on the market may have been recently reconstructed. Occasionally, these tables have a hollow section—either in the brick or between the wood—to add better resonance. Normally, a *qin* table is a little lower than a side table, and is not as deep. Frequently, it is in the shape of a scroll (see Fig. 252, page 101).

Gaming Tables

During the Tang dynasty, the game of *weiqi*, which is similar to the Japanese *go*, was popular among the upper classes. A lovely square *zitan* table with marquetry survived hundreds of years because it once belonged to the Japanese emperor Shomu (Fig. 277). Gaming became increasingly popular during the Ming period, and both square and rectangular tables were made to accommodate not only *weiqi* but "double sixes" and chess. Special tables were fitted with boards, but could also double as an eating table for those socializing. As Sarah Handler suggests, these tables were not unlike collapsible card tables that are still used today in the West.

Fig. 276

Fig. 276
Qin table in Ming-dynasty style with bottom foot stretcher, set with hollow tomb bricks to give a resonate sound (see detail), *yumu* (northern elm), possibly sixteenth century. Photo courtesy Oi Ling Chiang.

Fig. 277
Mahjong table, *nanmu* and *yumu* (northern elm), early twentieth century, Jiangnan region. Photo courtesy John Ang.

Fig. 278
Mahjong table, *hongmu* (blackwood) frame and top with burl wood inset, nineteenth century, Jiangsu province. Collection of Philip Ng.

Fig. 277

Fig. 278

108 Chinese Furniture

Tables with Drawers or Desks

The typical desk drawer did not become common until the late Qing dynasty and was obviously influenced by the West. The drawers were used for storing writing materials. There are many kinds of desks on the market, often sourced from Guangzhou and Ningbo where a great many were made, possibly for the export market or because they were influenced by foreigners. That said, even the Beijing imperial family had them. In the late nineteenth and early twentieth centuries, desks that were simple pedestal tables, with one drawer along the sides, were often referred to as Chinese medicine practitioner's desks, possibly because they were the perfect furniture for a surgeon who needed more desk space and fewer drawers than a businessman. Locks are sometimes in the shape of a bat with outstretched wings, emblematic of happiness and longevity.

Fig. 279

Fig. 280

Fig. 281

Fig. 282

Fig. 279
Writing desk, built like a pedestal table, often referred to as a doctor's desk, *hongmu* (blackwood) and *yumu* (northern elm), late nineteenth century or early twentieth century, Ningbo. Photo courtesy Altfield Gallery.

Fig. 280
Writing desk, obviously influenced by Western design but with Chinese features such as the bottom grille, *hetaomu* (walnut), Shanxi province. In Canton, this style of table, very popular in the nineteenth century, was known as a doctor's table. Photo courtesy Cola Ma.

Fig. 281
Writing desk, *baimu* (cypress), twentieth century, Zhejiang province. Collection of Hannah Chiang.

Fig. 282
Writing desk with two-toned wood, Shanghai. The bottom latticed stretcher is a Chinese adaptation of a Western form. Photo courtesy Art of Chen.

Tables and Desks 109

110 Chinese Furniture

Beds

The traditional Chinese bed or *chuang* cannot be defined solely by its nocturnal function. It was an all-purpose platform that served as a recliner, banquet table, lectern and meditation platform. It also symbolized the division of labor between the sexes. For men, it was a utilitarian piece of furniture used primarily to read and sleep. For women in wealthy households, however, it was everything. It was the most important part of a woman's dowry and remained in her possession during marriage and even after divorce.

During the Ming dynasty and into the Qing, patriarchy prevailed. Houses were divided into male and female quarters. Men, who occupied the front rooms of the house, had freedom to prowl throughout. Women were confined to the inner courtyards. Hampered by bound feet (during the Qing dynasty) and claustrophobic traditions, they were virtual prisoners of their chambers. The bed thus became the center of their world. When the curtains around the canopy bed were drawn, it became a potent symbol of sexual intimacy. But when the curtains were pulled back, the bedding rolled up and tables pulled alongside, the bed became a wife's private reception hall. Soft bolsters, cushions and *kang* tables added luxury and comfort and allowed women to idle away the hours by eating, playing games and embroidering.

If the horseshoe chair was the symbol of power for men, the canopy bed marked the social rank of wives within the home (Fig. 284). Status could literally be measured by the craftsmanship. The pampered wife demanded an ornate bed decorated with mother-of-pearl inlay or carved scenic panels. A marriage bed—or canopy bed—described in a passage from the eighteenth-century classic novel *Dream of the Red Mansion* was enshrouded by purple gauze curtains to create a romantic atmosphere. Because of its importance in procreation—most sexual encounters took place in the women's quarters—it was critical that beds be made with favorable dimensions and inscribed with symbolic carvings such as plum blossoms and bats to depict immortality, happiness, longevity and wealth. In contrast, there are few descriptions of male sleeping chambers. What we know is that the long, narrow platforms known as day beds were shuffled at whim from study to garden (Fig. 285). Larger versions with three sides—referred to as a couch bed or *luohan chaung*—were too heavy to move around

Fig. 284

Fig. 285

Fig. 286

Fig. 287

and usually remained within the confines of a study or bedchamber (Fig. 286).

The prototype of the bed is a 1000 BC Shaanxi bronze box-like platform (now in the Metropolitan Museum of Art in New York) that was originally used to give ritual vessels greater height, but later adapted to serve as a ceremonial platform. By the Han dynasty (206 BC–AD 220), low-lying platforms had legs and were called *ta*. Tang-dynasty craftsmen made similar looking platforms in wood. A rare example was excavated in the tomb of Cai Zhuang (r. 907–60) in Jiangsu province. These boxy, bench-like structures feature six scalloped leg columns joined together by a bottom stretcher. Over time, the number of legs on the low bed was reduced to four, and the bottom stretchers disappeared. By the Ming dynasty, beds were usually constructed with four solid legs that ended with a delicate upturned horse hoof foot—a vestige of the Tang leg columns. While most beds have horse hoof feet, some classical specimens have round legs (Fig. 287). These early beds

Fig. 283 (previous page)
Canopy bed, *jumu* (southern elm), ca. 1850, probably from Jiangsu province. Private collection, Singapore.

Fig. 284 (previous page)
Canopy bed, *yumu* (northern elm) and *changmu* (camphor), eighteenth century, Shanxi province. Photo courtesy John Ang.

Fig. 285
Day bed with rounded legs, *yumu* (northern elm), ca. eighteenth century, Shanxi province. Photo courtesy John Ang.

Fig. 286
Luohan chaung bed with solid railings, *jumu* (southern elm), eighteenth century. Photo courtesy Albert Chan.

Fig. 287
Day bed with built-in chest and round legs in an early style, *hetaomu* (walnut), Pingyao, Shanxi province. The carving on the apron is similar to carving styles found on old square tables. It was probably not a traveling bed because the chest, used for storage of money and documents, made it too heavy to carry. Photo courtesy Hannah Chiang.

112 Chinese Furniture

Fig. 288

Fig. 289

Fig. 290

Fig. 291

were entertainment platforms *par excellence*. Items such as musical instruments and writing utensils were found on the earliest beds which stretched some two meters.

The bed also holds an important place in Chinese furniture because it is the closest cousin to architectural forms. As Evarts postulates, "Beds are intermediate elements between the grand timber constructions that housed them and the smaller portable tables, chairs and cabinets placed inside."

Day Beds

To the Western eye, a day bed resembles an oversized bench. Although it is the most popular form of bed in China, it has no counterpart in the West. It is of Oriental original. Its progenitor was the low-lying *ta*. With subsequent generations, the *ta* grew higher, reaching 16 inches (41 cm) off the floor. With the exception of some archaic examples found in Shanxi province, the original low-lying day bed has all but disappeared from the Chinese furniture repertoire. Those that remain are relics of the past.

Among scholars there has been some confusion over the terminology of *luohan chuang* or couch bed. Did it have railings or not? How was it different from a day bed? According to scholar Tian Jiaqing, the couch bed was a piece of furniture to recline upon, whereas the original *ta* or day bed was smaller, shorter and usually used to sit on. However, by the Ming dynasty, the day bed had evolved. It was higher off the ground—reaching 20 inches (51 cm) as in one rare example from north-central China—and longer. The confusion arises over usage. The couch bed, when placed in a scholar's room, was used for sitting, much like the day bed. Day beds, unencumbered by rails or canopies, were relatively light and easy to move so were frequently carried outdoors for reading and reclining. Rather than a hard top, a woven rattan mat provided a little give to the person seated on it. Furnished with an armrest and mosquito netting, it was a perfect platform to play chess or enjoy the *qin*.

If there is one item among Chinese furniture that has been consistently cut down for contemporary use, it is the lowly day bed. Many have been converted into generous coffee tables for the Asian-style home.

Fig. 288
Day bed, *huanghuali*. Photo courtesy Charles Wong.

Fig. 289
Day bed, *hetaomu* (walnut) with bamboo slat top, seventeenth century. This bed is lower than usual. Photo courtesy Art of Chen.

Fig. 290
Day bed, mulberry wood with cane platform, eighteenth century, Suzhou. Photo courtesy Andy Hei.

Fig. 291
Day bed with wooden insert, Shanxi province. Photo courtesy Art of Chen.

Fig. 292

Fig. 293

Couch Beds

The day bed is a challenge for people who like to slouch. The couch bed, with its simple back and side rests, offers more back support than its simple cousin, and is better for entertaining. The railings served another purpose: they were useful for blocking drafts on cold winter days. History suggests this was probably the original intent of carpenters who added railings. During the Han dynasty, those who could afford big screens strategically placed them along the sides of their low sleeping platforms to provide some protection against chilly gusts. The next logical step was to add built-in railings.

In its earliest form, the couch bed had three sides of equal dimensions. By the Yuan dynasty, a new style had been introduced: the side railings of these day beds were slightly lower than the back panel. During the Ming dynasty, when

114 Chinese Furniture

Fig. 294

Fig. 295

the proportions of the couch bed were perfected, a slightly higher back became the standard. While many *huanghuali* side panels were made of solid wood, there are gorgeous examples featuring latticed railings with complex geometric patterns, as well as panels displaying intricate carvings. The beds themselves are often of woven cane. Couch beds from the southern regions had heavier proportions and were often inlaid with marble. These beds are now extremely popular among collectors who use them as couches in contemporary living rooms.

Fig. 296

Fig. 297

Fig. 298

Fig. 292
Couch bed, with open scroll fretwork on the top rail and scroll cabriole legs resting on balls, *yumu* (northern elm), late Qing period. The lacquer is original but the seat has been replaced. Collection of Christopher Noto.

Fig. 293
Recessed-leg couch bed with unusual lattice rails, *yumu* (northern elm), mid-Qing period. The patina is consistent throughout, but there is evidence of more than one restoration. Collection of Christopher Noto.

Fig. 294
Couch bed with panel railings and cabriole legs, *yumu* (northern elm) and black lacquer, eighteenth century, Shanxi province. This is an elegant traditional style with a slight humpback line to the back railing and a gentle sweep of the side rails. Photo courtesy Cola Ma.

Fig. 295
Couch bed, *huanghuali*. Collection of Philip Ng.

Fig. 296
Couch bed with low relief medallions carvied alongthe sides, Shanxi province. Photo courtesy Art of Chen.

Fig. 297
Couch bed with post railings and bottom stretchers. Photo courtesy Christopher Cooke.

Fig. 298
Couch bed with a double-coin design forming the railings, *yumu* (northern elm), eighteenth century, Hebei province. Collection of Hannah Chiang.

Beds 115

Fig. 299

Canopy and Alcove Beds

The first beds discovered in Henan and Hubei around 316 BC were collapsible and most likely had huge canopies. However, actual remains of a canopy frame were only found in tombs dating from the Warring States period, including the tomb of Liu Sheng who died in 113 BC.

Canopies are created when four to six posts extend above the bed frame and are joined by stretchers along the top to create a wooden frame from which gauze or brocade curtains are hung. At night, the hanging curtains created a cocoon of privacy—the ultimate love nest. By day, they were pulled back and tied with silken cords to hooks attached to the posts, creating a silken silhouette for repose.

Like couch beds, decorative panels on the canopy ranged from the simple to the ornate. The most desirable pattern among the early Western collectors was the geometric continuous *wanzi* style, such as on the Ming-style bed displayed in the Philadelphia Museum of Art. However, canopy beds often had more ornate

Fig. 300

Fig. 301

116 Chinese Furniture

Fig. 302

Fig. 299
Six-post canopy bed with geometric latticework and "fish-eye" inserts along the top, *jumu* (southern elm), late eighteenth century, Jiangsu province. Collection of Philip Ng.

Fig. 300
Six-post canopy bed with unusual recessed legs, Shanxi province. Photo courtesy Art of Chen.

Fig. 301
Four-post canopy bed, *yumu* (northern elm) and lacquer, seventeenth century, Shanxi province. This bed exhibits an early traditional style and retains much of its thick black lacquer coating. The top of the canopy is covered with two paneled frames put together. Decorative panels around the top are pierced with long *haitangshi*-shaped openings. Beaded *haitangshi*-shaped panels are repeated along the bottom waist. The C-curved legs and supporting post terminate in a scroll and rest on a round pad. Photo courtesy Cola Ma.

Fig. 302
Six-post canopy bed with a high waist and open-frame top, *huanghuali*, eighteenth century, north China. The pierced openwork carving includes *chi* dragons and *shou* and *fu* characters symbolizing longevity and wealth. The cabriole legs are carved with *sichituntou* animal masks and clawed feet. Photo courtesy Peter Fung.

Beds 117

Fig. 303

symbols carved into the panels: plum blossoms to symbolize beautiful women, dragons for male virility, and clouds and rain, a euphemism for sexual intercourse.

During the Ming dynasty, the wealthy took the canopy bed to the next level by extending the platform into an alcove to create a room within a room. These beds are known as *babuchuang*. Sometimes the bed and alcove both rested on a platform; at other times, the alcove box was free-standing, like the example here from Fujian province (Fig. 305). This red lacquer and gilded alcove bed belongs to a wealthy family from Fujian that managed to safeguard it during the Cultural Revolution by shipping it to Hong Kong and out of harm's way. A similar highly intricate style of bed, ornately carved and painted with red lacquer and gold leaf, is found in Singapore and Malaysia where it is referred to as a Straits Chinese bed.

118 Chinese Furniture

Fig. 303
Six-post canopy bed, red lacquer and gilt, late Qing dynasty, Zhejiang province. Collection of Just Anthony.

Fig. 304
Four-post canopy bed, *hongmu* (blackwood), early Republican period, possibly from Shanghai. Collection of Just Anthony.

Fig. 305
Front of platform bed with fine carving, *hongmu* (blackwood) and *huangyangmu* (boxwood), nineteenth century, Fujian province. This bed has been passed down through the generations and remains in the hands of the original family from Fujian province. Private collection.

Fig. 306
Six-post canopy bed with beaded openwork on the top panel in the form of stylized *lingzhi* fungus and rails with geometric designs, *huanghuali*, late sixteenth to early seventeenth century. Collection of Dr S. Y. Yip. Photo courtesy Grace Wu Bruce.

Fig. 304

Fig. 305

Fig. 306

Beds 119

Cabinets and Bookshelves

The architecture of traditional Chinese homes makes no allowances for built-in closets. As a result, clothes and bed linens were folded so that they could be stored flat in large cabinets. Similarly, paintings were rolled up for storage in cabinets. These cabinets were usually located in the women's quarters and in reception rooms where official robes were kept. Such cabinets remain eminently functional and are much admired—and sought after—for their elegant shapes and ornamentation. The best examples combine the natural beauty of the wood grain with the design and degree of ornamentation.

There are three main kinds of cabinet, their names derived from their contours: the square corner cabinet, the round corner cabinet (also known as the sloping-stile, wood-hinged cabinet), and the bookshelf or display cabinet. In practice, there are variations on this rule, including one unusually tall cabinet featuring a secret back door owned by Hong Kong dealer Hannah Chiang (Fig. 310). Romantics might conclude that this escape hatch was designed to facilitate illicit affairs, but Chiang, who purchased the piece in Hebei province, believes it was probably used to conceal a secret storage room or a safe built into a wall behind.

Prior to the nineteenth century, many cabinets had removable doors, enabling the cabinet to be readily disassembled. The hinge door is a variation on the mortise-and-tenon joint, and is a classic feature of Chinese furniture.

With this style of furniture, a key to quality was matching the wood grain pattern on pairs of adjoining door panels. Collectors also look for scalloped overhang edges and beading along the bottom apron. Original bronze lock plates, lock pins and lockets as well as metal handles add further value to cabinets.

Fig. 307 (opposite)
Small sloping-stile cabinet and side table decorating the Shanghai home of Curtis Evarts.

Fig. 308
Square-corner cabinet with a circular brass lock plate with two handles. Collection of Christopher Noto.

Fig. 309
Close-up of custom-made bookshelves incorporating old carved panels in the home of Cola Ma in the city of Tianjin.

Fig. 308

Fig. 309

Fig. 310
Open wardrobe with secret escape door, *yumu* (northern elm), nineteenth century, Hebei province. The secret door was used either as an escape route for a mistress who could slip through a back door, or as a cabinet to hide a security room. Photo courtesy Hannah Chiang.

Fig. 311
Square-corner cabinet of excellent workmanship, *zitan*, *huanghuali* and *nanmu*, eighteenth century, Beijing. The three small *taohuan* panels are carved in relief with dragons. Photo courtesy Peter Fung.

Fig. 310

Square-corner Cabinets

This rectangular-shaped storage cabinet derives its name from its boxy roof overhang. The imposing size of the cabinet is softened only by the slight splay of the legs and the decorative lock panels on the front. These cabinets almost always come in pairs and are either positioned at opposite ends of a room to create a sense of balance or along a wall, separated by a table. The primary function of a square-corner cabinet was to store clothes.

Many of these cabinets are lacquered and decorated with pictorial landscapes. The open flat surfaces of its doors proved an irresistible canvas for artisans. Although cabinets of the Beijing élite were black enameled with mother-of-pearl inlays, cabinets from the regions were more lavishly decorated. Both Shanxi and Fujian provincial cabinets featured red lacquer embellished with gold designs.

Another archaic-style cabinet was also discovered in Shanxi province. This cabinet features *taohuan* panels associated with the earliest styles of the Jin culture, which began in AD 265 after the Emperor Zhou Cheng Huan gave some of his land to a younger brother. The Jin culture is a term that now refers to the "unrestrained nomadic style" of the Shanxi region. The cabinets often have pronounced carving and cabriole legs. They also known simply as paneled cabinets and can be found in

Fig. 311

122 Chinese Furniture

Fig. 312

Fig. 313

Fig. 314

Fig. 312
Oversized square-corner cabinet with assembly marks inscribed on the top rail, *zitan* and *huanghuali*, early seventeenth century, North China. This cabinet was sourced in Wuwei, Gansu province, but it is unlikely that it was a local production and was probably brought to Wuwei by a high official or wealthy Muslim merchant. The cabinet has cabriole legs. The front apron and frame are decorated with carved relief of the various precious treasures linked by flowing ribbons and mythical lions. Photo courtesy Peter Fung.

Fig. 313
Square-corner cabinet with stand popular in southern Fujian and Jiangsu provinces, *huanghuali*. Photo courtesy Charles Wong.

Fig. 314
Pair of square-corner cabinets, *yumu* (northrn elm), nineteenth century, Shaanxi province. This pair is typical of the style of cabinets found in the northwest, in Shanxi, Gansu and Shaanxi provinces. Photo courtesy Altfield Gallery.

Cabinets and Bookshelves 123

Fig. 315

Fig. 316

Fig. 315
Paneled cabinet, once possibly covered with black lacquer, Shanxi province. Photo courtesy Art of Chen.

Fig. 316
Small square-corner cabinet, possibly used as a bedside table and adapted for Western use, Zhejiang province. Photo courtesy Art of Chen.

Fig. 317
Double cabinet, red and black lacquer with gilt painting. There has been some painting over this cabinet and the bottom apron has been replaced—a common repair in this type of furniture. Photo courtesy Altfield Gallery.

Fig. 318
Paneled cabinet, red lacquer, eighteenth century, Shanxi province. Photo courtesy Altfield Gallery.

Fig. 317

Fig. 318

Cabinets and Bookshelves 125

Fig. 319

Fig. 320

Fig. 319
Pair of storage coffers with very plain carving and cabriole feet, *hetaomu* (walnut), late nineteenth century, Gansu province. Photo courtesy Altfield Gallery.

Fig. 320
Compound cabinet, *changmu* (camphor), nineteenth century, Shanzi province. Photo courtesy John Ang.

Fig. 321
Cabinet, black and red lacquer, late Qing dynasty, Zhejiang province. Although this type of cabinet is often referred to by dealers as a food cabinet, it was obviously not used for food storage. According to Amanda Clark, it was most likely placed in areas where food was prepared to store crockery and utensils, much like Westerners use a sideboard today. Collection of Just Anthony.

Fig. 322
Rare cabinet, *huanghuali* and bamboo. Private collection. Photo courtesy MD Flacks.

Fig. 321

126 Chinese Furniture

Fig. 322

Cabinets and Bookshelves

both black and red lacquer. Other adaptations include a joined double cabinet from Shanxi province (Fig. 317). This black and red lacquered version has gilt painting. In the late Qing dynasty, around the port areas, a smaller form of square corner cabinet emerged that was perhaps used as a bedside table (Fig. 316). In addition, an elongated square cabinet—which looks like a cross between a square corner cabinet and a coffer table—might possibly have been used as a storage chest on a *kang*. It is otherwise simply known as a *kang* cupboard.

There is a version of the square-corner cabinet, referred to in the *Lu Ban Jing* (Classic of Lu Ban) as a medicine cabinet (*yaochu*), which is generally lower and wider than a standard cabinet (Figs. 323, 324). These cabinets have numerous pull-out drawers used to store herbs. Many functional cabinets such as these have been reconstructed in order to store CD players—a popular marketing strategy for contemporary furniture dealers.

The hardware used on cabinets is usually made of brass or metal alloy and mounted with tiny pins. Often neglected in the literature, these accessories are aesthetically important. The brass plates allow the eye to settle on the center of the cabinet rather than try to absorb its entire bulk. A bad restorer, who sloppily chooses hardware replacements, can wreck an elegant piece of furniture.

Fig. 323

Fig. 324

Fig. 323
Medicine cabinet, late Qing dynasty, Shanxi province. Collection of Just Anthony.

Fig. 324
Medicine cabinet, eighteenth or nineteenth century. Usually these cabinets are made of *huaimu* (locust) and *yangmu* (poplar) but this one is made of *huaimu* and *hetaomu* (walnut). This cabinet is from Shanxi province but the medicine cabinets in Hebei and Shangdong are similar in style. Collection of Cola Ma.

Fig. 325
Pair of display cabinets, *huanghuali*, late sixteenth to early seventeenth century. Photo courtesy Grace Wu Bruce.

Fig. 326
Compound cabinet with panels in one piece and original brass work, *huanghuali*, seventeenth century, possibly Shanxi province but used in Beijing. Photo courtesy Charles Wong.

Fig. 327
Compound cabinet, *changmu* (camphor), nineteenth century, Hebei province. Cabinets of *changmu* were used particularly in northern provinces for storing furs and other heavy articles of clothing. Photo courtesy Altfield Gallery.

128 Chinese Furniture

Compound Cabinets

When a smallish storage chest is stacked on top of a regular-sized cabinet, the combination is collectively referred to as a compound cabinet (Figs. 326, 327). There was a clear division of use between the two units. Hats or out-of-season clothes were stored in the upper half, and everyday garments and bedding were packed in the lower half. Some compound cabinets are so large that ladders were needed to reach the items stowed up high. Needless to say, this piece of furniture dominated a room.

Circular brass hinges and lock plates, often with pear-shaped handles, as in Fig. 327 (the pear symbolizes fortune and prosperity in Chinese), are a dominant feature of compound cabinets, providing an elegant contrast to the beauty and simplicity of the wood panels.

Fig. 325

Fig. 326

Fig. 327

Cabinets and Bookshelves 129

Sloping-stile Cabinets or Tapered Cabinets

This cabinet is the softer, kinder version of its square-cornered cousin. The construction is similar, but both sides and upper overhang are rounded, and the legs are slightly splayed, giving it a tapered A-frame silhouette. Larger cabinets are roughly 72 inches (183 cm) high, 33 inches (84 cm) wide and 26 inches (66 cm) deep.

Sloping-stile cabinets were made in a range of sizes. The larger pieces were often used for storing clothes, but the shorter ones served as bookcases or storage spaces for scrolls and scholarly items. Since dynastic robes were folded and stacked horizontally rather than vertically on hangers, removable stiles were created to allow owners to neatly pile the items in the cabinets. This functional innovation was intended to reduce the labor required to manage fussy garments. Besides these removable stiles, the genius in its design lies in the way the doors neatly swivel on rounded wooden pegs. Because scholar's studios did not have desks with big drawers for storage, the drawers within the inside shelf were loosely fitted, thus enabling the owner to easily pull them out and take them to his desk to work.

Many collectors consider this cabinet to be one of the most beautiful forms of Chinese furniture. Its simple A-frame line underscores just how craftsmen were able to inject dynamism and movement into a static object. The base is made wider by the slight splay of the legs, creating the impression of upward movement. Academic and dealer John Ang compares it to the growth of a flower whose stem emerges from its wide root base and shoots up before unfolding its tiny bud.

Occasionally, collectors have discovered tapered cabinets with latticed door panels, but for the most part these cabinets are free of decoration. Even the apron is usually straight and the metal hardware on the front is usually long and narrow. The beauty is inherent in the shape and proportions.

The tapered cabinet with a stand was popular in southern Fujian and Jiangsu provinces and differs from the

Fig. 328

Fig. 328
Sloping-stile wood-hinged cabinet, *huanghuali*, seventeenth century. The four main stiles are recessed from the top and slope gently into an almost imperceptible splay. The wood grain on the two doors matches. Collection of Lu Ming Shi. Photo courtesy Grace Wu Bruce.

Fig. 329
Pair of small sloping-stile cabinets, *huanghuali*. Photo courtesy Charles Wong.

Fig. 330
Sloping-stile wood-hinged cabinet. One factor that distinguishes a great cabinet from a merely good one is whether or not the carpenter was able to match the wood grain pattern on the doors. The doors in this cabinet are almost mirror images, a sign of a master craftsman able to access wood. Photo courtesy Christopher Cooke.

Fig. 331
Sloping-stile cabinet with vertical bamboo slats on doors, *songmu* (pine), late nineteenth or early twentieth century, Anhui province. This vernacular piece was intended for kitchen use. Photo courtesy Altfield Gallery.

Fig. 329

Fig. 330

Fig. 331

Cabinets and Bookshelves 131

standard Ming-style tapered cabinet in its proportions, the woods used, the decoration and the joinery, according to John Ang. The depth of these cabinets is also narrower than usual. While many are made of *jumu* (southern elm), Ang discovered many higher quality specimens in *jichimu* (chicken-wing wood). Another notable feature among the southern Fujian cabinets is the removable latticework which served as a low shelf, perhaps for storing shoes or boxes (Fig. 335). There are also versions known as kitchen cabinets, used for storing dishes. One shown here was sourced in Anhui province and is made of *songmu* (pine) with bamboo slats (Fig. 331).

Fig. 332

Fig. 333

132 Chinese Furniture

Fig. 334
Two-piece sloping-stile cabinet with lower drawers, *huanghuali*, seventeenth century, Nantong city, Jiangsu province. Collection of Philip Ng.

Fig. 335
Two-piece sloping-stile cabinet with stand, southern Fujian province. Photo courtesy Christopher Cooke.

Fig. 334

Fig. 332
Sloping-stile cabinet with a circular lock plate (see detail), *yumu* (northern elm), late Qing dynasty, Shanxi province. Collection of Just Anthony.

Fig. 333
Sloping-stile cabinet with rounded corners, *yumu* (northern elm), eighteenth century, Shandong province. The upper doors and sides are decorated with round openings. Cloud-head spandrels are present under the storage compartment at the lower level. Photo courtesy Art of Chen.

Fig. 335

Cabinets and Bookshelves 133

Bookshelves

Open bookshelves fall into the cabinet category and were considered an important item in a scholar's library. As the printing press developed, books became an increasingly essential element of a scholar's room. By the late Ming, they were a status symbol, demanding display. Books were stacked on top of one another with the covers facing up rather than horizontally with the spine facing outwards. As a result, these bookshelves are deeper than their Western counterparts.

Fig. 336

Fig. 337

Fig. 336
Display cabinet with *wanzi* pattern fretwork suggesting infinity or immortality, *huanghuali*. Photo courtesy Grace Wu Bruce.

Fig. 337
Display cabinet, possibly designed for storing leather chests, eighteenth century, Hebei province. Collection of Hannah Chiang.

Fig. 338
Display cabinet with vertical rods on front and sides, most likely used to store books, burgundy lacquered *baimu* (cypress), nineteenth century, sourced in Donggunan, Jiangsu province. A double-coin pattern (symbolizing doubled happiness) is prominent in the latticework. Photo courtesy John Ang.

Fig. 339
Small display cabinet with vertical rods on front, back and sides, possibly used for storing and carrying books, seventeenth century, Zhejiang province. Photo courtesy Charles Wong.

Fig. 340
Book case with three shelves and a built-in drawer, softwood. Photo courtesy Christopher Cooke.

Fig. 341
Broad book case with three shelves and a raised humpback railing above each shelf, *huanghuali*, seventeenth century. Photo courtesy Robert A. Piccus.

Fig. 342
Tall vertical bookcase with four shelves, Shanxi province. Photo courtesy Art of Chen.

134 Chinese Furniture

Fig. 338

Fig. 339

Fig. 340

Fig. 341

Fig. 342

Cabinets and Bookshelves 135

Fig. 343
Display cabinet or bookshelf, softwood, Jiangsu province. Photo courtesy Altfield Gallery.

Fig. 344
Display cabinet, *huanghuali*, seventeenth century. The cracked ice pattern of the display section emulates window designs in Ming architecture. Collection of Lu Ming Shi. Photo courtesy Grace Wu Bruce.

Fig. 344

Display Cabinets

This cross between a cabinet and a bookshelf was popular during the Qing period. It is the perfect multipurpose item of furniture—used to simultaneously store and display items. Some cabinets have an open upper shelf with decorative molding or railings to display antiques or plants and a larger cabinet below to store books. Wealthy collectors might commission a cabinet that has numerous individual compartments made to specific shapes and sizes in order to frame their favorite porcelains, bronzes or jades. The most innovative are those that are asymmetrical.

Fig. 343

Fig. 345
Pair of display cabinets, *yumu*, eighteenth century, Suzhou. Photo courtesy Charles Wong.

Fig. 346
Display cabinet, red lacquer, late Qing dynasty, Jiangxi province. Collection of Just Anthony.

Fig. 347
Display cabinet with side latticework, Hebei province. Collection of Hannah Chiang.

Fig. 348
Pair of matching display cabinets. Photo courtesy Charles Wong.

Fig. 345

Fig. 346

Fig. 347

Fig. 348

Cabinets and Bookshelves 137

Fig. 349

Lacquer Furniture

Made from the sap of a tree, lacquer is an ancient sealant and wood protector. Not only is it a water and insect repellent but its decorative properties were promoted by the Chinese. Painted across wood surfaces, it ensured uniform color and texture, which, in turn, made an ideal canvas for artists to exhibit their talents.

Lacquer use in China dates back to the fifth century BC, and in all probability was invented in the region. During the pre-dynastic era, lacquer was applied to wooden ceremonial utensils because it created durable sealed surfaces. It eventually came to be used in most furniture production. Until the seventeenth century, traditional Chinese furniture and lacquerware were virtually synonymous. Initially, basic black ruled, not only because it provided an ideal backdrop for inlay, but because red lacquer was initially restricted to imperial use. Color was eventually democratized and provincial carpenters in provinces such as Zhejiang, Fujian and Shanxi developed their own lacquer style. Large red cabinets were part of their repertoire.

Although the color range of lacquer is limited, techniques are not. There are at least fourteen different approaches to applying lacquer in furniture production. Some techniques were simply intended to enhance the grain pattern of wood or to disguise the fact that different varieties were used to construct a single piece of furniture. Lacquer could hide clashing grain patterns, a sign of shoddy workmanship. There were also utilitarian applications: lacquer was often coated along the underside of furniture to prevent warping from humidity. However, lacquered furniture is primarily collected not for its protective properties but its artistic merit. If applied in enough layers, lacquer can be carved. Other artists simply painted on the substrate. One special technique, called *miaojin*, involves tracing figures in gold, then coloring in the details with lacquer paints.

Not much is known about lacquer manufacturing. Did a group of furniture makers specialize in the technique or was furniture pre-made and then sent to lacquer artisans in other shops? Academics lean towards the latter view. At the imperial level, there were most likely two groups of artisans—those that built the furniture and another that applied the lacquer. In the regions, however, furniture makers would have had to learn lacquer techniques.

Just how popular was lacquer furniture? Most early collectors of Chinese furniture in the West rejected lacquer furniture in favor of unadorned hardwoods such as *huanghuali* and *zitan*. They believe that sophisticated scholars during the Ming dynasty shunned it as well. They may have been misguided. Old documents, including an inventory of confiscated furniture owned by the corrupt sixteenth-century official Yan Song, suggest that lacquered pieces were not only commonly used among the wealthy, but were also more expensive than hardwood. The value of one of the official's repossessed *huali* wood beds was listed as only one-fifteenth of the cost of his best lacquer bed.

If lacquer was so common, then why is there so little of it on the market today? The answer is simple. Although lacquer forms a natural polymer that makes wood less susceptible to water damage and fluctuations in humidity, few classical pieces survived because most lacquer ware was constructed from softwoods which did not hold up over time.

Lacquered export furniture has survived, however, and is now back in fashion. During the 1800s, a form of Chinese lacquer export furniture was popularized in the drawing rooms of France. The most extravagant black lacquer with mother-of-pearl inlay was so favored that the entire interior design movement at the time was called, fittingly, "chinoiserie." A new genre was born. Lacquered furniture, hand-painted wallpaper and decorative screens were all part of the look.

The style made a comeback in the early 1920s after collector Odilon Roche wrote his book *Les meubles de la Chine*. Ironically, collectors of Chinese furniture exported to France are now mainland Chinese who attend estate sales and small auction houses in France, and boost prices. Chinoiserie is clearly coming full circle.

In regions such as Shanxi, Fujian and Zhejiang, a popular piece of furniture is the red lacquer cabinet that features an upper overhang. The difference is that the legs do not splay and the doors do not have removable stiles. Instead, they have hinges on the sides. Many are constructed with two interior shelves, but there are some lower storage cabinets as well. There are regional variations, including cabinets with hidden compartments at the base. The outside panels that shield the secret spaces known as *men chung* cannot be opened from the outside. There are also massive black lacquer cabinets with numerous panels across the door panels that resemble terracotta models of cabinets dug up in old tombs. These also originate from Shanxi province.

138 Chinese Furniture

Fig. 349
Cabinet, black lacquer on *yumu* (northern elm), with dragon carvings along the leg spandrels (see detail), early eighteenth century. Judging by the lacquer application, it was made in Shanxi province. Photo courtesy Andy Hei.

Fig. 350
Component parts of the black lacquered tapered cabinet in Fig. 351. Note the use of coarse textile under the lacquer, a sign that the cabinet possibly dates back to the Ming dynasty. Note also the original hardware. Photos courtesy Oi Ling Chiang.

Fig. 351
Tapered cabinet with rounded corners and original hardware, black lacquer, seventeenth century. Photo courtesy Oi Ling Chiang.

Fig. 352
Detail of red lacquered butterflies over a black lacquer base, from a cabinet sourced in Shanxi province.

Fig. 353
Square-corner cabinet, red lacquer with gilt decoration of a hunting scene (see detail), a highly unusual narrative, late nineteenth century, Shanxi province. Photo courtesy Altfield Gallery.

Fig. 350

Fig. 351

Fig. 352

Fig. 353

Cabinets and Bookshelves

Doors and Screens

When it comes to architecture, East and West have espoused entirely different philosophies. The Chinese built in wood, the West often in stone. As a result, their relationship to nature, light and space was very different. Whereas doors and windows in the West were small and unadorned, the Chinese perspective, as underscored by early scholars such as Laozi and Zhangzi, was that "man is an integral part of nature." As such, doors and windows were seen almost as picture frames to enhance the visual prospect from inside the home. Not surprisingly, they were much larger and more intricate than their Western cousins. Even a spectacular Chinese temple is usually lined with doors with lattice windows. This philosophy was ingrained in classical architecture.

Classical Chinese architects and carpenters were also extremely pragmatic. Doors were made to keep intruders out, while windows, which in ancient times were known as *cong* or chimneys, were intended for ventilation and illumination. As partitions, they were used to divide and conquer rooms, but as society developed they also served a decorative purpose. Not only did screens protect people from prying eyes and cold drafts, they added a touch of elegance to drafty spaces. They were function and beauty combined (Fig. 356).

While the history of windows dates back to the Han dynasty, the concept of installing vertical rods did not occur until the Jin period, according to author Ma Weidu. They remained rather primitive until the Tang dynasty. By the Song dynasty, it was clear that ornamentation and latticework were now an integral part of such furnishings. There were originally only two types of doors: the single waist-bar and the double waist-bar. These waist-bars were rectangular pieces of wood inset in the mid-line of the door frame. Their purpose was to divide the upper half of the door, which was usually latticed, from the heavy plank portion of the lower part. A third type of door, dubbed a "soft door," later came into existence. The lattice panels of these doors were set into grooves along the waist-bar.

The doors and windows now available in the market are sourced either from official buildings or residences. The goal of the lattice panel was to reflect and refract light to make a play between light and shadow. Its beauty is so distinct that even ripped out of scavenged buildings, it holds value. Doors and other architectural elements are technically banned for export, but many have been smuggled across the border into Macau and Hong Kong and sold as room dividers or rebuilt as coffee tables.

Their beauty and diversity make them a worthy topic of study. Generally, doors that face the street have high waist-bars. This means a greater portion of the door is made from solid planks and can provide better security. Doors built for inner courtyards feature a greater percentage of latticework.

Ma Weidu has identified four different styles of lattice assembly. The first, which is used to make geometric designs such as the honeycomb or star pattern,

Fig. 355

Fig. 354 (opposite)
Close-up of the lattice doors under the narrow eaves of a side hall in the inner courtyard of a renovated courtyard house in Beijing. Latticework provides variable amounts of light, air and privacy.

Fig. 355
Detail of a large door with metal bolts, thick enough to ward off attacks, Shanxi province. Collection of Cola Ma.

Fig. 356
Anhui door screen in Kai-Yin Lo's home.

involves small pieces of wood carved into an integrated design. The mortise and tenons join at the end of the pieces of wood. The second approach to construction, which is used for the "cracked ice" pattern, involves carving out a mortise in the middle of a piece of wood and inserting the tenon. The third approach is less labor intensive and involves joining strips of wood vertically and horizontally in even, squared patterns. Rather than using a mortise-and-tenon joint, the strips are inserted into notches. The final technique is to carve a pattern from a whole piece of wood. This permits more intricate botanical motifs or narrative scenes. The disadvantage of this technique is that the wood has more tension points and is susceptible to splitting.

Lattice assembly is an important part of the door design, but many doors also feature carving either along the lower panel or the waist-bars. Ma Weidu identifies six types of carving:

- Relief carving, in which the wood is chiseled away to project the pattern.
- Openwork or pierced carving, in which the background is entirely dug out and only the pattern remains; this takes relief carving a step further (Fig. 359).
- Rounded or three-dimensional carving (Fig. 358).
- Inlay carving, created by engraving a pattern into the wood and filling it with different materials—lighter colored woods, ivory and stone—to produce a contrast in color.
- Pasting carving—the opposite of inlay—in which a design is simply glued on to a flat surface.
- Line carving, either simple engraving or round carving to create three-dimensional works.

Obviously, the richer the owner, the more decorative the door.

Doors also vary greatly from region to region. Those originating from Jiangsu, Zhejiang or Fujian were more intricate than the doors from the colder North, and tend to feature narrative scenes from vernacular novels or immortals. In conservative regions such as Shanxi, geometric

Doors and Screens 143

Fig. 357

Fig. 358

Fig. 359

Fig. 357
Close-up of a carved relief panel with a scrolling floral motif. Photo courtesy Peter Fung.

Fig. 358
Close-up of a carved screen panel, the interior medallion featuring a sacred vase, one of the "Eight Treasures" of Buddhist legend symbolizing good fortune and wisdom.

Fig. 359
Close-up of pierced floral motifs in one of the *taohuan* panels in the screen in Fig. 360.

Fig. 360
Standing screen, *zitan*, eighteenth century, Beijing/Tianjin. The 4 1/2 foot (135 cm) high screen may have been made at the Qing imperial workshops. Such screens traditionally held paintings, decorative stones and, occasionally, a mirror. The frame is removable and features carved relief motifs with clouds and scrolling lotus. The *taohuan* panels are pierced with floral motifs and four-clawed dragons. The foot of the screen features a sculpted lion. Photo courtesy Peter Fung.

latticework, such as squared or honeycomb patterns, is popular. It is uncommon for furniture carved in the north to feature folklore characters, but floral motifs do show up. In provinces like Anhui, a distinctive recurring lattice is the rounded brace pattern (Fig. 363).

As long as there have been drafty rooms, standing screens have existed. The single-panel screen was created out of necessity, but evolved into a ceremonial nicety. During the Zhou period (1050–256 BC), thin silk screens were placed behind the emperor when he held audiences. The purpose was to serve as a partition to divide a large room. A smaller painted lacquer screen dug out from a Warring States tomb (475 BC–AD 221), excavated in Hubei province, features an elaborate design of intertwining animals, and another example was unearthed from the tomb of the Marquis of Dai (168 BC) (Fig. 362).

When China was a mat culture, small screens were placed on tables and floors to reduce drafts, but as people moved off the floor and on to chairs, screen sizes grew to accommodate the changing lifestyle. Not surprisingly, its list of functions grew.

During the Tang dynasty, screens were ideal mounts for artists to display their works. Many scholars painted on silk or paper and stretched their creations across a screen frame. It was not uncommon for art patrons to commission screens from their favorite artists such as Cao Ba or later masters like Guo Xi from the Song dynasty.

In Chinese fiction, the screen was a focal point of intrigue and sexual tension. Naughty servants and mischief-makers stationed themselves behind screens to eavesdrop. They also served as a wooden veil to segregate men from women in strict Confucian homes or to literally fold around a bed at night to give couples privacy during lovemaking. As room dividers, they were carefully placed to instill harmony as decreed by traditional *fengshui*.

The Chinese screen dates back to the Warring States, but it was not until the 1700s that Europeans discovered the joy of room dividers. Obsessed with chinoiserie, the French imported large lacquered folding screens with painted or inlaid landscapes of gardens and imperial scenes. The European appetite was homogeneous, with one style fitting all, but the Chinese experimented with all shapes and sizes.

The oldest and most conservative style is the single-panel screen that usually consists of a single marble or stone panel mounted on a wooden stand, and sits as high as 7 feet (210 cm) (Fig. 360). Some single-panel screens were built to sit on a bed or table, ostensibly for decoration (Fig. 361). Larger versions, built with a detachable wooden stand known as a *chapingfeng*, were generally placed inside major entrances to important buildings to lend privacy and to block bad spirits. This style of screen was occasionally used as a backdrop to thrones or officials' chairs (Fig. 366). They conferred status and often served as an important fixture in reception halls.

A central marble slab, with natural striations resembling a landscape painting, was always a popular choice for screens. Smaller versions of these single-panel screens, with fixed bases, were placed on beds or tables as protection against drafts. These shrunken screens, which reached

Fig. 360

Fig. 361

Fig. 362

Fig. 363

Fig. 364

about 18 inches (47 cm) high, were referred to as "pillow screens" (*zuoping*), or "inkstone screens" (*yanping*) because they kept the ink from drying. A third kind of single-panel screen, which is mounted on the wall, is known as a *guaping*.

The elaborately pierced carved folded panel screens or *weiping*, which were a favorite concealment device, come in panels of six, eight, twelve or twenty-four (Fig. 367). They evolved around the Northern Wei period when people sought privacy in their bedchambers. The early screens, dating back to the ninth century, were low and often decorated with paintings in silk and paper. These ink brush works were mounted over latticework and mounted into frames. Screens painted by masters fetched high prices and were considered a status symbol.

The famous wall paintings at the Dunhuang tombs depict such works. Silk screens commissioned by famous artists petered out by the Yuan dynasty, and at this time the proportions of these folding screens grew to 10 feet (305 cm).

The classic novel *Dream of the Red Mansion* makes reference to a 24-panel folding screen. Such screens rarely make it to the market. One fine example, made of *zitan* and soapstone inlay, was sold for nearly $3 million at Christie's auction in 2003 (Fig. 365).

146 Chinese Furniture

Fig. 365

Fig. 361
Table screen, *huanghuali* with green stone inset, seventeenth century. This screen stands 35 inches (90.5 cm) high and probably dominated any large table it sat on. Collection of Lu Ming Shi. Photo courtesy Grace Wu Bruce.

Fig. 362
Table screen, *hongmu* (blackwood) stand with Dali marble inset. The pattern looks like Buddha going up the mountain. Collection of Philip Ng.

Fig. 363
Set of four fretwork panels, nineteenth century, typical of the design from Anhui province. Photo courtesy Altfield Gallery.

Fig. 364
Classic cracked ice window panel, *songmu* (pine), nineteenth century, Zhejiang province. This geometric design is found in most provinces. Photo courtesy Altfield Gallery.

Fig. 365
Imperial twelve-panel screen or *weiping*, *zitan* inlaid with soapstone, Kangxi period (AD 1662–1722). This magnificent screen sold for HK$23,583,750 (US$3,065,887) in *The Imperial Sale* at Christie's Hong Kong on July 7th, 2003. Photo courtesy Christie's Hong Kong.

Fig. 366
Table screen with mirror, *zitan* veneer, *hongmu* (blackwood) and glass, nineteenth century, North China. Standing 16 inches (41.5 cm) high, the screen features a black lacquer panel with gold-painted decoration depicting bats, crab apples and peaches— a wish for riches, officialdom and longevity. The opposite side of the screen is designed to hold a mirror. The fact that the mirror only has *zitan* veneer—and is actually made of *hongmu*—shows just how rare this wood had become by the nineteenth century. Photo courtesy Peter Fung.

Fig. 366

Doors and Screens

148 Chinese Furniture

Fig. 367
Eight-panel interior screen, *huanghuali* and semi-precious stone inlay and pierced panels featuring *chi* dragons among curling clouds, eighteenth century, North China. Medallions in various panels are carved in relief on one side with a "hundred antiques motifs" associated with sacrificial rights, literature and learning. There are also colored floral motifs composed of inlays of carved soapstone and ivory. While large twelve-panel screens were common in the Qing dynasty, smaller six- and eight-panel screens were mostly found during the Ming period. Photo courtesy Peter Fung.

Doors and Screens

Household Accessories

When it comes to furniture, collectors have always focused on the larger items: the cabinets, chairs and tables. However, there are many wonderfully crafted smaller items that were used in the home and merit a mention in any book about furniture. Not everyone could afford the creature comforts provided by household accessories—light, heat, decoration and amusement. Yet a studio with the finest painting table was not complete without an arrangement of an ancient ink stone, a brush pot holder, a brazier, a cosmetics box and a lantern for reading.

Candlestick Stands and Lanterns

Light is essential, and lamps carrying tallow tree wax candles and vegetable oil were commonplace in China. The earliest surviving candlesticks and candelabras were made of bronze and date back to the Eastern Zhou period. They were dramatically decorated with zoomorphic figurines that terminated with a scooped-out pan to hold burning oils. Eventually, boxy wooden

Fig. 368 (left)
Utilitarian objects feature in this bedroom in the Shen family home, Luzhi, Jiangsu province.

Fig. 369 (above right)
Materials for calligraphic writing on a long hardwood table in the studio-home of Xu Wei, Shaoxing, Zhejiang province.

Fig. 370 (right)
Once a functional item in a scholar's studio, these brush pots serve as decorative items in the home of Kai-Yin Lo.

Fig. 371
Pair of lamp stands, *huanghuali*, ca. seventeenth century. The stands are decorated with dragon spandrels at the lamp base and elaborately carved clouds or scrolling tendrils at the base panels and feet. The central post is extendable and secured in place by metal sliding bolts. Photo courtesy Grace Wu Bruce.

Fig. 372
Pair of candle stands, *hetaomu* (walnut), nineteenth century, Shanxi province. Collection of Cola Ma.

Fig. 373
Pair of lamp stands with original finish, *yumu* (northern elm), Shanxi province. Photo courtesy Oi Ling Chiang.

Fig. 374
Pair of candle stands, burgundy lacquer, wood unknown, nineteenth century, Fujian province. Photo courtesy John Ang.

Fig. 375 (opposite)
A chair and candle stand are placed against a perforated lattice wall in the Feng family residence, Langzhong, Sichuan.

Fig. 371

Fig. 372

Fig. 373

Fig. 374

152 Chinese Furniture

Household Accessories 153

Fig. 376

Fig. 377

Fig. 378

Fig. 376
Pair of table lanterns, *yangmu* (poplar) and *changmu* (camphor), nineteenth century, Shanxi province. Collection of Cola Ma.

Fig. 377
Red lantern with new paper, *qiu* wood, nineteenth century, Shanxi province. Collection of Cola Ma.

Fig. 378
Candle stand, burgundy lacquer, wood unknown, ca. nineteenth century, Fujian Province. Photo courtesy John Ang.

lanterns were created that could project candlelight across a room. Not only did lamps have to meet certain aesthetic demands, they also had to satisfy spiritual needs and safety concerns. Lanterns were often lit to last all night or to sit in front of ancestral tables as an offering to the dead. A dangerous or burned-out flame could lead to disaster or bad luck. There is even a lantern festival, the climax of New Year's celebrations, where beautifully decorated lanterns were competitively displayed.

Tall free-standing lamps, generally in pairs, became popular in the late Ming and early Qing dynasties to flank tables or chairs. They did not throw much light, so a variety of other styles in various shapes were used simultaneously. The bases of the tall stands varied from cabriole legs to the "cross-shaped base" in which four spandrels extend from the base to the pole to add support. Few original shades remain, but at the time they were usually made of paper or crafted from livestock horn. Some stands were adjustable. Smaller versions were called "book lamps" and would have been placed on a table. They also had paper or silk linings. Another form of lamp would have been carried at the end of a pole to light the way for people walking through courtyards and hallways, or hung from a ceiling. Expensive hanging lamps may have used glass panels by the middle of the Qing dynasty. Today, many of the light boxes have been reconstructed to project electrical light.

Chinese Furniture

Braziers

The brazier generally comprises a solidly constructed wooden stand and a metal liner or basin, often made of brass. Its purpose was to make warm a chilly room on a wintery day in the North by supplementing the heat radiating from the elevated *kang* heating system with its system of underground flues. In the South, braziers might have been the only source of heat.

Usually placed on the floor, braziers were filled with burning charcoal nestled within a heap of insulating ashes. The ashes prevented the metal container from overheating and burning the wood stand. These ovens could not heat up rooms like an electric furnace today. People wore layered clothing to survive—brocades and furs for the rich, cotton padding for the poor. The simple brazier did its part by keeping the circulation moving in cold fingers. Rubbing one's hands together to absorb some of the heat or stretching one's feet above the burning embers offered some relief in northern China, and it is easy to picture a family huddled around one for warmth. Besides serving as a hand and foot warmer, braziers sometimes doubled as a mini-stove to heat a little food, drink and even bathing water. While usually used indoors, there is some evidence that they made effective *hibachi* for ambitious picnickers.

Braziers were often placed in the center of the room, and fragrant incense could be added to the coals or jugs of water to boil tea or warm wine were placed on top. It was not uncommon to rearrange them around rooms of a home. As Sarah Handler points out, there was one serious consequence of using braziers: soot. Fine dust was spread around a study or bedroom, and scholars complained of the polluted air.

Shrines

Shrines, which look like miniature temples, were often placed on a table in the main hall of a home. It is believed that the spirits of ancestors reside in the "spirit tablets" placed inside the shrines. These have the power to bring good fortune or disaster to their descendants, and the faithful made offerings at auspicious times such as births and marriages.

Archaic memorial or shrine boxes, often referred to as *fu guai* or spirit houses, were used for storing images of the Buddha. These can be found in regions such as Shanxi. They resemble the terracotta models found in Tang tombs, an indication of how traditional such items were. These are often the last antique pieces people sell in their homes because they hold great sentimental value for the elderly.

Fig. 379

Fig. 379
Round brazier with the traditional high-waisted form with bulging apron, *yumu* (northern elm), seventeenth century, Shanxi province. Photo courtesy Cola Ma.

Fig. 380
Carved shrine box, *baimu* (cypress) and *changmu* (camphor). The inscription dates manufacturing to August 1840, Fujian province. Collection of Cola Ma.

Fig. 381
Memorial box, red lacquer with gilt painting, used to store images for ancestor worship or Buddhism. Photo courtesy Oi Ling Chiang.

Fig. 380

Fig. 381

Household Accessories 155

Garment Racks and Washstands

At night, Chinese nobles tossed their discarded robes over a garment rack to protect them from wrinkles. This ancient stand-up coathanger was once one of the most common of household accessories—a necessity because Chinese architectural traditions did not provide for closet space. Garment racks and washstands were usually part of the dowry and were decorated with auspicious symbols to promote marital bliss and longevity. The earliest examples give insight into how carpenters adapted architectural structures for furniture. The garment rack is a version of the simple post-and-rail design.

Bathing was an important ritual as far back as the Eastern Zhou dynasty (770–221 BC) when the élite bathed every fifth day, washed their hair every third day and scrubbed their hands five times a day. This was not only hygienic but ritualistic. Purity symbolized morality. As a result, the washstand, designed to hold a brass bowl, and a towel rack were other indispensable items in a bedroom. Initially, a basic metal bowl sat on the floor or was propped up by a stool, but eventually the stand became more elaborate and featured long cabriole legs and even an attached towel rack—an adaptation of the traditional garment rack. These stands generally have four to six round legs which are given extra stability by a brace. The ends of the top rails are upturned to keep the towels in place. They usually stood next to a bed or dressing table. While many were probably plain, those hardwood pieces that survived are decorated with openwork panels. Due to their frailty, few examples have survived.

Fig. 382
Garment rack, *jumu* (southern elm) and *hongmu* (blackwood), nineteenth century, Jiangsu province. Photo courtesy Altfield Gallery.

Fig. 383
Garment rack with a double-coin design in the latticework, black lacquer, nineteenth century, Zhejiang province. Photo courtesy Altfield Gallery.

Fig. 384
Garment rack, black lacquer, late nineteenth century, Zhejiang province. Photo courtesy Altfield Gallery.

Fig. 385
Garment rack, *yumu* (northern elm) with black lacquer, eighteenth century, Shanxi province. The top rail features carved dragon heads. Collection of Charles Wong.

Fig. 386
Clothes rack with openwork carving of four *lingzhi* fungi with a central floral motif arranged in a diamond shape, *huanghuali*, ca. seventeenth century. Collection of Dr S.Y.Yip. Photo courtesy Grace Wu Bruce.

Fig. 387
Washstand, *huanghuali*, eighteenth century, Shanxi province. As seen on this washstand, during the Qing dynasty the dragon's nose became elongated and the number of claws was reduced. The central panel features bats and clouds, symbols of happiness and longevity. Collection of Charles Wong.

Fig. 388
Washstand, *huanghuali*. Collection of Dr S.Y.Yip. Photo courtesy Grace Wu Bruce.

Fig. 387

Fig. 388

Household Accessories

Fig. 389
Folding mirror stand, not for travel, early eighteenth century, possibly from Suzhou or Shandong judging by the dark patination. Photo courtesy Andy Hei.

Fig. 390
Cosmetic stand with folding mirror in the shape of a lotus, *zitan*, eighteenth century. The pierced carvings on the panels are *chi* dragons. Photo courtesy Peter Fung.

Fig. 391
Folding travel mirror with *shou* longevity symbol, *zitan*, late eighteenth or early nineteenth century, purchased in a flea market in Beijing. Photo courtesy Andy Hei.

Fig. 392
Box, *zitan*, purpose unknown but possibly a hat box, carved in one piece for Liu Young, a small hunchbacked first-ranking official nicknamed "Hunchback Liu," during the Qianlong period. Photo courtesy Oi Ling Chiang.

Mirror Stands

Mirror stands are quite common (Fig. 389). Such stands would be fitted with bronze mirrors. Less common is the combination mirror stand and cosmetics case, a useful accessory in any boudoir. The hinged mirror shown here has five pierced panels around a central openwork panel with a lotus-shaped support to hold the mirror (Fig. 390). When the mirror stand is removed, the dressing case becomes a small table. This style of mirror was described in the Ming novel *Jin Ping Mei*, when wine and food are brought to one of the women's rooms and served upon a small dressing stand with its mirror removed, according to Christie's. People also needed mirrors when they traveled, and dealer Hei Hung Lu discovered this interesting little example that was well loved by its keeper (Fig. 391).

Clothing Chests

Closets did not exist, so rectangular storage chests were popular household items. In the bedroom they were used to pack clothes, linens and hats (Figs. 393, 394). In the kitchen, they were used for storing food and utensils, and in the study, they were used for scrolls. These ubiquitous items were often stacked on top of one another. In Shanxi province, a "treasure chest" to contain money was also common (Fig. 395). The earliest chests had detachable lids. Later versions came with a hinged lid and detachable base and were referred to as *yi long*. Camphor wood or *changmu* was popular for chests containing textiles and furs due to its insect repellent qualities. Because Chinese robes were never hung vertically, large chests or cupboards were necessary for storage. Most chests made of camphor were from Beijing or Hebei province in the north. In addition to chests, boxes were made to hold hats (Fig. 392).

Tiered Boxes and Tea Containers

Tiered boxes or carrying boxes were used for traveling as well as ceremonial outings and carried by a pole that passed through the iron ring at the top. These portable containers comprised three or four tiered trays used to separate and organize goods. The box sits on a base platform and a gallery-like balustrade is constructed on top of the frame. Tiered boxes come in a variety of sizes, and while they are often referred to as food trays, they were also useful for arranging documents. In Kai-Yin Lo's book, *Classical and Vernacular Chinese Furniture in the Living Environment*, Curtis Evarts gives three descriptions from the literature on tiered boxes. While referred to as food boxes in two references, thinner boxes were often used to carry a variety of items, including documents and money. Carrying boxes that were not tiered were used to carry paper offerings called *meng qi* and other things associated with funeral traditions.

Tea containers and cosies were popular items with both the rich and the poor. The beveled red lacquer tea caddy shown in Fig. 397 was not produced for the masses. It is made from bamboo silk, a technique by which bamboo stalks are sliced into thread-sized slivers and woven together.

Fig. 389

Fig. 390

Fig. 391

Fig. 392

158 Chinese Furniture

Fig. 393

Fig. 394

Fig. 395

Fig. 396

Fig. 397

Fig. 398

Fig. 393
Clothes chest, painted lacquer, nineteenth century, Shanxi province. Collection of Karen Mazurkewich.

Fig. 394
Clothes chest, *huanghuali*, seventeenth century. Collection of Dr S.Y.Yip. Photo courtesy Grace Wu Bruce.

Fig. 395
Treasure chest used for transporting money or silver much like a modern-day safe, *yumu* (northern elm) and mounted leather with brass nails, eighteenth century, Shanxi province. Collection of Andy Hei.

Fig. 396
Tea kettle box, *tielimu* and *jichimu* (chicken wing), late Qing dynasty. Collection of Philip Ng.

Fig. 397
Tea/wine pot caddy shaped like a brush pot with attached handles, base *huanghuali*, lid *hongmu* (blackwood), nineteenth century. Photo courtesy Peter Fung.

Fig. 398
Carrying container, possibly for food. Collection of Just Anthony.

Fig. 399
Food box (covered and uncovered) and folding table, black lacquer, sixteenth century, Shanxi province. A sliding panel at the bottom of the food box allows the legs of the folding table to be neatly folded and concealed. Photo courtesy Cola Ma.

Fig. 399

Household Accessories 159

Fig. 400

Fig. 401

Fig. 402

Fig. 403

Fig. 400
Concave document box, *jichimu* (chicken wing), early Qing dunasty, Jiangsu province. It was probably used to put valuables in and then double as a pillow, a safe way to sleep with your valuables close to you. Collection of Philip Ng.

Fig. 401
Document box with a concave lid, *jichimu* (chicken wing), early Qing. This chest possibly doubled as a pillow box, used to store documents while sleeping. Collection of Philip Ng.

Fig. 402
Rectangular box composed of individual panels and reinforced by external corner supports of plain brass, *huanghuali*, nineteenth century. Collection of Dr Michael R. Martin. Photo courtesy Altfield Gallery.

Fig. 403
Rectangular box with an unusual raised lip ridge where the box opens, *jichimu* (chicken wing). Collection of Robert Piccus. Photo courtesy Altfield Gallery.

Document Boxes

Small chests with hinged tops and recessed trays were frequently used for safeguarding rare treasures or for storing stationery and legal documents—hence the term document box. They were also used as money chests or presentation boxes as seen in many woodcut illustrations, including "Shen luan jiao chuanqi" (Figs. 402–404). The plain, rectangular forms were often relieved by escutcheon mounts and brass locks. While most boxes have flat lids, there are some domed or concave versions that look like Chinese pillows and may have served that very purpose—doubling as a neckrest and a mini-safe (Figs. 400, 401). It is most likely that boxes with sliding covers were used to safeguard rare treasures or for storing stationery (Figs. 417–420).

Chests featuring hinged doors are often referred to as dressing cases and might have contained cosmetics, jewelry, combs, mirrors and other trinkets (see Fig. 38, page 30 and Fig. 406). In the West, they were referred to as seal chests, and while they might have been used in this manner, the etymology of the word does not suggest that storing seals was a common usage.

What is most remarkable about these small chests is the development of multiple drawers. According to Clunas, this style of furniture was developed in tandem with the need to sort documents—probably in the fifteenth century. Clunas quotes the writings of Li Yu who waxes poetic about the need for a drawer to contain "the necessities of life for a man of letters, such as paper, a knife, inks and glues...." (Figs. 407, 409, 410, 413). While most are of plain wood, there are some examples of boxes inlaid with semi-precious stones and ivory, such as this example that dates to the Kanxi period (Fig. 408).

The smaller, rounder boxes were obviously multifunctional, and were used to hold jewelry, cosmetics, gaming pieces, ink stones and other such items (Figs. 411, 412). The shapes of the round containers ranged from perfectly round to an unusually shaped item that resembles a donut, which was used to carry court beads (Figs. 414, 415). Some rounded containers from Tibet would have been used as yak butter containers or food containers. (Fig. 415).

Fig. 404

Fig. 404
Three different boxes with trays. Photo courtesy Altfield Gallery.

Fig. 405
Scene from a bedchamber. Notice the mirror stand and the three-tiered carrying box used for food or documents on the long table. Clothes chests are also placed on top of low cabinets. Photo courtesy Grace Wu Bruce.

Fig. 406
Traveling apothecary's chest (see Fig. 38, page 31), open to show the drawers for storing items of trade, *huanghuali*, seventeeth or eighteenth century. Private collection, Singapore.

Fig. 405

Fig. 406

Household Accessories | 161

Fig. 407

Fig. 408 Fig. 409 Fig. 410

Fig. 411 Fig. 412 Fig. 413

Fig. 407
Seal chest (open and closed) with handle, probably used when traveling to carry seals, documents or stationery, *huanghuali*, eighteenth century, sourced in Beijing. Collection of Andy Hei.

Fig. 408
Cosmetics box, *huanghuali*, inlaid with semiprecious stones, Kanxi period. Collection of Philip Ng.

Fig. 409
Document boxes, *huanghuali*. Photo courtesy Oi Ling Chiang.

Fig. 410
Portable case with handle, *zitan*, eighteenth century. These cases had multiple uses, including as an artist's tool box. This interior is fitted with a tray and five drawers. Photo courtesy Peter Fung.

Fig. 411
Small cylindrical dice box, *zitan*, late Qing. Collection of Philip Ng.

Fig. 412
Box, *zitan* inlaid with mother-of-pearl, horn, turquoise, bone and soapstone, eighteenth century. The figures represent playing boys. Collection of Dr Ip Yee. Photo courtesy Altfield Gallery.

Fig. 413
Seal box, smaller than normal, *huanghuali*. Photo courtesy Oi Ling Chiang.

Fig. 414
Unusual box shaped in the form of a *lingzhi* fungus and carved with corresponding tight-fitted flange and groove for secure closure, *huamu*, eighteenth century. Photo courtesy Altfield Gallery.

Fig. 415
Unusual box with a hollowed-out center, *jichimu* (chicken wing), nineteenth–twentieth century. Photo courtesy Altfield Gallery.

Fig. 416
Boxes, probably used to store yak butter, burl wood, made in China but intended for the Tibetan market. Collection of Andy Hei.

Fig. 417
Sliding top box with fretwork, decorated with writhing dragons along individual panels, eighteenth century. Photo courtesy Altfield Gallery.

Fig. 418
Rectangular document box formed of individual *huamu* panels and a sliding top. Collection of Robert Piccus. Photo courtesy Altfield Gallery.

Fig. 414

Fig. 415

Fig. 416

Fig. 417

Fig. 418

Household Accessories

Fig. 419

Fig. 420

Fig. 421

Fig. 422

Fig. 419
Unusual box, *huamu*. Collection of Dr Michael R. Martin. Photo courtesy Altfield Gallery.

Fig. 420
Multi-layered sedan box that folds out for easy access, *hongmu* (blackwood). Collection of Philip Ng.

Fig. 421
Game board for double sixes, a popular game in the Tang period which declined in popularity by the early Qing, *zitan*, sixteenth century. Photo courtesy Peter Fung.

Fig. 422
Stationery box with a lid which slides back and forth to allow for the insertion of documents and papers. Collection of Andy Hei.

Fig. 423
Small brush pot carved to look like bamboo and inscribed with characters, *zitan*, early Qing dynasty. Collection of Philip Ng.

Fig. 424
Scroll holder, *jumu* (southern elm), eighteenth century. Photo courtesy Robert A. Piccus.

Fig. 423

Fig. 424

Stationery Trays and Gaming Boards

Rectangular serving trays were popular in prosperous homes. In addition to serving food and tea, they were often placed on scholars' desks to bring order to utensils such as paint brushes or ink stones. While usually open, the example in Fig. 422 sports a lid which slides back for the insertion of paper. Trays were often made of expensive woods, and when inlaid panels were inserted, sometimes doubled as gaming tables for dice games such as "double sixes." Perched on *kang* tables, gaming boards such as the one shown in Fig. 421 were popularized in the Tang dynasty but fell out of use during the Qing period. As a result, the game board, with its deep-sided tray and ivory inlays, is a rare find. Many utilitarian objects, including tea trays, have come from Fujian province. Tea, one of the major crops in Fujian, was popular among locals so it is not surprising that many surviving trays come from the region.

Brush Pots and Scroll Pots

A fixture on any scholar's desk was a brush pot or scroll holder. While they came in all shapes and sizes, there were essentially two styles: plain or decorative. Cylindrical pots, used to hold calligraphy brushes, scepters, wrist rests and fly whisks, were popular between the sixteenth and twentieth centuries. The best pieces had beautifully grained surfaces and were nicely polished (Figs. 424–426).

Most brush pots were made with highly polished fine wood in order to show off the grain and sometimes they were carved with calligraphy or landscapes (Figs. 423, 428, 429). A common wood used is burl or *huamu*, which has interesting swirling patterns created by abnormal growth. While most brush pots were easily cut from a tree trunk and made as simple cylinders, others utilized the natural knots of a tree trunk or root, or found ways of reproducing natural deformities through carving. Still others were transformed into unusual shapes such as the brush pot in Fig. 430 carved to appear as if it were flower petals.

Scroll holders were larger and often carved from a hollowed tree trunk. They were used as jars to hold calligraphy scrolls (Figs. 424, 431–433).

Fig. 425

Fig. 426

Fig. 427

Fig. 428

Fig. 429

Fig. 430

Fig. 431

Fig. 432

Fig. 433

Fig. 425
Brush pot with a waisted profile, *huanghuali*, eighteenth century. Photo courtesy Peter Fung.

Fig. 426
Brush pot formed from a single trunk of *huanghuali*, eighteenth century. Collection of Robert Piccus. Photo courtesy Altfield Gallery.

Fig. 427
Brush pot with a bellied-jar form with a lip and beaded base, *huanghuali*, eighteenth century. Photo courtesy Peter Fung.

Fig. 428
Brush pot decorated with a scene of a scholar and child with rocks and pine trees carved in low relief, *huanghuali*, seventeenth century. Photo courtesy Grace Wu Bruce.

Fig. 429
Brush pot with dragon carving, possibly imperial, *zitan*, eighteenth century. The five-clawed dragons float through clouds and waves. A keyfret pattern is incised around the top. Photo courtesy Peter Fung.

Fig. 430
Brush pot, *zitan*, eighteenth century. The sides are formed as an external ring of three massive concentric flower petals overlapping an inner ring of three similar, lesser petals. The sides of each petal are carved in relief featuring magnolia flower, prunus branches and persimmon. Collection of Dr Ip Yee. Photo courtesy Altfield Gallery.

Fig. 431
Scroll holder made from a *baimu* (cypress) root. The inscription is from the Kanxi period and says it belonged to the famous collector Kao Xi Chi. Photo courtesy Altfield Gallery.

Fig. 432
Scroll holder, *zitan*, eighteenth or nineteenth century. Photo courtesy Peter Fung.

Fig. 433
Scroll holder formed from a single trunk length of *huanghuali*. The exterior is carved to look like a knotted tree. Photo courtesy Robert A. Piccus.

Household Accessories

Fig. 434

Fig. 435

Fig. 436

Display Stands

A good scholar liked to collect antiques, bronzes, jades, snuff bottles and even teapots or other teaware. In order to properly display them in his studio, multi-level and multi-functional shelving units were made. Some of these units were highly carved (Figs. 434, 435). Others were simple or sturdily built to hold books. This particular stand looks like a *kang* table but is even smaller and was possibly used for holding icons and incense (Fig. 436).

Toggles and Figurines

The toggle—a miniature carving—is another example of a vernacular plaything (Fig. 437). Although toggles were primarily designed, much like Japanese *netsuke*, to fasten an object to a man's belt, they were also kept in pockets and rubbed and handled by owners over the course of the day. As such, collector Michael Wolf refers to them as "pocket monsters." They were also admired as table ornaments. On a practical level, the toggle acted as a counter-balance to hold an object in place on a belt. The long toggles pierced with two holes were called "spreaders" and were used to prevent the belt cords from twisting together. The wearer could easily disengage the object without having to undo his belt.

Toggles come in a variety of shapes. While some were crafted from ivory or jade, more commonly they were carved from boxwood, fruit wood and burl. Toggles made to look like drums or shoes

Fig. 434
Small precious treasures shelf stand with carvings that imitate jade, *zitan*, nineteenth century. Photo courtesy Peter Fung.

Fig. 435
Table stand with pierced carvings of bats, *nanmu*, either eighteenth or nineteenth century, possibly from Anhui province. Photo courtesy John Ang.

Fig. 436
Table stand much like a *kang* table with everted edges, but only 12 inches (30 cm) long, *huanghuali*, early Qing dynasty. Collection of Philip Ng.

Fig. 437
Toggles were frequently suspended from belts and used to counter-balance purses, chopsticks or fans. Collection of Hannah Chiang.

were common, as were divinity figures such as Shao Lo, God of Longevity. Also popular were flowers and animals, such as monkeys, frogs, cicadas and lions. Some are finely crafted, but most are crude and were probably made by the owner himself.

In addition to toggles, wooden sculptures of figurines and play objects were also common, including a small figure of a Lohan, an enlightened monk (Fig. 439) and an unusual duck carved from a piece of burl root (Fig. 441). While one might have found instruments or brush pots on the scholar's desk as a playful distraction, a merchant might have a carved animal on his desk as a good luck charm or to rub out of nervous habit, such as this one, made of *zuomu* (oak). This fine specimen is a favorite of dealer Hei Hung Lu (Fig. 440).

Miscellaneous Items

Birdcages remain common items in any household in China (Fig. 442). While they come in every kind of wood and shape, this special example is made of polished *zitan* and ivory.

Chinese musical instruments were traditionally classified according to the materials used in their construction, such as stone, wood, clay, skin and bamboo. Clappers are wooden percussion instruments used to keep a rhythmic beat (Fig. 438). Three clappers were loosely tied together with a silken cord and used as symbols to keep time. They were used in traditional Chinese operas but are now obsolete except in the Qun opera from Jiangsu/Zhejiang area.

Fig. 437

Fig. 438

Fig. 439

Fig. 440

Fig. 441

Fig. 442

Fig. 438
Clappers used for musical performances. Photo courtesy Oi Ling Chiang.

Fig. 439
Figure of a Lohan (an enlightened monk) formed from a single olive stone, nineteenth century. Collection of David Halperin. Photo courtesy Altfield Gallery.

Fig. 440
Play object meant to sit on a desk and be rubbed. This particular rabbit, made of *zuomu* (oak), sits on the desk of dealer Hei Hung Lu.

Fig. 441
Figurine from a piece of natural burl root (*huamu*) in the shape of a duck, eighteenth century. Photo courtesy Altfield Gallery.

Fig. 442
Birdcage, bamboo and ivory, Qing dynasty, purchased in Beijing. Collection of Andy Hei.

Household Accessories

Classical Versus Vernacular

Fine furniture was always a sign of hierarchical status. The first pieces—low platform beds and folding stools—were the domain of warlords and generals. It was a simple delineation at first: the masses sat on the floor, the élite were elevated (Fig. 444). When the new Imperial Palace was built in the early Ming dynasty between 1402 and 1423, imperial workshops were re-established and craftsmen from far and wide were recruited.

As furniture became increasingly popular during this time, class lines blurred. Next to the imperial family, the highest ranking people were military leaders and scholar-officials who were trained in Confucian principles that emphasized discipline, frugality, loyalty and piety. However, economic prosperity brought social changes. In the early Ming, agricultural advances led to a rise in population and the creation of new industries: textiles, ceramics, iron smelting and shipbuilding. Trade increased ten times in Jiangnan (which today comprises Jiangsu, Zhejiang and Anhui provinces, or literally the land south of the Yangtze River) between 1521 and 1620. In addition, a change in the maritime policy that allowed the flow of goods from East to West had an enormous impact on the standard of living. During the Wanli period (1573–1620), the imperial court went on a spending spree, buying lavish hardwood furniture and lacquerware. Almost overnight, the ranks of the merchant class swelled and its status improved. The hawkers and traders of salt and silk, who once occupied the bottom rung of society, now wielded financial clout. The blurring of class differences became more pronounced as the central government unraveled. Corruption was so rampant that official ranks and status could be bought.

In every culture, the new bourgeoisie flaunt their wealth and buy respect by embracing the arts. The new rich of the Ming dynasty were no different. As class dynamics shifted, merchants scrambled to emulate the lifestyle of the élite—a phenomenon dubbed by scholar/dealer John Ang as "Ben Mo Dao Zi," or the reversal of the traditional class system. The newly rich diversified by spending more on art and decorative homewares such as furniture. The spin-off benefit for craftsmen was more commissions. Carpentry became a respectable and lucrative profession in Canton (Guangzhou) and Jiangsu.

Furniture had long been an obsession of the imperial court in Beijing and among the literati—the ambassadors, ministers and learned men who passed the competitive exams in the Classics and ran the government. As Craig Clunas points out in his book *Superfluous Things: Material Culture and Social Status in Early Modern China*, "within the Confucian value-system there was a commitment to excellence in the creation of aesthetic values." In the early Ming, connoisseurship appeared to focus on the archaic items of earlier dynasties—bronzes, jades and scrolls. The élite were consumed by studying and collecting antiques. By the late Ming, the change in social hierarchies led to a shift towards more material consumption. As Clunas further suggests, the

Fig. 444

Fig. 443 (opposite)
Two side tables and a square *kang* table display two black-glazed Qing-dynasty wine pots and a terracotta vessel from the Xia dynasty (2100–1600 BC). Collection of Christopher Noto.

Fig. 444
The high and the low. In this scene taken from the Ming novel *Jingqi Xiang*, a man seated in front of his six-post canopy bed is dispensing justice to bound serfs. Next to him on a side table are his writing implements. Photo courtesy Grace Wu Bruce.

170 Chinese Furniture

Fig. 445
John Ang's studio combines classical pieces of Chinese furniture with Western flair. Here, Ang has put together a painting table with giant arm braces, a lamphanger chair, a half-moon table and a small Eight Immortals table with stools. The spaces are divided by calligraphy and ink-brush paintings.

Classical Versus Vernacular

Fig. 446

Fig. 447

elements of the "proto-consumer" society were in place by 1600 (late Ming) as luxury artifacts, including ceramics from the great potteries of Jingdezhen, and hardwoods like *huanghuali* were available to all who could afford them.

Many of the new rich did not gain their standing through academic achievement; they bought it. In those days, there was no house of Gucci or Cartier to bestow status. The only recognizable "label" for design and craftsmanship came from copying the styles of the imperial workshops or from commissioned studios. Designs often dictated by the imperial workshops were given to other commissioning studios, which in turn took creative license. With no imperial copyright, carpenters were free to "borrow" designs for their wealthy clients. This, of course, antagonized the arbiters of taste among the literati. It was a classic class collision: as the nouveau riche attempted to emulate

Fig. 446
Vernacular kitchen cabinet with "cracked ice" latticework, late Qing, Zhejiang province. Although classified as a sloping-stile cabinet, its coarse bottom drawers differentiate it from other classic styles. Collection of Just Anthony.

Fig. 447
Contemporary academic and dealer Curtis Evarts has arranged his Shanghai home to reflect the aesthetic style of the traditional scholar in Chinese history.

Fig. 448
Brush pot carved to resemble the rough natural surface of a pine tree trunk, *huanghuali*, nineteenth century. Photo courtesy Peter Fung.

Fig. 448

Classical Versus Vernacular 173

Fig. 449

Fig. 450

intellectual tastes, some literati tried to distance themselves from perceived vulgarity (Fig. 446).

The dos and don'ts of the proper domicile seemed to take on greater significance at the end of the Ming dynasty when the upper crust had to compete with an increasingly aggressive merchant class eager to step up in society. For scholars like Wen Zhenheng (1585–1645), who was born into a prestigious family, the corruption of the official class was reprehensible. His discourse "Treatise on Superfluous Things" was a way to address the erosion of values and conspicuous consumption. Wen's treatise was similar to an earlier work crafted by Gao Lian, a dilettante and the son of a wealthy merchant. He, too, addressed issues of suitable decor and decorum. A gentleman of the Ming era had to know how to do things properly. How many flowers could be placed in a vase? Was it improper to mix white and red blooms together? Should a porcelain vase be used only during the summer months and be replaced by bronze in the winter? Was it déclassé to have overtly curved flanges on an altar table? What was more appropriate, a ruyi head carving design or an elaborate dragon? Should canopy bed curtains be made of simple blue gauze or were silken drapes with painted scenes acceptable?

Scholars like John Ang believe this social clash led to greater aesthetic gaps in the style of furniture produced at the time. According to Ang, merchants tended towards excess: more carving, more inlay, more lacquer (Figs. 449, 450, 452) and, by contrast, scholars stressed the importance of naturalism and adopted a more severe aesthetic: simple lines, modest carving and natural wood grains. They took their fashion cues from the ancients, borrowing motifs from the Shang, Zhou, Qin and Han dynasties. A folding chair embellished only with silver hinges was more desirable than a folded chair painted gold. A plain day bed was considered refined while a canopied version with carved antechambers was vulgar. Whenever possible, furniture was made to look naturalistic. Scroll pots and stools made from roots were ideal (Figs. 447, 448), as were wooden rose chairs or tables sculpted to look like bamboo (Fig. 454).

What does this have to do with buyers shopping for furniture today? Plenty. The term "classical antique furniture"

Fig. 449
Detail of a garment rack showing openwork with bats and clouds, Qianlong period. Photo courtesy Charles Wong.

Fig. 450
Detail of a pierced carved panel from a platform bed, *huangyangmu* (boxwood), nineteenth century, Fujian province. Photo courtesy Charles Wong.

Fig. 451
Table skirt from a vernacular side table, *yumu* (northern elm), Shanxi province. Sourced by the Fan brothers in Beijing.

Fig. 452
Lamp stand or most likely a coathanger with an elaborately carved elephant head and trunk capped with a lotus, *huangyangmu* (boxwood), Qianlong period, possibly from Zhejiang province. The rich detail is typical of the Qianlong period. Photo courtesy Charles Wong.

Fig. 451

now refers to surviving hardwood furniture which was crafted in a minimalist Ming style espoused by scholars like Wen and Gao.

When buying today it is important to remember this fact: most classical antique furniture on the market is not from the Ming dynasty. Most of it was made in the early to mid-Qing dynasty. Ming structural elements in furniture persisted during the Kanxi emperor's reign, although the minimalist aesthetic was superseded by rich motifs, lacquer, mother-of-pearl and marble inlays. According to Beijing scholar Tian Jiaqing, this erosion of good taste can be partly attributed to the lack of influence the literati and officials had on the imperial courts established by the conquering Manchus of the Qing dynasty. The Manchus, who seized power in 1644, started the Qing dynasty and became increasingly more interested in overt symbols of power: dragons, qilin and phoenixes. Subtlety was not an imperial trait.

The distinction between "classical" furniture and "vernacular" furniture is an important one. Among the trade, the term "vernacular" is a synonym for softwood. However, this is misleading (Fig. 455). It implies that the furniture was made for the "illiterate" or middle classes. But this was not always the case. As Clunas points out in his book, given their desire for frugality, one should expect a great

Fig. 452

Classical Versus Vernacular 175

Fig. 453

Fig. 454

Fig. 453
An apartment of a young woman of the Kang family, decorated in late Qing-dynasty style, Kang family manor, Gongyi, Henan province.

Fig. 454
Detail of a square table made in softwood but simulating bamboo. Photo courtesy Oi Ling Chiang.

Fig. 455
Southern official's armchair (front and side views). Although this chair is made of *huanghuali*, its proportions are heavier and it looks more like a vernacular piece of furniture. From northern origins, the chair probably dates to the early Qing dynasty and features a *ruyi* and dragon motif along the back splat. Collection of Philip Ng.

Fig. 456
Couch bed with circular marble insets at back, whose patterns resemble mountains and clouds, Shen family home, Luzhi, Jiangsu province.

176 Chinese Furniture

deal of scholar's furniture to be made from local softwoods. In addition, some of the élite of the late Ming preferred lacquer over hardwood, despite the fact that hardwood is today coveted and significantly more expensive. In fact, records of the well-placed bureaucrat Yan Song's estate show that an inlaid lacquer canopy bed with an antechamber was fifteen times more expensive than a *huali* bed (see Fig. 305, page 119).

Judging the status of furniture based on a hardwood/softwood distinction is helpful for big pieces—tables, chairs and beds—but is not a useful tool when looking at smaller household accessories. Items such as food boxes, music stands, coolers and even tea cosies were made out of softwood for scholars. Take the *qin* table, popular among the élite. These tables, built for musical enhancement, were made of local softwood. Or the large *yumu* and pewter ice chest shown

Fig. 455

Fig. 456

Classical Versus Vernacular 177

Fig. 457

Fig. 458

Fig. 459

Fig. 457
Pair of chicken cages used for marriage ceremonies, *yumu* (northern elm) and black lacquer, nineteenth century, Shanxi province. Collection of Charles Wong.

Fig. 458
Carpenter's tool box, *huanghuali*, mid-Qing dynasty. Possibly the wood was from leftover pieces from a cabinet or table. Collection of Philip Ng.

Fig. 459
Ice chest used like a modern day air-conditioner, *yumu* (northern elm) with white brass mounts. These kinds of chests were popular in northern China, particularly in Beijing, during the summer, and were usually made of softwood and lined with pewter. Ice pulled from its deep storage pits was packed inside and cool air could escape from the holes in the top. These types of chests may have also been used to chill drinks or fruit. Photo courtesy Andy Hei.

Fig. 460
Southern official's armchair. This chair is in the archaic "Jin" style of furniture only found in Shanxi province. This chair is very rustic compared to the refined armchair next to it. Collection of Cola Ma.

Fig. 461
Vernacular chair from Shanxi province. Collection of Fan Rong.

Fig. 462
Set of four vernacular side chairs. Photo courtesy Christopher Cooke.

in Fig. 459. By definition it is "vernacular," yet it was probably used by the upper class as a coolant in the heat of the summer, and now has a sale price of $8,000. Another wonderful example is a pair of wooden chicken cages made of elm which were obviously used by a wealthy Shanxi family to parade goods down the street during a wedding procession (Fig. 457). Yet, these are no ordinary holding cages. The wavy cage bars and elaborate carving on the handles are proof that this "utilitarian" object was meant for show by someone whose pockets were deep enough to have ornate chicken cages. A tool box made of *huanghuali* (probably made from leftover wood from a big commission) was probably used as a storage case for carpentry tools (Fig. 458).

During the Qing dynasty, furniture became increasingly popularized and accessible. Of course, designs were exaggerated to suit the new rich or the middle class and regional aesthetics. It seemed that the farther away from the epicenter of culture (Suzhou and Beijing), the greater the creativity and experimentation.

The vernacular artisan took designs in directions that a craftsman to the élite would never dare attempt. Sometimes the experimentation bordered on hilarity, such as the oddity in Fig. 463, a *nuanyi* chair, reportedly designed by a scholar named Li Yu and constructed with a built-in coal heater. But while regional vernacular is less refined, with frequent visible joins, there is beauty in the exaggerated proportions and curves found in furniture made in Shangdong, Shanxi and Fujian

Fig. 460

Fig. 461

provinces. For example, the regional chairs shown in Figs. 461 and 462 were probably used in the home of a middle-class family. The proportions are heavy, but the over-arched back splats and sensuous curving arms and yokes display a certain playfulness. It is practicality and frivolity combined. Compare these to the more restrained scholarly yoke-back chairs from the seventeenth century illustrated on pages 52–3.

As one drifts down the social ladder, the decoration becomes less refined, the proportions more squat and the seats lower. Compare the grand proportions of the *huanghuali* horseshoe-back chairs in Fig. 465 with the sturdier, more compact ones from Hebei province in Fig. 466. Or the simplicity of the vernacular side chairs in Fig. 462.

So why is class distinction still used to evaluate furniture? The reason is partly due to marketing strategies. Auction

Fig. 462

Classical Versus Vernacular 179

Fig. 463

Fig. 463
Nuanyi warming chair, *yumu* (northern elm), eighteenth–nineteenth century, Shanxi province. Collection of Charles Wong. Photo courtesy Hannah Chiang.

Fig. 464
Round stool, *yumu* (northern elm), late Qing dynasty, Shanxi province. Collection of Just Anthony.

houses like Christie's and Sotheby's try to boost the cachet of objects for sale by underscoring the fact that they are from "a scholar's studio." Class distinction is a form of patina for some collectors and many dealers have built their reputation promoting the currency of hardwoods.

"A lot of dealers or scholars say the best period for furniture is the sixteenth or seventeenth century, which I don't believe," says dealer Jerry Chen. He not only blames the auction houses, but some of the early dealers who entered the field in the 1980s and were skewed "by personal taste and limited knowledge."

"Let's face it," he says, "prior to 1985 there was not even a good book written by a Chinese." Traffic and access were so restricted that any available information was incomplete or incorrect. "Chinese scholars always take the highest price of an auction house as a guideline for quality," he says. "That causes confusion." The West put a lot of emphasis on the Ming aesthetic, but there is more research now into the philosophy of the Liao and Yuan dynasties. Chen believes it will be another five years before the real value of Chinese furniture is revealed. The most expensive softwood pieces run to about $20,000.

The knowledge gap may shrink because of a wave of scholarship led by authors such as Nancy Berliner, Curtis Evarts and Sarah Handler, and collector

Fig. 464

Fig. 465

Fig. 466

Fig. 467

Fig. 468

Fig. 469

Fig. 465
Pair of vernacular armchairs, *yumu* (northern elm), eighteenth or nineteenth century, Shandong province. Collection of Hannah Chiang.

Fig. 466
Pair of vernacular chairs, *yumu* (northern elm), nineteenth century, Hebei province. Collection of Hannah Chiang.

Fig. 467
Folding vernacular stool, twentieth century, Shanxi province. Collection of Andy Hei.

Fig. 468
Folding stool reinvented using a rubber tire, an example of innovation throughout time, Beijing, 1998. Photo courtesy Michael Wolf.

Fig. 469
Recessed-leg stool, nineteenth century or early twentieth century, although this traditional style dates back to the Song dynasty. Collection of Cola Ma.

Kai-Yin Lo who are promoting the beauty of vernacular. They are blurring the lines that separate the élite and middle class, as well as the collectible from the decorative. Many of the softwood dealers are also challenging the status quo.

Amanda Clark has long argued that the divide separating hardwood and softwood furniture is an artificial one. "No scholar could think this criterion (evaluating furniture on the basis of the wood species) a sensible one, and no other country's furniture has ever been classified in this way. Can you imagine an English furniture dealer trying to persuade buyers that only Brazilian Mahogany pieces of late Georgian furniture are good and acceptable, and pieces made of English walnut are not worth anything? It's ridiculous." She also points out that the furniture found in China's royal tombs was made of indigenous softwood and have a lacquer finsh. "I am quite sure that over the next decade fine, well-designed and attractive examples of furniture made of indigenous woods will greatly increase in value and desirability. These pieces reflect the real tradition of Chinese furniture."

This begs the question. How does one determine whether a vernacular piece is worth collecting? One factor determining value is style. The most popular vernacular pieces are those made in simple, classical styles such as sloping-stile cabinets and painting tables. The Ming aesthetic is popular even in softwood furniture. But that is not the deciding factor; after all, there are many forms of vernacular

Classical Versus Vernacular 181

Fig. 470

Fig. 471

Fig. 470
Vernacular altar table with legs that resemble the legs of some vernacular horseshoe-shaped chairs from Shandong province. Photo courtesy Christopher Cooke

Fig. 471
Legs of two tables made in Shanxi province. The leg in the foreground is a heavier vernacular piece with beading compared to the more refined leg of lighter proportions behind it.

furniture that were never made in the classical style, such as the camphor blanket chest illustrated in Fig. 476 or the vernacular altar table in Fig. 470.

The difficult question is whether it can be elevated to the status of art. Are the lines both functional and beautiful? A more simple approach is to look at the craftsmanship (Fig. 471). The more time spent on detail, the more expensive the piece. A good cabinet—even if plain—will have beaded or beveled edges instead of straight ones. Look for detail where detail is not expected, such as inside cabinet doors or along aprons. What type of wood and how many pieces of wood were used for the table top? One piece is good, two are acceptable but if it is ten, then it is not collectible.

Rarity is a factor. The top one percent of pieces come from a scholar's studio or have imperial status. *Hetaomu* (walnut) and *yumu* (northern elm) are prized over *huaimu* (locust), *yangmu* (poplar) and *songmu* (pine). Also, check the condition. Where was it produced? Furniture made in centers like Suzhou, Jiangsu, and Shanxi and even Anhui were made well, but the further afield you go—Sichuan, Yunnan and other provinces—they do not have much of a furniture culture.

As furniture appreciation grows, and hardwood pieces become more difficult to find, regional designs will continue to gain acceptance. In September 2002, a small nineteenth-century sloping-stile cabinet made of *longyan* wood (a softwood from a fruit tree) sold at Christie's New York for $18,000—more than ten times the price achieved for a similar cabinet sold in 1992. Today, there is even a group of collectors who go after crude vernacular pieces that were used by street vendors during the Qing dynasty or Republican periods. Vendors' benches are the most common street furniture in the market, particularly those used by the street salesmen who polished mirrors, cut hair or mended porcelain. Hannah Chiang has assembled a small collection of vendor furniture, including dumpling carts, a food warmer from Shanxi province, and a cake stand from Beijing (Figs. 472–475, 479–82). These ingenious pieces were often made of poplar, elm and lacquer.

Fig. 472

Fig. 473

Fig. 474

Fig. 475

Fig. 472
Vendor's cart, perhaps used to sell dumplings, lacquer, nineteenth century, Hebei province. Collection of Hannah Chiang.

Fig. 473
Vendor's cart, lacquer on *songmu* (pine), nineteenth century, Shanxi province. Collection of Hannah Chiang.

Fig. 474
Tool box used by peddlers and hawkers. This particular vernacular piece was used to repair hardware, plates and household items. An air "pump" installed in the top is used to fan the fire of the burner. Collection of Just Anthony.

Fig. 475
Heating implement used by a street vendor, *songmu* (pine), probably from the Republican era, Zhejiang province. These pieces are easily broken, so are very rare. Collection of Hannah Chiang.

Classical Versus Vernacular 183

Fig. 476

Fig. 477

Fig. 478

Fig. 479

The markets of Zhuhai in Guangdong province, for example, are full of vernacular finds such as food boxes, stacking trays and baskets used to carry steamed dumplings and rice. The red rice container shown in Fig. 478 would have been used by the élite, whereas larger rattan baskets—used to carry uncooked rice—were common. Today, people have recycled old rice baskets and buckets to serve as laundry hampers or magazine holders (Fig. 477). Even the most basic household implement has found a decorative use. Anything old with some patina is fair game on the "antiques" circuit in China.

One of the hottest items is the humble stool—the one piece of furniture that truly crosses class lines (Fig. 469). In the homes of the moneyed, the simple seat took a formal profile: square proportions with hoofed feet. Sometimes the rich preferred stools in the shape of a barrel or arched legs, but in the hands of the poor, creativity abounded. A folding stool, found in a Shanxi market, is an example of innovation (Fig. 467). Not only has the worn seat been reworked with twine and rubber piping between the legs, the owners have inserted a wire and strung old coins through for decoration and sound effects. Its decorative appeal is so strong that even diehard, high-end hardwood dealers such Hei Hung Lu have been picking them up for sale. Another stool that caught the eye of photographer Michael Wolf is this refurbished contemporary piece made with rubber tires (Fig. 468). While the dynasties may have ended long ago, the level of improvising old furniture still exists on the streets today.

Fig. 476
Clothes chest with carving of bamboo, *changmu* (camphor), nineteenth century, either from Ningbo or Suzhou. Collection of Charles Wong.

Fig. 477
Food basket, coarsely woven rattan, nineteenth century, Jiangsu province. Collection of Charles Wong.

Fig. 478
Teapot, bamboo covered with cinnabar lacquer, Wanli period, possibly from an imperial workshop in Anhui province. Photo courtesy Oi Ling Chiang.

Fig. 479
Cooking cart. Collection of Hannah Chiang.

Fig. 480
Barber's stool and tool chest with drawers for holding tools, *huaimu* (locust) and *yangmu* (poplar), 1850s, Shanxi province. Some stools have a slot in the top for collecting money. The accompanying brazier would have been used for heating water.

Fig. 481
Vendor's bench used for juicing fruits and vegetables, late Qing dynasty. Shanxi province. Collection of Just Anthony.

Fig. 482
Wheelbarrow, late Qing dynasty, Hebei. Collection of Just Anthony.

Fig. 480

Fig. 481

Fig. 482

Classical Versus Vernacular 185

Regional Differences

When people began actively collecting Chinese antique furniture in the mid-1980s, the focus was on "Ming style"—tastefully subdued pieces that had survived intact for 400 years because they were constructed from solid rosewoods. Collectors relied heavily on Wang Shixiang's seminal book, *Classical Chinese Furniture*, which mainly featured items from the coastal region of what was then known as Jiangnan, the land south of the Yangtze River. With his book as a style guide, the hardwoods of Jiangnan became the collectors' Holy Grail.

In the mid-twentieth century, academic scholars were enamored of Beijing- and Jiangnan-style furniture because of its refinement, but they were not the only styles to evolve over the centuries. The focus on these regions was partly due to the aesthetic preferences of academics, and partly due to the lack of access to other examples. When Wang Shixiang was first surveying furniture, a simple trek to the outskirts of Beijing was an adventure. Instead, he and others like Chen Zengbi relied on the furniture that made its way to the local markets.

In fairness, it is also extremely difficult to detect regional differences in classical Chinese furniture, particularly when assessing hardwoods. That is because design was standardized during the Ming dynasty. Carpenters outside Beijing were forced to do work rotations at the Imperial Palace workshop as a form of taxation. This practice of forced apprenticeship meant many carpenters were indoctrinated with rules laid down by their imperial masters. These basic styles also endured because many wealthy officials, who could afford hardwood furniture, wanted classic pieces without regional flourishes. In addition, trying to determine regional provenance is difficult because government officials frequently traveled. Thus, a table sourced by dealers in Anhui or Henan province might actually have been constructed in Guangzhou.

Interest in regional furniture grew after the sources of Ming-style hardwoods dried up in the early 1990s. When dealers began to expand their collections to include softwoods, they also began to

Fig. 484

Fig. 483 (opposite)
The central room in the courtyard house of Mei Lanfang (1894–1961), a celebrated actor of Peking opera, located in the Shichahai neighborhood in the Western District of Beijing.

Fig. 484
Typical Qing-style chairs and tea table, *changmu* (camphor), Suzhou region. Normally these would come in a set of eight chairs and four tables and be placed in a formal sitting room. Collection of Cola Ma.

Fig. 485

Fig. 486

Fig. 485
Book or display cabinet, *yumu* (northern elm), eighteenth century. This cabinet displays typical geometric features and craftsmanship from Jiangsu or Suzhou region. Photo courtesy Altfield Gallery.

Fig. 486
Jiangsu province is famous for its elegant furniture, such as this pair of nineteenth-century bamboo rose chairs and stand. Collection of Charles Wong.

explore provincial distinctions. Unfortunately, scholars have been slow to catch up with the dealers who have been peddling vernacular furniture at a rapid pace. With the exception of a handful of books, including Curtis Evart's book on Cola Ma's Shanxi furniture collection and Nancy Berliner's *Friends of the House*, very little has been written about vernacular furniture, including the lacquered cabinets from Fujian province or the ornate side chairs of Guangzhou.

Most softwood furniture today was made between the mid-Qing (1750s) and the Republican period (1912–49). During this time, furniture production filtered into all segments of society. Although carpenters were still influenced by designs generated from the workshops, most furniture was made to appeal to a local clientele whose commercial tastes differed from the élite. As a result, there was more innovation in regional softwood furniture, making it is easier for scholars and dealers to group the various classes.

Despite pitfalls in regional classification, dealers who travel far and wide to source furniture in China have identified different stylistic schools, including those in the provinces or regions of Jiangsu (in particular the city of Suzhou), Zhejiang (which also includes the port city of Ningbo which has its own distinctive style within the province), Guangdong province, Fujian province, Shanxi province, Beijing (or Northern style) and Shanghai. The main distinguishing factors are timber preferences, joint physiognomy, proportions and carving styles.

Suzhou Style or Jiangsu Style

Jiangsu furniture is largely represented in the seminal book by scholar Wang Shixiang. When people speak of Jiangsu furniture, they are usually referring to pieces made in the city of Suzhou, the former center of the entire Southern Yangzi region. This city is where much of China's most elegant furniture originates. Suzhou was along the Grand Canal linking Bejing to Hangzhou and was literally the regional hub of hardwood furniture during the Ming and early Qing dynasties. Some academics do suggest that other cities, such as Yangzhou, which was along the Canal, once rivaled Suzhou as a furniture center in the Ming and Qing periods.

As an economic power base, the city of Suzhou also became the center of scholarship and refined taste. Not surprisingly, furniture from the Jiangsu region is beautifully restrained. Even during periods of excessive design, such as the Qianlong period, furniture from Suzhou remained relatively subdued. Latticework and archaic jade patterns dominated. Carpenters also favored naturalistic designs, like imitation bamboo. While the best pieces were made of *huanghuali*, *yumu* (northern elm) was also common here.

Unlike their counterparts in Guangzhou, Jiangsu carpenters were miserly with materials. They reserved choice timber for important surfaces and used cheaper wood for the hidden elements. In order to camouflage the fact that they did not have huge pieces of hardwood to work with, they improvised by assembling large cabinets and tables using small

pieces of wood crafted into geometric patterns. It was as if they were emulating the old Chinese saying, "The best steel should be used to make the knife's edge." This approach was not only pragmatic but functional. Open latticework provided good ventilation in a hot climate.

This region has other signature elements. Early sloping-stile cabinets have round legs and exhibit a pronounced amount of splay. The joinery is also distinctive from that used in Guangdong province or the North. Generally speaking, carpenters from Jiangsu used hidden joinery. In other words, they did not cut through the tops of tables or legs to fit pieces together. The joints are cut halfway through. This was undoubtedly more time consuming, so in places like Guangdong province where they had to meet mass-production needs, many carpenters did not bother with such niceties. In the North, carpenters relied on traditional fifteenth-century techniques. The focus was on strength and little consideration was given to the surface, according to Taiwanese dealer Jerry Chen. In the South, the reason for through joinery was in part due to suspicious buyers. In order to avoid cheaply glued furniture, buyers wanted to see protruding joints to satisfy themselves that the furniture was properly made, according to Albert Chan.

Another typical feature of the region was the diagonal joins in a floating table top. Normally joins are perpendicular, but Jiangsu carpenters added their own creative flair. Moreover, chair seats tended to be made of rattan whereas they were wooden in other parts of the country. The late Qing chairs from this region also featured headrests and short armrests.

Fig. 487
Bench, *jichimu* (chicken wing), 1930s style. Private collection, Singapore.

Fig. 488
Altar table with everted edges and pierced carving along the side panels. This table was made for the élite. Photo courtesy Charles Wong.

Fig. 489
Side table with rounded leg braces, *huanghuali*, seventeenth century. It is also known as a summer and winter table because the legs can be shortened along one of the bamboo nodes. The table doubles as a *kang* table during the winter and as an eating table during the summer. Collection of Lu Ming Shi. Photo courtesy Grace Wu Bruce.

Regional Differences 189

Fig. 490

Fig. 491

Canton Style

The Pearl River delta and the city of Canton (now Guangzhou) were lively sea trading areas. When the imperial court finally lifted its shipping ban in the 1500s, the numbers of prosperous traders mushroomed. With wealth came demand for elaborate furniture, and it was said that business was so good that carpenters in Canton could make three times the salary of those working in other places.

Cantonese carpenters innovated joinery and their own style of design. They were also famous for developing a lacquering technique know as *kuan cai*, an engraved polychrome process adapted from Japan, initially developed in the 1600s for the export market. According to Craig Clunas, the technique was known as "Bantam work, after the port in Indonesia through which it was shipped." The design was carved into a thick coat of black lacquer and filled in with colored lacquers or oil paints. The style eventually petered out in the West, but a second technique "borrowed" from Japan, known as *maki-e*, in which gold power is dusted over an outline of wet lacquer, became so popular that for some time it was embraced by the imperial court and Cantonese workmen were sent to Beijing. As Clunas states, this was one of the first times the export market and domestic market co-mingled.

The southern Chinese liked to flaunt their wealth and no expense was spared. Cabinets and large pieces of furniture from Canton were often crafted out of solid blocks of timber, which obviously required access to choice imported wood. This form of extravagance ran counter to the philosophy practiced by cabinetmakers in Jiangsan who believed the best materials should be used only for key components, often piecing together geometric panels from smaller bits of wood.

Perhaps because craftsmen catered to their merchant clientele, the furniture of this region tends towards the ornate, some might say flamboyant. Carpenters liked to contrast brightly colored materials such as cloisonné enamel and marble with dark-grained woods such as *hongmu* (blackwood), which was especially popular during the late Qing. This sensibility spilled over to commissions from the Imperial Palace. Furniture crafted for the Imperial Palace by Cantonese carpenters had exaggerated proportions: extremely high waists and horseshoe-shaped feet with bold, rectangular scrolling.

A Cantonese chair can be distinguished from other regions by its especially straight and ornate back. Back splats often feature round pierced carvings or rounded marble inlays. By contrast, similar chairs from the Suzhou region feature a straight splat. Cantonese chairs and tables often have carvings on their aprons whereas carpenters from Suzhou would have been more restrained.

Canton was the gateway between China and the rest of the world, so it comes as no surprise that carpenters here were influenced by Western design. Romanesque architectural columns can be found in court furniture made from the region, and Western floral patterns were also common. This cross-pollination increased after British, Dutch, Swedish

and even Danish companies set up warehouses in the Canton port and ship captains dealing primarily in tea and export porcelain began profiteering by making side deals to export furniture and lacquerware. During the eighteenth century, Cantonese carpenters took orders for "export" furniture. It is unclear how much of their time was devoted to foreign buyers and how much to the domestic market. However, the Victoria and Albert Museum has a fine Secretaire bookcase in *huali* wood that was made in China around 1770. Based on the inscription, the carpenter was fully apprised of the function of the cabinet even though he had probably never seen a Western bookshelf before. The Danish Museum of Art and Design also has furniture imported in the mid-seventeenth century, including a cupboard lacquered in red, green and yellow with landscapes of streams and geese executed in high relief on the cabinet doors, and a throne-like chair with rich lacquer ornaments, including a five-clawed dragon, cloud scrolls and rocks. A bamboo chair dating to the late eighteenth century was found in a country manor home built by the Danish merchant Andreas Bodenhoff sometime between 1782 and 1795. According to the museum catalogue, it was common in Denmark, as in most other European countries, to "furnish single rooms or entire summerhouses and pavilions with Chinese furniture, wainscots, porcelain etc." Clunas also concludes that such commissions were not uncommon at the time. Export furniture from Canton ranged from cabinets with glossy matte black lacquer finishes and elaborate painted scenery to elongated side chairs that resembled the British Queen Anne style.

During the Republican period, another wave of export furniture came out of China. One factory specializing in this Westernized furniture was the Ng Sheong, which printed a catalogue more than 100 years ago with 200 pages of pattern designs for blackwood furniture. These elaborately carved pieces included a U-shaped chair that typifies the late Qing style from the Canton region, as well as Westernized side chairs with grapevine carvings. One armchair pattern is described as a copy of a seventeenth-century "Charles the Second" style.

Hundreds of pieces of blackwood furniture from Canton reached Britain. Albert Chan, a Hong Kong dealer who travels to Britain in search of antiques, says more than 90 percent of the so-called antique Chinese furniture found in London was built in this export style. As Chan notes, "Guangdong people put a lot of emphasis on what they eat, not where they sit." By contrast, Jiangsu carpenters paid more attention to architecture and furniture design.

Zhejiang Style

Zhejiang was a wealthy province during the late Qing and Republican period (1912–49) because its biggest city, Ningbo, was an active trading center. The province also abutted the city state of Shanghai, which was a major furniture center during the same period. While Ningbo has its own distinctive "style," it is difficult for dealers to distinguish furniture made in Shanghai from other parts of Zhejiang province. What is known is this: when dealers such as Albert Chan began buying antique furniture, much of what they bought from the government at trade fairs originated from the "Shanghai Concession" and is presumed to have come from Zhejiang province. Chairs from this region often had short arms and featured marble inserts such as those found on the meditation chairs shown in Figs. 492 and 493. Zhejiang furniture is

Fig. 492

Fig. 493

Fig. 490
Round-back chair with carved bamboo and grapevine design, *hongmu* (blackwood) and Dali marble inlay, early twentieth century, Canton. Photo courtesy Albert Chan.

Fig. 491
Rectangular-back armchair with open-carved *ruyi* scepters and a bat and a basket of peaches carved into the back splat, *hongmu* (blackwood), late nineteenth or early twentieth century, Canton. Photo courtesy Albert Chan.

Fig. 492
Meditation chair with marble back panel, *hongmu* (blackwood), nineteenth century, Zhejiang province. Photo courtesy Charles Wong.

Fig. 493
Meditation chair or bench from what is referred to as the Shanghai Concession. It was probably made in or around one of the workshops in Shanghai or Zhejiang province. Chairs featured marble inserts.

Fig. 494
Cabinet, red lacquer on *songmu* (pine), nineteenth century, Zhejiang province. Photo courtesy Hannah Chiang.

Fig. 495
Cabinet, red lacquer on *shanmu* (fir), nineteenth century, Ningbo. Most cabinets of this type are made of fir. Collection of Cola Ma.

Fig. 496
Horseshoe-back vernacular chair, *hongmu* (blackwood), nineteenth century, Zhejiang province. The detail shows the chair grip. Collection of Hannah Chiang.

Fig. 497
Side chair, *yumu* (northern elm), nineteenth or early twentieth century, Ningbo. Collection of Hannah Chiang.

Fig. 498
Southern official's armchair with slat seats, *hetaomu* (walnut) and bamboo, seventeenth century, Zhejiang province. There are few examples of these flush-side seats. Photo courtesy Oi Ling Chiang.

Fig. 494

Fig. 495

Fig. 496

Fig. 497

Fig. 498

also distinctive in its use of red lacquer and panel inserts (Fig. 499). Its also leans towards a more folksy style compared to furniture from Jiangsu province.

Within this province, the port city of Ningbo produced its own distinctive, less refined style of furniture during the late Qing and Republican period (Figs. 494–497, 499–503). Cabinetmakers used cheaper, light-colored woods such as fir, and also liked to combine dark and light woods, as seen in Fig. 499, a typical cabinet from the region. Red carved furniture is a distinctive factor in Ningbo, according to Nancy Berliner, although other regions such as Sichuan and Hunan also do some red carving and this can cause confusion.

Many folk stories, legends or daily operas are incorporated into the carving styles of this region. This characteristic is shared by Hubei, Shanxi and Hunan provinces. In the North, however, the carving is more simple and straightforward, focusing on a single thought or motif. In the South, carving can be excessive, with each panel on a canopy bed or door frame telling a snippet of story. The Eight Immortals are recurring characters, as are scenes from novels laden with symbolism, such as the famous book *Dream of the Red Mansion*. Other symbols that are popular are the eight auspicious symbols from Buddhist teachings which are believed to grant protection and bring prosperity.

Fig. 499

Fig. 500

Fig. 501

Fig. 502

Fig. 503

Fig. 499
Red lacquer-finished cabinet in a very classical design described by Wang Shixiang, nineteenth century, Zhejiang province. This is a more refined cabinet compared to the others. Collection of Cola Ma.

Fig. 500
Cabinet, burgundy lacquer on cedar, nineteenth century, Zhejiang province. Collection of Hannah Chiang.

Fig. 501
Cabinet, *jumu* (southern elm) and *hongmu* (blackwood), nineteenth century, Ningbo. Photo courtesy Hannah Chiang.

Fig. 502
Writing desk, *jumu* (southern elm), nineteenth century, Zhejiang province. Photo courtesy Altfield Gallery.

Fig. 503
Three-drawer table, red lacquer, late nineteenth or early twentieth century. Zhejiang province. Photo courtesy Altfield Gallery.

Fig. 504

Fig. 505

Shanghai Art Deco

During the late Qing and early Republican period, Shanghai became a major export center, and as a result many furniture workshops sprouted up in and around the city. Although it is difficult to distinguish furniture that was made for the domestic market, there were some distinct styles of furniture made for Western clients or for the export market, the most famous being the Shanghai Art Deco style—a type of furniture often overlooked by academics but coveted by collectors today. Shanghai was not the only concession port that made Art Deco furniture. The ports of Qingdao, Tianjin and Canton also made it, but nowhere was it as popular as in Shanghai. Here, too, the wood types—*hongmu* (blackwood) and *zuomu* (oak)—and craftsmanship were supreme.

Art Deco furniture was a great leap forward in Chinese design. New styles, such as multi-level dressing tables with mirrors, suddenly became part of the Chinese furniture lexicon. Today, Art Deco furniture has become all the rage in showrooms in New York and London. Its sweeping corners and angular profiles are still considered the height of chic—the ultimate blend of East meets West. While the design was pure European, Art Deco furniture was put together without nails, using perfect diagonal mitered corners instead of Western-style right angles, according to dealer Hannah Chiang. The finish is also typically Chinese: high-gloss lacquer rather than the French polish associated with Western carpenters (Fig. 510).

Shanghai Art Deco furniture was usually made of blackwood (*hongmu*) and featured lighter colored burl wood panels. Other styles were the earlier Arts and Crafts style, but even Art Nouveau and Biedermeier-style furniture was commissioned by foreigners in the 1920s and 1930s. Many pieces of furniture sourced by Hong Kong dealers were also obviously fashioned after the designs of Austrian designer Michael Thonet, who had a studio in Vienna and was the progenitor of the "bentwood" furniture, as seen in earlier rocking chairs, and the round-seated bistro chair which inspired many versions in China—and elsewhere.

"Foreigners were the most likely customers of local craftsmen, although there were probably some Westernized Chinese who also wanted something out

Fig. 506

Fig. 507

Figs. 504, 505
Art Deco and Art Nouveau furniture from the 1920s Shanghai era are all the rage in fashionable homes from New York to Paris. The curved armchairs featured in Curtis Evarts' Shanghai home are in such demand that asking prices in chic Soho galleries go as high as $15,000.

Fig. 506
Colonial-style chair, made in Shanghai for Western clients, 1920s. These look very much like the chairs found in music rooms in Western Europe. Collection of Cola Ma.

Fig. 507
Republican chair with Western influences, *hongmu* (blackwood), twentieth century, Shanghai. Collection of Hannah Chiang.

Fig. 508
Republican chairs from Shanghai, *hongmu* (blackwood), grace the home of Cola Ma. These chairs are reminiscent of the nineteenth-century upholstered chairs designed by John Henry Beller.

of the ordinary when they ordered furniture," says Chiang. That would have been easy by the turn of the twentieth century, according to John Heskett, professor at Hong Kong's Polytechnic University's School of Design. Design magazines published at the end of the 1800s, such as the London-based *The Studio* and the German magazine *Kunst und Dekoration*, were easy to transport. "Their format included heavily illustrated articles on furniture and furnishings, among other things, often with very nice colored lithographs of complete room settings by leading architects and designers," he says. Great for copying. If that were not enough, the A. W. Gamage catalogues of London (ca. 1920s) were also replete with illustrations.

Fig. 508

Regional Differences 195

Fig. 509

Fig. 510

Fig. 511

Fig. 512

Fig. 513

Fig. 514

Fig. 509
Art Deco-style dressing cabinet, *changmu* (camphor). Collection of Just Anthony.

Fig. 510
Art Deco-style desk featuring floral knobs, *hongmu* (blackwood), twentieth century, Shanghai. Photo courtesy Art of Chen.

Fig. 511
Art Deco-style dressing cabinet, *yumu* (northern elm). Collection of of Just Anthony.

Fig. 512
Art Deco-style mirror stand, *hongmu* (blackwood) and spotted bamboo, early twentieth century, Shanghai. Photo courtesy Curtis Evarts.

Fig. 513
Art Deco-style dressing table, *hongmu* (blackwood), twentieth century, Shanghai. Collection of Hannah Chiang.

Fig. 514
Art Deco-inspired chair, *hongmu* (blackwood), nineteenth century, Guangdong province. Although the bulk of these chairs came from Shanghai, other port cities like Canton and Tianjin also produced such items. Collection of Hannah Chiang.

Northern Styles

When foreigners living in China first began collecting Chinese furniture in the northern capital of Beijing, they assumed that much of the fine furniture was local. However, as more research went into Chinese furniture it became clear that this was not always so. Previous owners were usually families of scholar-officials, whose duties required them to move from one regional posting to another. The most difficult genre to pinpoint is the Beijing style because so many carpenters had rotational work terms in palace workshops, creating a cross-pollination of styles. Chinese professor Chen Zengbi says Beijing furniture can be identified by what it is not: it does not have the lightness and grace of the Jiangsu style. It does not have the weight of the Shanxi style. It is more closely related to the imperial style with an emphasis on craftsmanship and patterns related to the emperor, such as the phoenix and dragon, particularly what is known as the D-form dragon.

These features are illustrated in two benches (Fig. 517). The Beijing bench or table above is more refined and has beaded legs. On the bottom is an unusual coffer table or chest from Shanxi featuring dense carving. The square table in Fig. 516 is also an example of the Beijing style.

Fig. 515

Fig. 516

Fig. 517

Fig. 515
Beijing-style cabinet with fretwork decorating the front panels. Photo courtesy Art of Chen.

Fig. 516
Square Eight Immortals table. Academic Chen Zhengbi believes this table probably came from either Beijing or Hubei because of its unusual cloud pattern spandrels. It has a high degree of workmanship, far more than most furniture from the North, but does not have the delicacy of tables from the Jiangnan region. Collection of Chen Zengbi.

Fig. 517
Heavy coffer table from Shanxi province (below) and a lighter table from the South (above). Collection of Chen Zengbi.

Regional Differences 197

Fig. 518

Fig. 519

Fig. 520

Fig. 521

Fig. 518
Fur storage chest on stand, *changmu* (camphor), nineteenth century, Hebei province. Photo courtesy Altfield Gallery.

Fig. 519
Side table with recessed legs and round legs supported by side spandrels in the shape of a cloud and giant arm braces, black lacquer, seventeenth century, Hebei province. Despite the heavy structure, the detailing is fine. Photo courtesy Art of Chen.

Fig. 520
Heavy bookshelf with open pierced carving on the lower apron of the cabinet and bookshelves, Hebei province. Photo courtesy Art of Chen.

Fig. 521
Pair of side chairs, *yumu* (northern elm) with cane seats and back panels, nineteenth century, Hebei province. Photo courtesy Altfield Gallery.

Fig. 522
Display cabinet with heavy proportions classic of so-called Northern styles, *changmu* (camphor), eighteenth century, Hebei province. Photo courtesy Altfield Gallery.

Fig. 522

Fig. 523

Fig. 524

The decorative fretwork spanning the legs and table top is unique to Beijing. Cantonese tables also have fretwork but not with this design (Fig. 520).

In general, Northern furniture features fat legs and sturdy joinery (Figs. 522, 523). Even the pair of side chairs from Hebei province in Fig. 521 shows a boxier bottom than chairs from the more refined region of Jiangsu. Another distinguishing factor is the function. For example, furniture made for the storage of heavy winter clothing is obviously more prevalent in the North, such as the camphor chest from Hebei province that was probably designed for furs (Fig. 518). Among the so-called Northern furniture styles, Hebei province (with its proximity to Beijing) tends to have more added features, such as the decorative spandrels of the side table in Fig. 519.

Shanxi Style

Shanxi furniture is well represented in the marketplace today. Its abundance can be attributed to the fact that the region was cut off from the rest of China by the Taihang mountain range and became accessible only after the mid-1990s when China's economic policies opened up the poorer regions. Because of its isolation, Shanxi was also less susceptible to political upheavals, such as the Taiping Revolution (1865), the Qing overthrow (1911) and the Cultural Revolution (1966–76). It was also blessed with an abundance of coal, a factor that saved old furniture from being burned as firewood.

Shanxi furniture is well documented thanks to Tianjin-based dealer Cola Ma, who collected from this region and hired Curtis Evarts to write a book about his collection in 1999. This regional style of furniture intrigued Ma because it featured archaic forms, such as the low day bed with flush corner legs (also known as *ta*), and ornate coffer tables with multi-layered floral patterns and cabriole legs.

Shanxi was a place frozen in time. The province formed part of China's cultural heartland from 386 to the 1400, when it served as a buffer state between Central Asia and China proper. Salt barons and trade merchants who settled here became rich, built large mansions and filled them with furniture. It remained a prosperous

Fig. 523
Cabinet, black lacquer on *huaimu* (locust), seventeenth century, Shanxi province. This style resembles many pottery models excavated from burial sites in Shanxi and Shaanxi provinces. Photo courtesy Cola Ma.

Fig. 524
Cabinet with recessed legs and an overhanging cap frame, red lacquer on *yumu* (northern elm), Shanxi province. The legs do not splay and there is no central removable stile. The door panels show a continuous landscape scene with villages dotting the shores of a central lake. Photo courtesy Cola Ma.

Fig. 525

Fig. 525
Panel of a scroll table leg showing pierced carving with beaded edges of a wish-fulfilling *ruyi*. This design was especially popular in China. Collection of Fan Rong.

Fig. 526

region until the mid-Ming era. But hard times followed, and the once-wealthy families were forced to economize. Rather than commission new furniture for auspicious occasions, old solid wood pieces were passed down from generation to generation, making Shanxi a Mecca for antique dealers.

As an impoverished region, cut off from its neighbors, Shanxi clung to many of its old customs, including furniture design that echoes dynasties long past. To the untrained eye, there are some obvious characteristics of the Shanxi style. Its closest cousin is Shandong province vernacular furniture. One distinguishing factor is the use of period coins that serve as escutcheon mounts on cabinets and coffer tables. Other elements are less obvious. Cabinets from Shanxi are more box-like than in other provinces. While the early round-leg tapered cabinets from the Suzhou region exhibit a pronounced amount of splay, those from Shanxi are more parallel. Some cabinets even have short cabriole legs, which is highly unusual. Another distinctive style of cabinet from the region resembles the pottery model cabinets found in tombs (Fig. 523).

Many of the large Shanxi cabinets were lacquered red and feature fine gold paintings, the most popular being classical landscapes (Figs. 524, 526). Some pieces are so well crafted that the artist has signed his name. Another hallmark

Fig. 527

Fig. 528

Chinese Furniture

of Shanxi furniture is its deep and florid carving, often featuring zoomorphic and floral designs as well as multiple pierced geometric designs. Although employed throughout China, the wish-fulfilling *ruyi* was especially popular in Shanxi (Fig. 525). (Ruyi are loosely associated with auspicious clouds and the magical *lingzhi* fungus, which symbolizes good fortune and happiness.)

Some types of furniture found in Shanxi have not been found elsewhere. Remarkably long benches, most likely used for operatic performances, have been sourced in the province and occur nowhere else. Another inventive piece of furniture, known as a *nuanyi*, or a chair with a built-in coal heater to warm the user's bottom, was found in Shanxi province by dealer Hannah Chiang (Fig. 463, page 180). Coffer tables with paneled lower drawers are also characteristic of the region (Figs. 527, 529).

Shanxi furniture, unless made of hardwood, was not considered collectible until recently. Cola Ma is hoping to change that. Much of the furniture made in this province is of *yumu*, *hetaomu*, *huaimu* or *yangmu*. Ma has focused on *hetaomu* (walnut) furniture. Although not highly ranked among Chinese collectors, *hetaomu* is a much-desired wood in North America. Ma has astutely surmised that antique walnut furniture in archaic forms will one day be highly desirable.

Fig. 529

Fig. 530

Fig. 531

Fig. 532

Fig. 526
Cabinet with recessed legs and an overhanging cap frame, red lacquer on *yumu* (northern elm), eighteenth century, Shanxi province. The legs do not splay and there is no central removable stile. Narrow vertical side panels flank the doors. The apron, which has carved dragons and a central foliated *ruyi*, has two drawers and a lidded storage compartment. Landscape and garden scenes depicting famous figures from ancient stories are carved on the panels. Photo courtesy Cola Ma.

Fig. 527
Coffer table with two drawers and four aprons angled out of the corners of the table, late Qing dynasty, Shanxi province. Collection of Just Anthony.

Fig. 528
Storage coffer, *hetaomu* (walnut), late nineteenth century, Gansu province. This is an example of the plain carving style characteristic of this region. Photo courtesy Altfield Gallery.

Fig. 529
Altar coffer with paneled lower drawers, *yumu* (northern elm), nineteenth century, Shanxi province. Photo courtesy Altfield Gallery.

Fig. 530
Altar coffer table, *hetaomu* (walnut), late nineteenth century, either from Shaanxi or Gansu province. This is an example of a plain coffer that could come from either of these provinces. Along border areas it is often difficult to distinguish the exact origin of these pieces. Photo courtesy Altfield Gallery.

Fig. 531
Altar table, *hetaomu* (walnut), nineteenth century, Gansu province. Note the high everted edges of the table. Photo courtesy Altfield Gallery.

Fig. 532
Painting table with L-shaped notched legs and highly exaggerated everted edges resembling the lips of a bronze vessel, red lacquer, seventeenth century. The rectangular table top consists of one piece of wood set within a frame. Probably made in a remote area of Shaanxi or Gansu province. Photo courtesy Art of Chen.

Regional Differences 201

Fig. 533

Fig. 534

Fig. 533
Cabinet with stylized legs but little decoration, *yumu* (northern elm), late nineteenth century, Gansu province. Photo courtesy Altfield Gallery.

Fig. 534
Cabinet, black lacquer and gilt, with ornate pierced carving typical of the region, late nineteenth century, Fujian province. Carvings on furniture frequently depict the Immortals or illustrate Chinese opera stories. Collection of Cola Ma.

Other furniture from the northern regions of Shandong, Henan and Gansu share similar characteristics to Shanxi and Shaanxi, but their carving styles are often less sophisticated. Gansu furniture, for instance, is distinctive because of the short cabriole legs on cabinets, the simplicity of structure, and the plain carving styles (Figs 528, 531, 533). Variations are few, but there is one major trait—the leg of many Gansu tables is in an L-shape and altar tables sometimes have exaggerated everted edges which look like the lips of a bronze vessel (Fig. 532). In the South, the everted edges are an extension of a table top; in Gansu, they look like book ends.

Despite this, the borders are fuzzy, and determining whether a piece of furniture is from Shanxi, Hunan, Gansu, Shaanxi or Shandong can be difficult (Fig. 530). Take for instance, the furniture found in Yuncheng, Shanxi, which was once a major furniture center. Because the town is on the border of Shanxi, Shaanxi and Hunan provinces, it is difficult to determine what exactly came from these different provinces. In Datong, the northern corner of Shanxi next to Mongolia, the furniture styles also blur and regionalization is an inexact science.

Fujian Style

The coastal province of Fujian has also given rise to its own distinctive style of vernacular furniture. Like Shanxi province, Fujian was a wealthy region in the late Ming and early Qing dynasties. According to John Ang, a number of spectacular pieces were discovered in the province between 1990 and 1993. He concludes that early Fujianese furniture resembled Suzhou-style furniture but was often made of *longyan* wood. Fujian pieces can look "stiffer and more angular in form than most examples of Suzhou furniture which usually have softer-looking well-rounded edges and corners." Another genre favored in Fujian was simulated bamboo furniture, which coincidentally was popular among Suzhou carpenters.

The Suzhou-type style morphed over time as Fujianese merchants began importing woods like *jichimu* (chicken wing). This hardwood was so favored by Fujianese that about 80 percent of all *jichimu* furniture on the market is from the region. Jerry Chen, however, points out that *jichimu*

202 Chinese Furniture

wood in the North is yellow in character (and possibly imported), whereas most of the furniture in Fujian province is made from the lesser grade black *jichimu*. While *jichimu* was popular, less expensive pieces from the region are made of fir and pine.

Fujian furniture can be exquisitely refined, especially those pieces made of *longyan* wood, or the elaborately carved platform bed made from *hongmu* and inlaid with *huangyangmu* in Fig. 305 (page 119). Like its counterparts in Guangdong, however, Fujian furniture tends to have thicker proportions than furniture from Suzhou. The legs of Fujian cabinets also tend to be longer than on cabinets found elsewhere, with floral-looking bulges or pumpkin-like knobs where the apron meets the spandrels (Fig. 535). The legs of late Qing tables or stools from the region tend to have high horseshoe-shaped feet. Another typical feature is the way the legs join seat frames without aprons. The need to embellish humpback stretchers with designs such as a central double-coin, bamboo stems and specially indented or pointed ruyi-shaped designs and sharp angular humpback stretchers seemed to preoccupy Fujianese carpenters. Also popular are the elongated metal brass plates found on many cabinets. Cabriole legs that end with outward-pointed feet are also quintessential design features from the region.

One specific style of furniture from Fujian is the "D-form" (hexagonal half-moon) table. Some of these have low-lying lattice panels that serve as a bottom shelf. Another Fujianese feature is the extremely high backs and side boards of couch beds, and the fact that in some examples the horseshoe feet are raised off the ground by small balls at their base. Like the southern patrons of Canton, the Fujianese were interested in displays of wealth and excess, splurging on sizeable slabs of wood (Figs. 535–538).

Red lacquer was commonly used in Fujian during the Qing dynasty, particularly for the unusually large wardrobe cabinets with their hallmark butterfly lock plates and embedded decorative glass. Often these lacquered pieces were decorated with gold leaf to show wealth, and featured ornate carvings.

Fig. 535

Fig. 536

Fig. 537

Fig. 538

Fig. 535
Cabinet notable for its butterfly lock plates and unusually large size, red lacquer on *songmu* (pine), nineteenth century, Fujian province. Also note the floral looking bulges. Collection of Hannah Chiang.

Fig. 536
Cabinet with unusual inlay image of a vase on the panels, *baimu* (cypress), red bean and *songmu* (pine), nineteenth century, Fujian province. Collection of Hannah Chiang.

Fig. 537
Cabinet, red lacquer on *songmu* (pine), nineteenth century, Fujian province. Collection of Hannah Chiang.

Fig. 538
Pair of tables, red and black lacquer on *songmu* (pine), with gilt sides, nineteenth century, Fujian province. These tables are common in the marketplace and are frequently copied because they make good bedside tables. Traditionally, these small tables were embedded in canopy beds and used to store valuables. Collection of Hannah Chiang.

Regional Differences

Chinese Furniture

To Strip or Not to Strip

To strip or not to strip, that is the question. When the first wave of furniture came out of China in the early 1980s, the first impulse was to strip down the lacquer and dirt to expose the beauty of the wood. Hong Kong craftsmen, more familiar with blackwood furniture, used traditional methods of restoration. This usually involved softening the wood with water before scraping away the old surface and adding a layer of wax or shellac. This method is often referred to as the "French polish" finish.

Should furniture be refinished to look as it might have looked the day it left the carpenter's workshop a hundred or more years ago? Should it look shiny and new? Or should it look like it has lived more than a hundred years? Do you celebrate the wear and tear, preserving the patina of a piece?

As Amanda Clark of Altfield points out, most shoppers looking for a decorative piece to accent their home want furniture that blends into their décor. They want furniture that looks clean and polished and not as if it has just been dropped off a truck from Shanxi province.

Fig. 539 (opposite)
Reproduction of a sloping-stile cabinet with old carved panels inserted. Photo courtesy Art of Chen.

Fig. 540
Charles Wong, who started his career as a furniture restorer in Hong Kong, now deals in furniture in addition to repairing it. He is considered one of the best restorers of Chinese antique furniture.

Fig. 540

Fig. 541

But what about the serious collector? Even among this group there are dissenters. Dealers such as Grace Wu Bruce do not believe classical Ming furniture was ever heavily lacquered and advocate removing all dirt and existing lacquer layers to return the furniture to its original state. She asserts: "The notion that restoration or polishing might remove the original finish on the furniture does not hold water with me. I have never seen a piece to convince me that any of these hardwood pieces has an 'original' finish other than wax when they were first made, except of course what is on the underside and the interior." Wax was not a Chinese custom, but a Western one, adopted by the Chinese in the early twentieth century, so it is not necessary to preserve it.

Fig. 541
Tools in a contemporary restoration workshop in Hong Kong.

Fig. 542
Wong keeps pieces of old *huanghuali* for use when matching the wood grains of a piece of furniture for a seamless repair.

Fig. 542

206 Chinese Furniture

Others disagree. The UK restorer Christopher Cooke is not a fan of the "consistently yellow, honey-colored furniture" that was the norm for *huanghuali* Ming-style furniture. "The sanitized yellow surface we so often see today is the product of overzealous restoration," he says. In the early days along Hong Kong's Hollywood Road, "hundreds of pieces were scraped and sanded, and their patination ignominiously removed and hosed down to join the detritus of the city in Hong Kong's gutters."

Cooke and a handful of other dealers now insist that all efforts should be made to retain whatever lacquer remains on a piece. Rather than strip and wax, they remove dirt without disturbing the oxidized surface. "To remove all surface waste would be to deny the history of the piece," says Cooke. "Patina is the magic; without it, there is nothing."

Taipei-based dealer/scholar John Ang agrees. The patina formed after years of weathering and use creates a desirable aesthetic or *puzhou*, he says. Softer woods weather more unevenly. The *puzhou* of an armchair is one that shows signs of a grip, or a table that shows an ink stain or water ring. These signs of age have become more desirable among collectors today.

Restoring and repairing Chinese furniture was never an easy task. It is no different today, and it is fair to say that the price of antique furniture is partly dependent on the quality of restoration. When buying old furniture, check out the restoration work. Does the store have its own workshop so it can monitor quality control? What are the restoration techniques that are employed? If you like French polish, buy from someone who does it well. If you prefer a less glossy look, turn to dealers who are trying to preserve the patina. The upside is that it makes the surface uniform and stops softwoods from warping because of the humidity, says dealer Albert Chan. "I put on a bit of shellac because wax fades in one year."

In the past, Chinese carpenters generally made their own sets of tools. An inked line, used to measure surfaces, was indispensable—and a piece of art in itself (Fig. 544). Dealers like Hong Kong-based Charles Wong continue to use traditional wooden hammers and hand drills to reconstruct furniture. Even palm tree brushes and bamboo implements are still used to polish surfaces (Fig. 541). If there is a large crack or gap, Wong repairs it by inserting a piece of wood similar in style and texture to the furniture. Often, restorers must rebuild a tenon to refit a join (Figs. 542, 543). For the final touches, he uses simple "Briwax," a product that contains beeswax and carnauba wax.

To prevent overzealous cleaning, Cooke says restorers should avoid oxalic acid stripper and instead use gentle water-soluble removers. Acid strippers open the pores of the wood, and the aggravated pores are then difficult to fill. As a result, it can leave surfaces pock-marked. "Stripping is alteration, not preservation," he argues. "Only if the piece is really dirty will we use it," says Wong, who prefers simple rubbing alcohol.

As a collector, it is important to develop a critical eye for restoration. The state of repair can give buyers clues about the authenticity of a piece. About one-third of all furniture sold as antique in Hong Kong, for example, is actually new furniture made to look old, while most of the rest is furniture restored to varying

Fig. 543

Fig. 544

Fig. 543
The spandrel of a large *zitan* standing marble screen from the Qianlong period which Wong is repairing. Some of the carving has been broken and new pieces will have to be inserted and recarved.

Fig. 544
Antique measuring device used by carpenters to make chalk lines. Inked lines survived in greater numbers because they were indispensable to anyone who worked in cabinetry or construction, to ensure proper proportions. Chinese carpenters generally had their own sets of tools which they made themselves. Collection of Andy Hei.

Fig. 545
Cabinet, red lacquer with gilt lotus decoration, nineteenth century, Shanxi province. This is an example of a fine cabinet with badly replaced aprons. Before selling the cabinet, Altfield removed them. Photo courtesy Altfield Gallery.

Fig. 546
Reproduction of a square-corner cabinet with old carved panels inserted. Photo courtesy Art of Chen.

Fig. 547
Many buyers do not care whether the furniture is new or old as long as it looks good. Can you tell whether this cabinet is new or old? It is brand new. Designer Jerry Chen's company, Ancient and Modern Furniture and Design, is based in Shanghai. Photo courtesy Art of Chen.

Fig. 545

Fig. 546

Fig. 547

degrees. It is common practice for an antique to be disassembled and its components used to make new items of furniture (Figs. 545, 549). Forgers even developed techniques to prematurely age wood and convincingly crack the surface lacquer so that the patina appears to be from the Qing or Ming dynasty. Often they will use metal brushes and steel wool to make the surface look rough, and even bury the furniture in mud to "age" it.

Some pieces have their legs sawn off to reduce height and others have been converted from a standard look to something more rare and desirable. For example, small side tables are popular in modern homes, so square tables are sometimes altered to make smaller pieces of furniture. Scraping off decorative carving is a popular trick when a seller wants to pass off a Qing-era piece as Ming (Fig. 554). Another way to increase prices is to add rare elements such as S-shaped braces to a standard square table.

Many alterations, however, are considered acceptable in the antiques business. It is quite common to repair the bottom apron of a cabinet or the foot of a table. Take the cabinet in Fig. 545, for instance. The apron on the bottom was obviously repaired at some point and feels out of place. When Altfield restored the cabinet, the unsightly apron was removed.

But when is a piece of furniture restored to such a degree that it can no longer be considered antique? There is no simple answer. In principle, the goal of restoration is clear: to return the piece to the condition that would seem to be in character with its estimated age. No one advocates leaving furniture totally untouched. "To keep it in 'as found' condition would deprive the world of what is hiding below its gray and dismal exterior," says Cooke. But in practice it is more complicated.

Most furniture has broken components and stains. While repairs are necessary, a good restorer will do his best to avoid epoxy and other adhesives when reassembling furniture. One recipe passed down over the ages is a natural adhesive jelly derived from fish. This is sometimes painted into the joints, but easily dissolves when put in hot water. Joints must accommodate the shrinkage and expansion that occurs with humidity and heat fluctuations. Floating panels in table tops or cabinet doors are prone to shrinkage. As a result, adhesives are rarely applied to these types of panels. But one new technology that is being used in studios is

Fig. 548
Christopher Cooke, a restorer based in the UK, lovingly restores a folding horseshoe-shaped chair for auction.

Fig. 549
Long storage cabinet, red lacquer, late nineteenth century, Zhejiang province. This is another example of a cabinet with replaced aprons. Photo courtesy Altfield Gallery.

Fig. 548

Fig. 549

To Strip or Not to Strip

Fig. 550
This stylized red lacquer kitchen cabinet has decorative panels from doors inserted into the top. Photo courtesy Art of Chen.

Fig. 551
Day bed with cane seat mat, *yumu* (northern elm), late nineteenth to early twentieth century. The length of this day bed has been reduced, as it should be long enough for a man to stretch out. Photo courtesy Altfield Gallery.

Fig. 552
The restoration of a cane seat of a *huanghuali* humpback stool.

Fig. 553
Square *kang* table, the frame carved to simulate bamboo poles, *huanghuali*, ca. seventeenth century. This is an example of the literati taste of simulating mundane bamboo into precious woods. and is a really realistic depiction. Collection of Dr S.Y.Yip. Photo courtesy Grace Wu Bruce.

Fig. 554
Nice carvings such as that found on the skirt of this chair are sometimes scraped away by unscrupulous dealers hoping to pass off a piece as a classical Ming item.

Fig. 550

Fig. 551

Fig. 552

Fig. 553

Fig. 554

210 Chinese Furniture

Fig. 555

Fig. 556

Fig. 557

Fig. 558

Fig. 559

Fig. 560

the use of cyanacrylate, a strong bonding glue used to repair hairline cracks in joins (Fig. 548).

If it looks as if nothing has been touched on a piece of furniture, then the repairs are good, says Wong. If the gaps between the panels are too large, it is not a good job. Repairs should be difficult to detect, and a table should sit flat on the floor with its legs tapered evenly. A good carpenter will smooth out the warps.

Wong considers it reasonable to expect that some furniture parts will be replaced. A repaired or replaced apron skirt on a chair is acceptable. Another common restoration is to replace the cane weave on the seats of chairs and benches—a complicated procedure that requires weaving fibers through holes in the chair seat (Fig. 552). But Wong draws the line at replacing a missing back panel—a critical part of the chair—entire legs, or table tops. By this criteria, many

pieces of furniture available at markets like Zhuhai in Guangdong province have been heavily restored. If a piece of furniture has been reassembled using multiple pieces of old furniture or timber, it cannot be classed as antique at all.

While not "collectible," much of the heavily restored furniture on the market is still great value for money. The pieces are made of solid wood, crafted by hand, and as inexpensive as build-it-yourself furniture. And while some wholesalers try to pass off reassembled furniture as true antiques, many dealers are now upfront about reproductions (Figs. 539, 546). Dealer Zafer Islam, who runs a wholesale operation from Panyu selling both antiques and reproductions, has discovered that there are many buyers who "don't care if it's half new and half old." Sometimes his company takes old doors and creates a new bookshelf by using them as shelves or the decorative top

Figs. 555–557
Medicine chests of the Qing dynasty have been elongated and reformatted to make the perfect container for CDs and DVDs. They also double up as TV stands. Photos courtesy Art of Chen.

Figs. 558–560
A new take on the old Tang-style day bed, with curved openings and bottom stretchers found in old tombs. Jerry Chen gives Tang a twist with his modern versions of benches and chests. Photos courtesy Art of Chen.

To Strip or Not to Strip 211

Fig. 561

of a new coffee table. All that matters is that the piece looks good and is affordable (Figs. 547, 550, 551, 553).

Not surprisingly, as the number of antiques in the market diminishes, more dealers are reinventing themselves as designers. "There is not enough old material to go around any more, so making new furniture was a natural development for the workshops that were already in place," says Curtis Evarts. "Most of these dealers haven't stopped dealing in antique furniture, but they can no longer depend on volume trade for sustenance and are positioning themselves for the future." Call it "Ming-style ca. 2005." Centuries-old forms are meeting twenty-first century function. The traditional medicine cabinet, used to store herbs, has been redesigned as a CD holder (Figs. 555–557). A Gansu-style painting table has been given a sleek Scandinavian makeover and now serves as a dining table. Nothing is sacred. Even official document boxes, popular in the eighteenth century, have inspired a new version of the humble tissue holder.

Drawing inspiration from the past, people like Jerry Chen of Taiwan-based Art of Chen are shaking up the traditions laid out in early carpentry manuals. After years of studying and restoring old furniture, he is giving the old dynastic models a make-over. A Tang-dynasty box platform is grafted on to a Ming-style sloping-stile cabinet and modern day chests (Figs 558, 559), and a Song-style side table is now stackable. The color palette of yesterday has been expanded. While classic red and black lacquers are still available, Chen has also developed an aged-looking cracked finish in modern shades such as turquoise and lime green.

The new Ming manufacturers are not shying away from mixed media either. In the horseshoe-shaped chair in Fig. 561, designed by Barrie Ho, steel legs are used to contrast the hard chair seat and back splat. Architect Henry Wang, who also owns an antique store in Shanghai, is marrying Chinese chic and Japanese aesthetics in a line of furniture that breaks away from the past. Here, the curved armrest of a horseshoe chair is fused to the *tatami* mat culture (Fig. 562). This highly stylized take of the reception hall has the top half of an official's armchair suspended above, to serve as a pole for a silk wall hanging (Fig. 563). This is a break with tradition, and a possible signal that China is ready to once again lead the world in interior design.

"Every era contributed something to the evolution of furniture, but during the Cultural Revolution everything went dark," says Julie Ting of Art of Chen. There was no design, no tweaking of the old formula, she says. That is all changing today. The emergence of this new design wave in China is picking up where the Art Deco innovators of the 1930s left off. Driven by both Western tastes and local demands, Chinese furniture is entering an innovative phase. The new designers will no doubt create a new aesthetic that will be studied by generations to come.

Fig. 561
Architect Barrie Ho combines wood and steel in a contemporary version of the classic horseshoe-shaped chair.

Fig. 562
Architect Henry Wang marries Chinese chic and Japanese aesthetics in a line of furniture he is selling alongside antiques in his Shanghai-based store.

Fig. 563
Henry Wang's stylized take on a yoke-back armchair for a Shanghai Art Museum exhibition featuring new Chinese furniture design.

Fig. 562

Fig. 563

To Strip or Not to Strip 213

214 Chinese Furniture

May the Buyer Beware!

The markets in China are brimming with Chinese furniture. One of the largest, the Zhuhai market, a fifteen-minute drive from Macau, is a Mecca for antique hunters, both amateur and professional. The southern province of Guangdong is the heartland of a growing industry fed by workshops in Zhuhai, Zhongshan, Jiangmen and Panyu. Its scale is overwhelming: makeshift shops line either side of several lanes stretching for hundreds of meters. The stalls overflow with furniture and homeware: red lacquer wedding cabinets, carved courtyard screens, rectangular stools, horseshoe armchairs, lacquer baskets, terracotta horses and Tibetan chests. But for every real antique here there are dozens of fakes and reconstructed pieces. As the supply of old Chinese furniture diminishes, more and more dealers are switching to replicas to feed a global appetite for the fashionable Oriental look.

Here, merchants like Li Chang try to sell dirt-encrusted furniture outside their shop. Some of the 6 foot (1.8 meter) doors have seen better days—the paint is peeling and the iron fixtures are corroded—but they have the aged finish that many are seeking. But are they over 100 years old, and thus antique, or were they made yesterday? On the street, Li wavers before finally telling the truth. The doors, he admits, are not antique at all. He scavenges old pine lumber from around China and transforms it into fortress-like doors that look as though they could have been used to hold back Mongol invaders in Shanxi province. He makes them on the street outside his shop, then leaves them out in the weather to age the timber and give the metalwork a rusted patina. The final touch: a layer of paint. "Before the paint is dry, we add mud, then when we remove the mud, the paint peels," he says.

Touring the market, Hong Kong dealer Oi Ling Chiang identifies dozens of items that have been manufactured to look old. She determines immediately that Li's doors are fake. Bending down to examine the smooth timber at the bottom of the doors, she sees the circular imprint of an electric saw. If the door was original, wear and tear would be evident, with no signs of modern tools.

But few buyers of Chinese antiques, either visiting Zhuhai or browsing in antique shops elsewhere, have Chiang's expert eye. Guangdong craftsmen have turned faking into an art form, improving their techniques to camouflage major alterations or prematurely aging wood. Herein lies the rub: shopping for antiques is fun but treacherous. Shoppers would be shocked to know that a narrow, elongated altar table labeled "late Qing Dynasty elm wood" and priced at around $2500, was cobbled together using parts from several damaged pieces of old furniture, or reconstructed from wood scavenged from derelict buildings. To give it a weathered look, the furniture may have been submerged in a mud pit, left outside in the rain for months, or treated with a cocktail of chemicals including lime soda, oxalic acid (bleach), acetone and lacquer.

For dealers and tourists, such shopping expeditions are a test of wits. Counterfeits and originals sit side by side.

Fig. 564 (opposite)
The Zhuhai market in Guangdong province, near Macau, is one of the largest in China, and is full of real antiques and fakes. Photo courtesy Sinopix.

Fig. 565
Fake stool, purchased by Cola Ma twenty years ago for 2000 yuan. "It was the first fake I ever encountered," he says. The dealer came later to buy it back and apologize but Ma decided to keep it as a reminder of the pitfalls of the trade.

Fig. 565

Fig. 566

Fig. 566
Throne chair, *huanghuali*, seventeenth century. Chairs like this one were used to transport Buddhist or Daoist deities to religious ceremonies. The rich carvings featured include a horned *qilin*, a magpie on prunus branches, a phoenix and a dragon. First purchased by Robert Piccus for a mere HK$8000, it sold in auction in 1997 for US$34,000. Photo courtesy Robert A. Piccus.

Fig. 567 (overleaf)
The Zhuhai market is a fascinating playground for bargain hunters. In this shot of the market, dozens of doors and windows taken from old homes in provinces like Shanxi and Zhejiang province are strewn about. Photo courtesy Sinopix.

Some shopkeepers are honest, others are not, blending fact and fiction to weave plausible tales about the provenance of their wares. So, before you start pulling out your wallet, do a little research. Here are some tips.

The Meaning of "Styles"

The earliest Western collectors favored "classical Chinese furniture," a term referring to Ming-style pieces crafted from hardwoods such as *huanghuali*, *zitan* and *jichimu*. The term "Ming style" is somewhat misleading because not all "Ming-style" hardwoods were crafted during the Ming dynasty (1368–1644). Ming style refers to the austere, spare designs favored by the literati during the Ming dynasty, but this conservatism survived well into the Qing dynasty until the Qianlong emperor (1736–95) promoted ostentatious carving. Most of the "Ming-style" classical furniture was made in the early Qing dynasty. So-called "classical" furniture achieves the highest prices at auction, not only because the workmanship is superior but because the first Western collectors of Chinese furniture focused on these more severe styles.

From a collector's viewpoint, classical furniture should not be confused with Chinese antiques made from softwood. A piece of softwood furniture, even if it was made during the Ming dynasty, is not considered "classical." There are 400-year-old tables and chairs made of softwood in circulation, but they do not hold the same value as their *huanghuali* or *zitan* counterparts from the same era.

Most pieces of furniture on the market today are softwood pieces from the mid- to late Qing dynasty. While furniture made of *yumu* or *huaimu* may never reach the same retail heights as *huanghuali*, good quality vernacular pieces are rapidly appreciating in value. Simple designs and good proportions are also favored among the softwoods.

What to Buy

Buying as an investment versus buying a few nice pieces to decorate your home are quite separate undertakings. If you ask most high-end dealers like Andy Hei, the only furniture that has truly appreciated

in value is that made of the classical hardwoods such as *huanghuali* and *zitan*. Dealers and collectors who purchased wisely in the 1980s, when pieces were flooding out of China, have done well. Robert and Alice Piccus purchased a *huanghuali* throne chair for roughly $1000 from Albert Chan's father in Hong Kong in the 1960s (Fig. 566). Chan repurchased the chair at auction in 1997 for $34,500. A pair of *huanghuali* yoke-back chairs sold ten years ago to a collector for $6400 were resold at Christie's New York auction in September 2003 for $343,500.

For most people entering the market right now, the bar for hardwoods is high. At Christie's New York auctions in 2004, prices ranged from $130,700 for a pair of *huanghuali* southern official's hat armchairs from the seventeenth century to $847,500 for a carved *zitan* couch bed from the Qianlong period. The least expensive piece was $6000 for a *huanghuali* cosmetic case with a folding mirror stand from the eighteenth century. If you are planning to start a collection, it would take a great deal of money to enter into the "classical" furniture sweepstakes. However, if you are interested in buying a couple of pieces of furniture to give your home an Oriental accent, you will not go far wrong with a traditional altar table, a sloping-stile cabinet or a pair of southern official's chairs.

Altar tables and yoke-back armchairs are still quite abundant in the market. Square center tables, which were once relatively common, are usually good value for money, and because people have difficulty in finding a place for them in their homes, they are not in great demand. Couch beds and rare items such as folding chairs and screens are significantly more expensive.

There is an attractive alternative to collecting classic Ming-style furniture: vernacular. For investment purposes, it takes a long time before prices of softwood catch up with *huanghuali* and *zitan*, but even Christies' expert Theow Tow is encouraging friends to stock up: "The construction and lines are great, and sometimes the wood is as good or as interesting as *huanghuali* or *zitan*, and it's readily affordable," he says. As an example, a massive rectangular *changmu* fur clothes storage chest and stand sold for $7170 at Christie's in 2004, and a set of six *yumu* southern official's hat armchairs with square scroll carving on the back splat from the seventeenth or eighteenth century sold for $9000.

Dealers like Beijing-based Cola Ma say antique furniture made of walnut is now in demand by new collectors. Walnut does not carry the cachet of *huanghuali* or *zitan*, but its stock is rising because it is a wood that is valued in North America. Most of the top-notch *hetaomu* pieces come from the Shanxi region, which is noted for its archaic styles. Ma has several pieces of Ming-style furniture that date back to the early or middle Qing dynasty, but are probably only worth $20,000–$40,000. An average Qing table can be as affordable as $2,000.

Albert Chan agrees. If you prefer early furniture in softwood, turn to Shanxi. It has the best pieces because people were rich in the Ming dynasty. The same applies to items originating from Fujian province. It was also a prosperous center, and carpenters used good material and had lots of individual style.

Other tips: Albert Chan suggests "going for a large painting table" because it is more practical. Today you can use it as a writing desk or a dining table, and because "it was the scholar's main piece of furniture, they are usually of the best quality."

Another popular collector's item today is Shanghai Art Deco furniture. During the 1920s and 1930s, Shanghai craftsmen, inspired by Western designs, build Art Deco furniture from shiny blackwood or *hongmu*. Over the past decade, as old homes have been torn down in Shanghai, a group of salvagers amassed some serious collections. Most of this furniture has been snapped up by retailers in Europe and the US. A pair of Art Deco chairs costs about $5000 in Hong Kong or China, but can reach $15,000 in New York today.

Pitfalls of Collecting

Many pieces of furniture advertised as antique are fakes. To avoid fake Ming, Charles Wong cautions buyers to look carefully at any repairs and check for alterations. If the proportions are too good to be true, the piece is probably a fake. If a medicine cabinet fits CDs perfectly, beware. If the coffee table is the perfect height for your couch, watch out. It is common to saw legs off day beds and tables to reduce the height. Look out also for over-restoration. Today, the glossy varnished look or a new black lacquer may mask a bad repair. Look also for pockmarks along the surface of the wood. Pockmarks are a sign that the pores of the wood have been exploded by strong chemicals used to strip lacquer. You want to look for furniture that has been returned to a condition that would seem to be in character with its estimated age. In recent years, epoxy resins and other adhesives have been used in furniture restoration, but never on a floating panel table top. Glued table tops can spell disaster down the road. Wood is a slave to its environment. It expands or contracts when necessary. If flexibility is not built into the joints, the wood will crack in other places and wreck the beauty of the piece.

Buying before Restoration

Try to buy antique furniture before it has been repaired or restored. Some dealers will allow prospective buyers into their workshops to shop around. According to Andy Hei, this is the only way buyers can really see what they are getting. It is easier, for example, to see if the joints are old and whether the timber looks as though it has been cut by an electric saw and reassembled. If the furniture has already been restored, "beware of 100 percent perfect pieces," says Hei. "There are almost no perfect pieces, not even those in museums."

There is some good news. Many dealers believed that America's lust for antiques drove demand for Chinese furniture, so when supplies dwindled, they panicked. Many desperately churned out fakes to survive. Dealers like Zafer Islam filled the vacuum by mixing and matching old and new, converting old doors and window screens into coffee tables and bookshelves. But rather than losing business, sales grew. Zafer Islam gained a great deal of insight into the American retail market: "The buyers don't care if it's half new or half old," he says. Now, many dealers are less reluctant to divulge the extent of restoration of their pieces. Consumers' ambivalence about antique versus reconstituted furniture has made them more honest.

Fig. 567

Quality of Restoration

Heat and humidity play havoc on wood furniture and poor restoration can add further damage. A repair should take into account the shrinkage and expansion properties of wood. Sometimes glue at seams causes furniture to warp and crack in visible parts of the piece. Check for repairs along the main seams. It is usually preferable to repair cracks or gaps between panels of wood using strips of wood. If plaster or glue are used, this may indicate a bad restoration job. "Restorers are reassembling a table or chair back into a piece of furniture, not something cobbled together with glue," says restorer Christopher Cooke.

The Joints

The joints are the places where one piece of wood has been fitted into another, such as a leg into a table top. Over time, the wood's expansion and contraction will make the joint protrude or retract into the wood panels. If the joint seamlessly fits into the panels, it is unlikely that you are looking at an old piece of furniture. Also, check to see whether joints are made of several pieces of wood or one solid piece. Before the Chinese antique furniture boom ten years ago, it was common practice to repair old loose joints by pounding in little wood wedges to stabilize a weakened one. If the joint has old repair work like this, it is more likely that it is an old piece of furniture.

Wear and Tear

Over time, table tops and the bottoms of legs of tables or chairs usually become worn and battered. If these areas look too pristine, chances are they have been replaced. Turn over a piece of furniture and look at the underside. It should look dry and raw, and frequently bits of old lacquer will still be clinging to the wood. Examine the condition of the lacquer. If the patina is too shiny or fresh, the piece may be new or the dealer may be trying to camouflage a serious flaw or major reconstruction work. Today, good restorers like Cooke and Wong try to retain the original finish of the lacquer or wood.

Price Watch

When it comes to antiques, if the price is too good to be true, it probably is. To show her clients the difference between a fake and an original, Chiang bought a fake lute table (a long and narrow style) for $1923. If it was genuine, it would have cost $32,000, she says. Honest retailers will make sure that prices reflect how much repair was done on a piece, she says. The more repair work and new parts, the cheaper it should be. "But with so many fakes on the market, it's hard for people to learn," she adds.

Credible Dealers

With so many fakes on the market, it is important to find a credible broker. Before you buy, quiz your dealer. Force him to

tell you everything he knows about a piece. From his answers you can pick up valuable information that may indicate how much knowledge he really has, and whether he is telling the truth. Do not accept lines such as "We know it's genuine because we are experts and have been in the business a long time." Ask him what condition the antique was in when he bought it. Was it restored or unrestored when he purchased it? If it was unrestored, what work was done on it? Does he have pictures of the piece before it was restored? What kind of finish has been used? Most importantly, is it still the original size or was it cut down?

"Dealers should guide you," says Andy Hei. "I don't mind if people come to learn from me. It's an education, and dealers should take responsibility for what they sell." In the end, go with the dealer with the strongest inventory and knowledge, says Albert Chan. "They have the instinct to determine whether a piece is correct or not." If you are buying as an investment or to build a collection, check to see how many important pieces in famous collections were purchased from that shop. You should be able to cross-check this by talking to other collectors and curators. Shop around (see the list of reputable dealers on pages 220–1 of this book).

Conclusion

The growing demand for Chinese furniture is both about aesthetics and pricepoint. Since they were first introduced in the 1980s by US designers such as Jay Spectre and Kalif Alaton, Chinese lanterns, terracotta horses, Buddha heads and lacquered cabinets have steadily become a decorative mainstay. Minimalism and beige treatments kept the chinoiserie look at bay, but as the home décor industry ramps up color and textures, the demand for Oriental accents—and furniture—has climbed dramatically. "There's been an increased integration of the Chinese aesthetic into (American) design," says New York-based interior decorator Kathryn Scott. The clean lines of Chinese furniture blend well into homes today, she adds. "In the beginning it felt new and exotic … now it feels normal."

Fueling the Chinese furniture trend, in both antiques and reproductions, is that Chinese pieces are perceived as good buys. They are made of solid wood, they are crafted by hand, and they can compete with assemble-it-yourself Ikea-style furniture or country-style American furniture in price.

The China-style décor trend has been a boon to dealers on the mainland. What is more exciting for many traders, however, is that Chinese furniture design has finally emerged from the Dark Ages. After the People's Republic of China was created in 1949, function, not craftsmanship, became the priority. Traditional workshops catering to a wealthy clientele closed, and even the wood craftsmen guild, known as the Lu Ban Jin, disbanded. The last of the great "looks" originating from China was the Shanghai Art Deco pieces of the 1920s and 1930s—curvy armchairs and angular tea tables in blackwood and walnut.

It has taken seventy years, but Chinese furniture design is finally making a comeback. In 2002 Shanghai-based Henry Wang started his own collection of furniture after he produced some contemporary pieces for an exhibition held at the Shanghai Art Museum. His pieces, including an S-shaped lover's seat and C-shaped patio furniture, were inspired by lacquer and bronzeware tomb objects that date back to 475 BC. What excites Wang about the groundswell of interest in antiques is how it is serving as a catalyst for new design in the field of furniture. While modern furniture design in China is still in its infancy, Wang is confident it will regain its stature in the crafts world. "Traditional Chinese furniture has a lot of design value—there's a deep reserve of Chinese culture that people are just discovering," he says. Chinese style will one day be as ubiquitous as the Scandinavian look is today. "As long as the design is original, it won't matter if it's made in the West or in China," says Wang.

Fig. 568
Fake table, purchased by Cola Ma in 2001, made in Shanxi province. The dealer was trying to replicate the early Song style of furniture by imitating the shape and lacquer finish. "This is a very good fake," says Ma. Only on close inspection of the surface can an expert determine that the cracks in the lacquer and the patina are not right. "But most people would be easily fooled," he says.

Fig. 568

Guide to Dealers

The old adage "it is best to shop around" is particularly true when it comes to buying antique furniture. The dwindling supply of Chinese antique furniture has led to a sharp spike in prices and a wave of cheap reproductions and fakes. The lines between a restoration and a reproduction have blurred over the years making collecting a perilous hobby. One way to navigate the forgery mine field is to identify good dealers. Here is a carefully collated list of some of the best dealers in the world.

China
Ancient and Modern Furniture and Design
1780 Fanghe Road
Shanghai 201109
China
Tel: 86-21-6450-8369
Fax: 86-21-6450-1966
E-mail: shanghai@aamfd.com
Website: www.aamfd.com

C. L. Ma Furniture
No. 803, Long Zhao Shu Cun
Xiao Hong Men Xiang
Beijing
China
Tel: 86-10-6466-7040
Fax: 86-10-6466-7037
E-mail: clmafurn@public1.tpt.tj.cn

Henry's Studio & Antiques
796 Suining Road
Shanghai
China
Tel: 86-21-5217-3833
E-mail: henrywang1958@yahoo.com.cn

Shanju Shanghai
158 Gaochao Road (at Jinshajiang West Rd)
Shanghai
China
Tel: 86-21-5160-5212
Fax: 86-21-6283-9246
E-mail: shanju@chinese-furniture.com
Website: www.chinese-furniture.com/shanju.html

Denmark
Galerie Bork of Copenhagen
Regnegade 2
Copenhaen
Denmark 1110
Tel: 45-33-93-97-71
Fax: 45-33-93-97-72
E-mail: bork@galeriebork.com

France
Clark & Smith
1 place du Chapelet
Bordeaux 3300
France
Tel: 33-5-56-521066
Fax: 33-5-56-72708
E-mail: ryst-dupeyron@wanadoo.fr

Galerie Baikal
24 rue Saint-Paul
75004 Paris
France
Tel: 33-1-42-747339
Fax: 33-1-42-747335
Website: www.baikal.fr

Galerie Luohan
21 quai Malaquais
Paris 75006
France
Tel: 33-1-40-156400
Fax: 33-6-80-416844

Maison du Gouverneur
151, rue du Faubourg-Saint-Antoine
75011 Paris
France
Tel: 33-1-46-281385
Website: www.maisondugouverneur.com

Hong Kong
Altfield Gallery
248-9 Prince's Building
10 Chater Road
Hong Kong
Tel: 852-2537-6370
Fax: 852-2537-6433
E-mail: altfield@netvigator.com

Andy Hei
Ground Floor, 84 Hollywood Road
Central
Hong Kong
Tel: 852-3105-2002
E-mail: andyhei@andyhei.com.hk

Barrie Ho Architectural Interiors Ltd
1, 3-4 Floor, 31 Wyndham Street
Central
Hong Kong
Tel: 852-2117-7662
Fax: 852-2117-7661
E-mail: barrieho@barrieho.com

Chan Shing Kee
Ground Floor, 228-230 Queen's Road
Central
Hong Kong
Tel: 852-2543-1245; 852-2544 0808
Fax: 852-2815-0561
E-mail: albert@chanshingkee.com

China Art
Ground Floor, 15 Hollywood Road
Central
Hong Kong
Tel: 852-2542-0982
Fax: 852-2854-1709
E-mail: chinaart@chinaart.com.hk

Contes D'Orient
52 Hollywood Road
Central
Hong Kong
Tel: 852-2815-9422
Fax: 852-2545-8599
E-mail: condorie@netvigator.com

Ever Arts Classic Furniture
Ground Floor, 34 Elgin Street
Central
Hong Kong
Tel: 852-2522-8176
Fax: 852-2521-8797
E-mail: everarts@netvigator.com

Grace Wu Bruce
701 Universal Trade Center
3 Arbuthnot Road
Hong Kong
Tel: 852-2537-1288
Fax: 852-2537-0213
E-mail: art@grace-wu-bruce.com

Singapore
Just Anthony Antique Furniture
379 Upper Paya Lebar Road
Singapore 534972
Tel: 65-6283-4782
Fax: 65-6284-7439
E-mail: justanthony@justanthony.com
Website: www.justanthony.com

Luban Zhuang Pte Ltd
43 Jalan Merah Saga
#02-70 Workloft@ Chip Bee
Singapore 278115
Tel: 65-6479-7688
Fax: 65-6479-7008
E-mail: admin@lubanzhuang.com.sg
Website: www.lubanzhuang.com

Pagoda House Gallery & Co.
143/145 & 138 Tanglin Road
Tudor Court
Singapore 247930
Tel: 65-6835-9435
Fax: 65-6737-8260
Website: www.pagodahouse.com

Spain
Memorias de Oriente
Santiago 22
Vallaodolid, 47001
Spain
E-mail:
memoriasoriente@memoriasdeoriente.com

Taiwan
Artasia
No. 436, 1st Floor, Ren Ai Road
Section 4
Taipei
Taiwan
Tel: 886-2-8780-1242
Fax: 886-2-8780-1347
E-mail: artasia@gcn.net.tw

Art of Chen
No. 24, Tongfeng Street
Taipei
Taiwan
Tel: 886-2-2325-2501
Fax: 886-2-2704-2124
E-mail: artchens@ms12.hinet.net

Thailand
Lamont Design Ltd
Gaysorn Plaza
3rd Floor, Room 3F-23
999 Ploenchit Road
Lumpini Pathumwan
Bangkok 10330
Thailand
Tel: 66-2-656-1250
Fax: 66-2-656-1251
E-mail: alex@lamont-design.com

United Kingdom
Gerard Hawthorn Ltd Oriental Art
104 Mount Street
London, W1Y 5HE
UK
Tel: 44-0-20-409-2888
Fax: 44-0-20-409-2777
E-mail: mail@gerardhawthorn.com
Website: www.gerardhawthorn.com

Gordon Reece Gallery
16 Clifford Street
London W1X 1RG
UK
Tel: 44-0-20-7439-0007
Fax: 44-0-20-7437-5715
E-mail: london@gordonreecegalleries.com
Website: www.gordonreecegalleries.com

Nicholas Grindley
2 Courtney Square
London SE11 5PG
UK
(by appointment only)
Tel: 44-0-20-7437-5449
Fax: 44-0-20-1449-614523
E-mail: nick@nicholasgrindley.com

Susan Ollemasns Oriental Art
9 Comeragh Road
London W14 9HP
UK
Tel: 44-20-7381-4518
E-mail: ollemans@tiscali.co.uk

United States
Beyul
353 West 12th Street
New York
New York 10014
USA
Tel/Fax: 212-989-2533
E-mail: beyul@minspring.com
Website: www.beyul.com

CaShi Gallery
3458 Walnut Street
Denver
Colorado 80205
USA
Tel: 303-297-2947
Fax: 303-382-1263
E-mail: info@cashigallery.com

Evelyn's Antique Chinese Furniture, Inc.
381 Hayes Street
San Francisco
California 94104
USA
Tel: 415-255-1815
Fax: 415-255-0688

Ever Arts Antique Furniture
1782 Union Street
San Francisco
California 94123
USA
Tel: 415-776-7582
Fax: 415-776-0868
Email: everarts@msn.com

Fine Asian Furnishings and Art
2000 Baltimore Street 100
Kansas City
Missouri 64108
USA
Tel: 816-221-2727
E-mail: robin@fafagallery.info

Honeychurch Antiques
411 Westlake Avenue N
Seattle
Washington 98109
USA
Tel: 206-622-1225
E-mail: john@honeychurch.com

MD Flacks Ltd
38 East 57th Street (6th Floor)
New York
New York 10022
USA
Tel: 212-838-4575
Fax: 212-838-2976
E-mail: md.flacks@verizon.net

Ming Furniture
31 East 64th Street
New York
New York 10021
USA
Tel: 212-734-9524

Ming Mai Gallery
1335 4th Street, Suite 1A
Santa Monica
California 90401
USA
Tel: 310-458-3903
Fax: 310-451-4207
E-mail: jane-wills@ming-mai.com

Shangri-La Antiques Gallery
371 North Main Suite 10
Ketchum
Idaho 83340
USA
Tel: 208-725-2249
Fax: 208-725-2248
E-mail: wei@shangrilaantiquesgallery.com

WaterMoon Gallery
110 Duane Street
New York
New York 10007
USA
(by appointment only)
Tel: 212-925-5556
E-mail: watermoon@mindspring.com

William Lipton Ltd
805 East 57th Street
New York
New York 10022
USA
Tel: 212-751-8131
Fax: 212-751-8133
E-mail: gallery@williamliptonltd.com

Bibliography

Altfield Gallery, *Wood from the Scholar's Table: Chinese Hardwood Carvings and Scholar's Articles*, Hong Kong, 1984.

Ang, John Kwang-Ming, *The Beauty of Huanghuali*, Taipei: ArtAsia, 1995.

———, "Further Studies of Chinese Furniture in Various Woods: Longyan Wood Furniture," *Arts of Asia*, September–October 1994, pp. 64–80.

Berliner, Nancy et al., *Beyond the Screen: Chinese Furniture of the 16th and 17th Centuries* (exhibition catalogue), Boston: Museum of Fine Arts, 1996.

Berliner, Nancy and Handler, Sarah, *Friends of the House: Furniture from China's Towns and Villages* (exhibition catalogue), Salem: Peabody Essex Museum, 1995.

Cammann, Schuyler, *Substance and Symbol in Chinese Toggles: Chinese Belt Toggles from the C. F. Bieber Collection*, Philadelphia: University of Pennsylvania Press, 1962.

Chambers Fine Arts, *The Chinese Scholar's Mind: Furniture from Late Ming to Early Qing Dynasties* (sales catalogue), New York, 2001.

———, *A Minimal Vision: Furniture with Paintings by Yun Gee* (sales catalogue), New York, 2002.

China Art, *Antiques in the Raw*, Hong Kong, 1997.

———, *Regional Furniture*, Hong Kong, 1999.

Christie's, *The Mr. and Mrs. Robert P. Piccus Collection of Fine Classical Chinese Furniture* (sales catalogue), September 1997.

Clunas, Craig, *Chinese Furniture*, London: Bamboo Publishing, 1988.

———, *Superfluous Things: Material Culture and Social Status in Early Modern China*, Cambridge: Polity Press, 1991.

——— (ed.), *Chinese Export Art and Design*, London: Victoria and Albert Museum, 1987.

Ecke, Gustav, *Chinese Domestic Furniture in Photographs and Measured Drawings*, New York: Dover, 1986; first published Rutland, Vermont: Charles E. Tuttle, 1962.

Ellsworth, Robert H., *Chinese Furniture: Hardwood Examples of the Ming and Early Ch'ing Dynasties*, New York: Random House, 1970.

———, *Chinese Furniture: One Hundred Examples from the Mimi and Raymond Hung Collection*, New York: privately published, 1996.

Evarts, Curtis, *C. L. Ma Collection: Traditional Chinese Furniture from the Greater Shanxi Region*, Hong Kong: C. L. Ma Furniture, 1999.

———, *A Leisurely Pursuit: Splendid Hardwood Antiquities from the Liang Yi Collection*, Hong Kong: Art Media Resources, 2000.

FitzGerald, C. P., *Barbarian Beds: The Origin of the Chair in China*, South Brunswick and New York: A. S. Barnes, 1966.

Garrett, Valery M., *Chinese Clothing: An Illustrated Guide*, Hong Kong: Oxford University Press, 1994.

Handler, Sarah, "Alluring Furnishings in a Chinese Woman's Dominion," *Orientations*, January 2000, pp. 22–31.

———, *Austere Luminosity of Chinese Classical Furniture*, Berkeley: University of California Press, 2001.

———, *Ming Furniture in the Light of Chinese Architecture*, Berkeley: Ten Speed Press, 2005.

Kates, George N., *Chinese Household Furniture*, New York: Dover Publications, 1962.

Knapp, Ronald G., *China's Living Houses: Folk Beliefs, Symbols and Household Ornamentation*, Honolulu: University of Hawaii Press, 1999.

———, *Chinese Houses: The Architectural Heritage of a Nation*, Vermont and Singapore: Tuttle, 2005.

Knapp, Ronald G. and Lo, Kai-Yin, *House Home Family: Living and Being Chinese*, Honolulu: University of Hawaii Press, 2005.

Lam, Willy Wo-Lap, *Classic Chinese Furniture: An Introduction*, Hong Kong: FormAsia, 2001.

Latham, Richard J., "Regional Chinese Furniture," *Orientations*, January 2002, pp. 40–9.

Lo, Kai-Yin (ed.), *Classical and Vernacular Chinese Furniture in the Living Environment*, Hong Kong: Yungmingtang, 1998.

Ma, Weidu, *Zhongguo Gudai Men Chuang/ Classical Chinese Doors and Windows* (bilingual edition), Beijing: Zhongguo Jianzhu Gongyi, 2001.

MD Flacks, *Classical Chinese Furniture IV* (sales catalogue), New York, Spring 2001.

———, *Classical Chinese Furniture VI* (sales catalogue), New York, Spring 2003.

National Museum of History, Taipei, *Splendor of Style: Classical Furniture from the Ming and Qing Dynasties*, 1999.

National Palace Museum, Taipei, *Special Exhibition of Furniture in Paintings*, 1996.

Orientations, *Chinese Furniture: Selected Articles from Orientations 1984–1999*, Hong Kong, 1999.

Roche, Odilon, *Les meubles de la Chine*, Paris: Librairie des Arts Décoratifs, 1922.

Ruitenbeek, Klaas, *Building and Carpentry in Late Imperial China: A Study of the Fifteenth Century Carpenter's Manual Lu Ban Jing*, Leiden: E. J. Brill, 1993.

Tian Jiaqing, *Classic Chinese Furniture of the Qing Dynasty*, Hong Kong: Phillip Wilson Publishers, 1996.

Wang Shixiang (trans. Sarah Handler and Karen Mazurkewich), *Classic Chinese Furniture: Ming and Early Qing Dynasties*, Hong Kong: Joint Publishing, 1986.

———, *Connoisseurship of Chinese Furniture*, 2 vols, Hong Kong: Joint Publishing, 1990.

Wang Shixiang and Evarts, Curtis, *Masterpieces from the Museum of Classical Chinese Furniture*, San Francisco: Tenth Union, 1995.

Wu Bruce, Grace, *Chinese Classical Furniture*, Hong Kong: Oxford University Press, 1995.

———, *Living with Ming: The Lu Ming Shi Collection*, Hong Kong: Grace Wu Bruce, 2000.

———, *Zitan Furniture from the Ming and Qing Dynasties* (sales catalogue), Hong Kong: Grace Wu Bruce, 1999.

Yip Shing-Yiu and Wu Bruce, Grace, *Chan Chair and Qin Bench: The Dr. S. Y. Yip Collection of Classic Chinese Furniture II*, Hong Kong: Chinese University of Hong Kong, 1998.

Acknowledgments

Until the early 1980s, relatively little was known about Chinese furniture. In the West, only a handful of good pieces were in the public domain. With the opening of the People's Republic of China to the outside world two decades ago, the antique furniture market came into its own. The most experienced dealers were transformed into frontline scholars, sifting through the finest pieces to hone their expertise. It was these hands-on dealers whom I turned to when I decided to write this book. Without their help—providing photographs from their collections and sharing expertise about regional styles—this book would not have been possible.

First, I would like to thank Oi Ling Chiang. When I first approached Ms Chiang about a story I was researching on fake furniture for the *Wall Street Journal*, she shared her insights as we teamed up for a tour of the good, the bad and the ugly in the marketplace. It was her belief that the antiques market should be more transparent. The more that buyers understood fakes and forgeries, the better they could avoid them. And the more confidence they would have in good dealers. By opening the door to this secret world, she inspired me to write a book that would shed more light on this fascinating genre of the Chinese art world.

I would also like to thank Cola Ma, another dealer, who generously shared his insights into the "runners" of the trade—the scouts who seek out hidden gems in the Chinese countryside for restoration and resale. Cola Ma let our talented photographer, A. Chester Ong, into his warehouse to shoot pieces from his personal collection.

I am also indebted to dealers Andy Hei, his father Hei Hung Lu, and Charles Wong, who also gave us access to their workshops and showrooms to take photographs, and supplied us with additional images for this project. Collector Edmond Chin and Kai-Yin Lo invited us into their homes for some situational images. In addition, dealers John Ang, Albert Chan, Jerry Chen, Christopher Cooke and Amanda Clark, as well as collector Peter Fung generously provided photos from their personal archives. I owe a debt of gratitude to photographers Michael Wolf and Richard Jones of Sinopix who gave us permission to reproduce some of their images. Also, a big thanks to the Minneapolis Institute of Arts, Hong Kong Museum of History, the National Palace Museum of Taipei and Christie's Hong Kong who also provided images. Without these donations, such a comprehensive survey of Chinese antique furniture would have been impossible.

Several people in Singapore also allowed photographer A. Chester Ong into their homes and shops to take additional photographs. I am grateful to Christopher Noto of Pagoda House Gallery, Philip Ng of Luban Zhuang Pte Ltd, Anthony Lee and his daughter Danielle of Just Anthony Antique Furniture, as well as those collectors who wish to remain anonymous.

Ronald G. Knapp, distinguished author of *Chinese Houses: The Architectural Heritage of a Nation* (Tuttle Publishing, 2005), generously allowed the publisher to use several photos from his book, taken by A. Chester Ong, to illustrate the context of many of the fine old hardwood pieces shown in the book. These photos appear on pages 9, 12–13, 21, 33, 74, 85 (top right), 88, 89, 140, 150, 151 (top), 153, 176 (top), 177 (below), 186. Similarly, my thanks go to Sharon Leece and A. Chester Ong for a photo from *China Modern* (Periplus Editions, 2003), reproduced on page 2, and to Sharon Leece and Michael Freeman for a photo from *China Style* (Periplus Editions, 2002), reproduced on page 224.

Finally, my thanks to Curtis Evarts for reading a draft of the manuscript. And my gratitude to my editor at Periplus/Tuttle, Noor Azlina Yunus, for her thoughtful contributions.

Fig. 569 (overleaf)
A reconstructed seventeenth-century Ming-dynasty reception hall at the Minneapolis Institute of Arts in the United States. A large folding screen serves as a backdrop to a couch bed and a pair of horseshoe armchairs. Photo courtesy Michael Freeman.